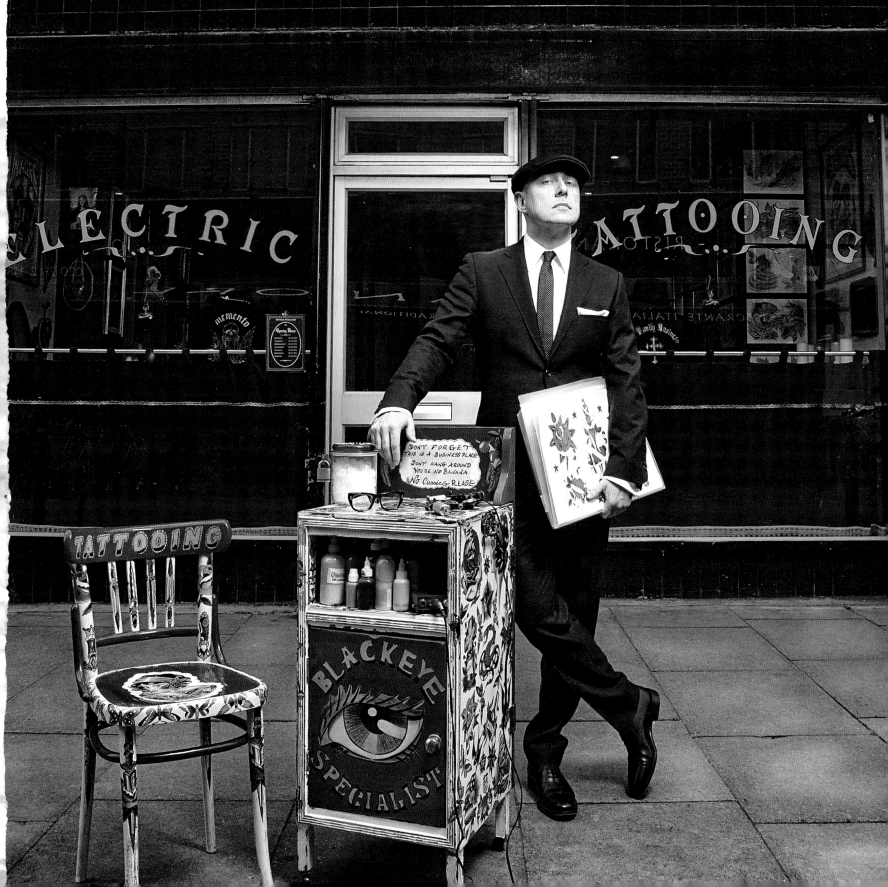

TATTOOED ⚓ BY THE FAMILY BUSINESS

PORTRAITS BY **FREDI MARCARINI** · REPORTAGE BY **CHRIS TERRY**

PAVILION

First published in the United Kingdom in 2010 by
PAVILION BOOKS
10 Southcombe Street, London W14 0RA
An imprint of Anova Books Company Ltd

In association with Heartbreak Publishing Ltd

Text, design and layout © Anova Books, 2010
Photography © Fredi Marcarini and Chris Terry, 2010

Associate Publisher: Anna Cheifetz
Senior Editor: Emily Preece-Morrison
Photography: Fredi Marcarini (portraits) and Chris Terry (reportage and selected portraits)
Text: Tom Tivnan
Designer: Steve Russell
Artworks: Mo Coppoletta
Production: Oliver Jeffreys

ISBN: 978-1-86205-883-5

A CIP catalogue record for this book is available from the British Library.

10 9 8 7 6 5 4 3 2

Reproduction by Mission Productions, Hong Kong
Printed and bound by 1010 Printing International Ltd, China

www.anovabooks.com

CONTENTS

FOREWORD

I was born and raised in the Italian countryside of Verona, and from an early age I was exposed to a huge amount of religious and decorative art from my historical background. So when tattooing came into my life when I was 17, I was immediately charmed by those types of images – they looked pretty powerful and extreme to me.

Quickly drawn to this world of tattooing, I travelled the world for few years as a fan before deciding that it was time for me to give it a shot and see if I could develop my own vision of this art. I moved to London and landed jobs in the two most prestigious tattoo shops of the city. After 5 years of hard work I opened my own studio, The Family Business Tattoo Shop. With its unique style and appeal the shop completely reflects my Italian background.

The Family Business has become a reference point in the landscape of the tattoo world, promoting an array of resident and international guest artists and taking part in various art projects. Since its opening, the shop has attracted the wildest audience which has led to various collaborations (CD covers, street wear collections, exhibitions), challenging me to reinvent a way of looking at western and eastern religious and decorative icons in order to use them in a strictly non-tattoo environment.

Still remaining first and foremost a tattoo shop for all lovers of this amazing craft, today The Family Business is also a melting pot, where I and the other artists of the shop, can explore the artistic side of a variety of industries, from fashion to film, and from music to books.

This book is a testimony to the first 7 years of The Family Business

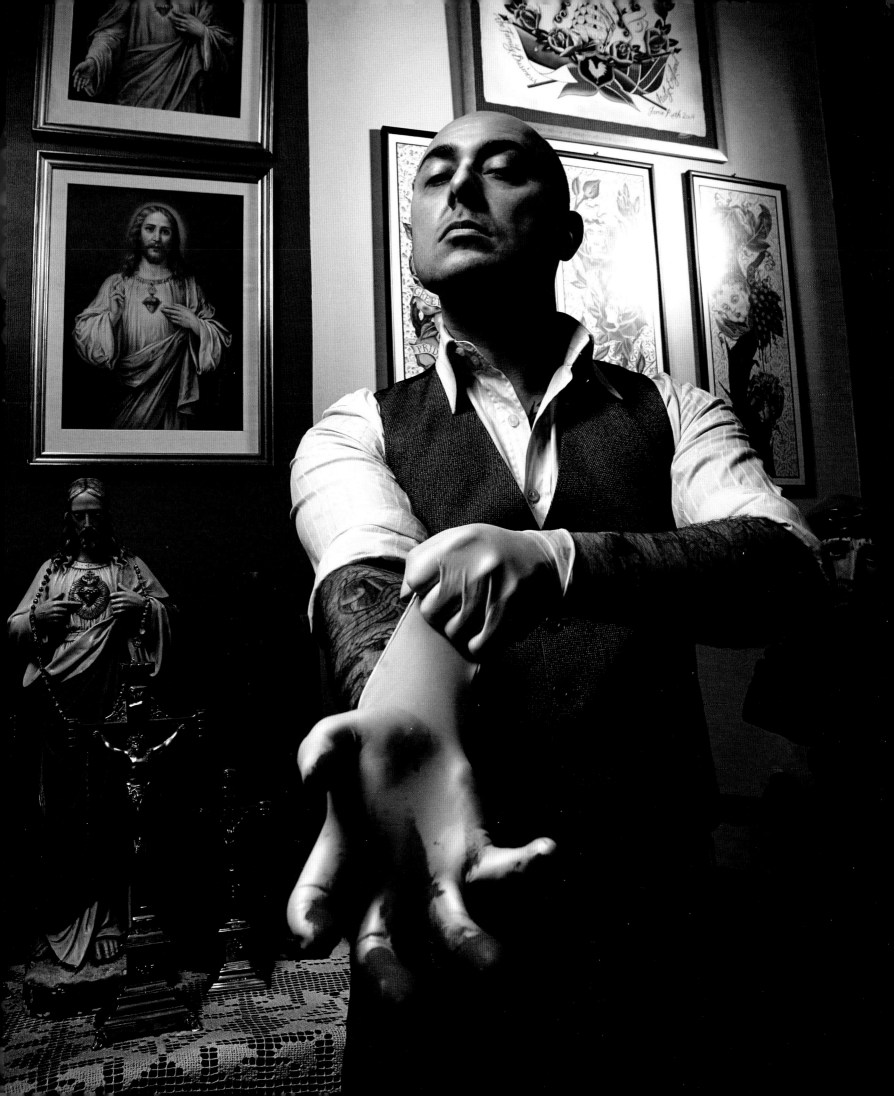

INTRODUCTION

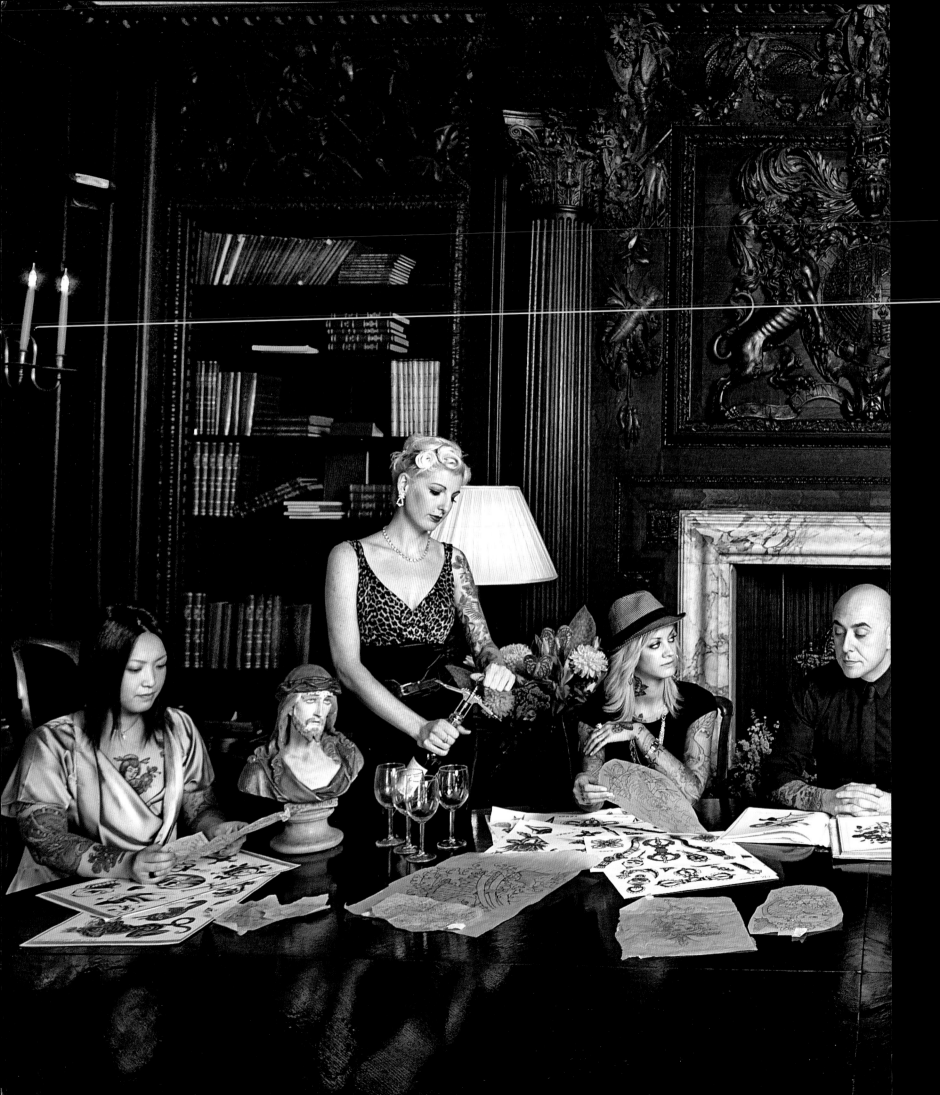

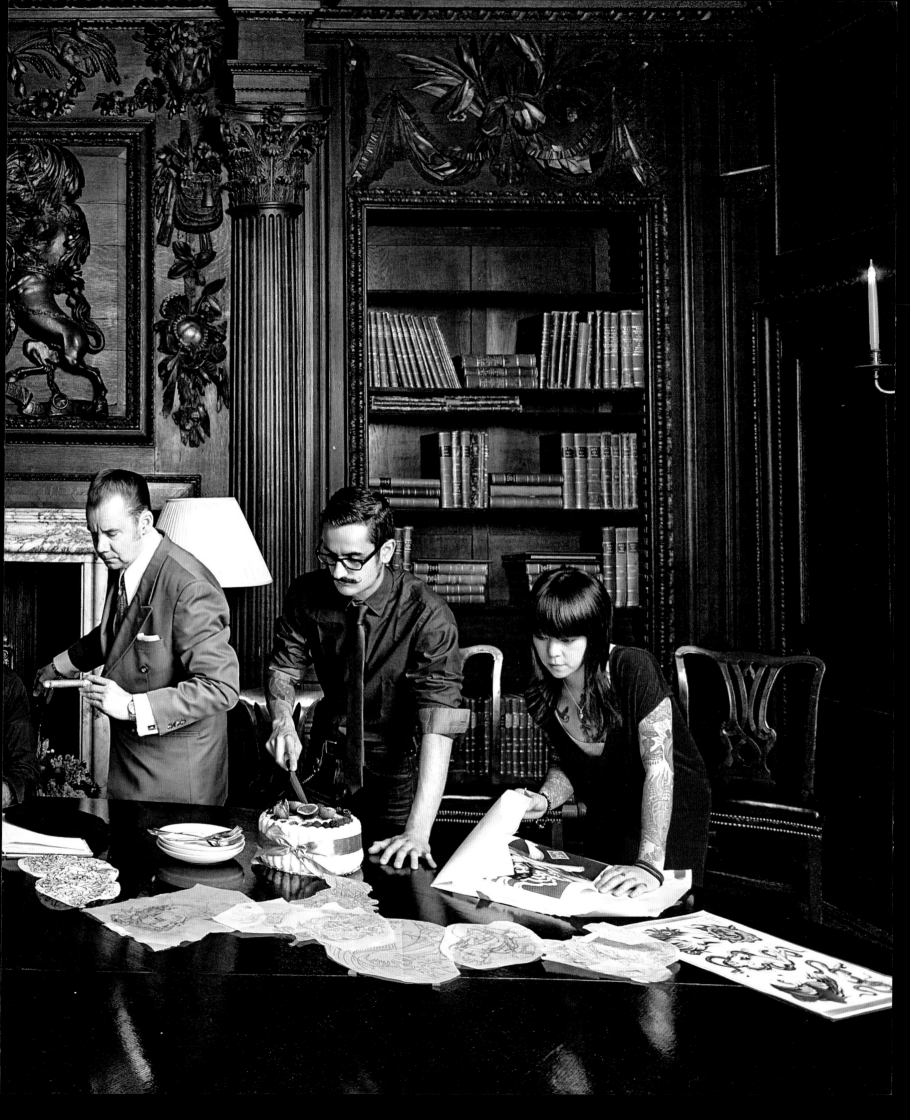

E ven though Mo Coppoletta is one of the most influential artists in modern tattooing and the founder and driving force behind the Family Business Tattoo Parlour – one of London's most in demand, and arguably the best, shops – he knows how daunting getting a tattoo can be. Even in this day and age, long after tattooing has shed its less than salubrious back-alley reputation and is more popular and mainstream than ever before, the "scene" can be jarring, somewhat exclusionary and unwelcoming to newcomers, and even not so newcomers. The Family Business is a far cry from the more intimidating end of the tattoo shop spectrum, those cheap and nasty bolt-holes which blare death metal and unfriendly staff knock out by-the-numbers dolphins, unicorns and "tribal" tattoos.

In fact, part of the whole philosophy of the Family Business is to simply ignore the scene and put the emphasis squarely onto the excellence of the art.

"It is about being welcoming and it shouldn't
matter if you already have tattoos or not."

Indeed, since opening its doors in 2003, the Family Business has been the least stereotypical of tattoo shops, exuding class and charm. From David and Tracy, the friendly suited and booted front of shop maestros, to Mo's stable of world class tattooists: Diego Azaldegui, Dom Holmes, Kanae, Mie Sato, Andrea Furci and Diego Brandi, plus a steady stream of visiting international guest artists, there is a feeling that everything is curated, that nothing is out of place. The interiors are warm blood red and yellow and tasteful Japanese-influenced wood panelling separates the waiting area from the workroom. Roman Catholic iconography – crucifixes, miniatures of saints, statuettes of Jesus, paintings of Sacred Hearts, rosary beads dangling from lighting – is juxtaposed against delicate tracing paper on the walls with tattoos in waiting: dragons, birds, roses, skulls, interlaced peacock feathers, Mexican Day of the Dead figures. The music – which veers from vintage swing to indie to classic rock – is chilled and relaxed. The whole effect is at once instantly familiar, somehow like coming home.

"It is about being welcoming and it shouldn't matter if you already have tattoos or not," Mo explains. "It is not a shop of extremes. And by that I don't necessarily mean the tattoos themselves, because we do big tattoos and our clientele does want to experiment. But I'm talking about the surroundings; the décor is not extreme, the music is not. Tattooing can be a painful process. I wanted to create a place, if I could, that makes tattooing a little less painful; in a strange way, like an old fashioned beauty parlour. People who come to the Family Business say that, compared to other shops, it is soothing, comfortable, relaxing. That is how I wanted it."

Even the name alone separates it from the pack, eschewing any kind of self-consciously hip, in-yer-face or punny title. The Family Business. It implies permanence, an adherence to tradition, a commitment to the craft, and it is more than a bit of a nod to Mo's close-knit Veronese upbringing. Yet it is also about a focus on the personal touch, no tattooing pun intended. Spend an afternoon in the shop and it is like dropping into your favourite local to have a pint with a bunch of your best mates. Yes, there is dedication and a seriousness of purpose about tattooing, but this is balanced by the laughter and the friendly banter coming from staff and customers alike.

The location works, too. In sheer wealth of numbers, the bulk of the London tattoo scene is congregated around the tourist hotspots of trendy Camden Town and libertine Soho. Yet the Family Business is nestled in the lively, car-free Exmouth Market, in Clerkenwell. Though still close to central London, the area is a bit off

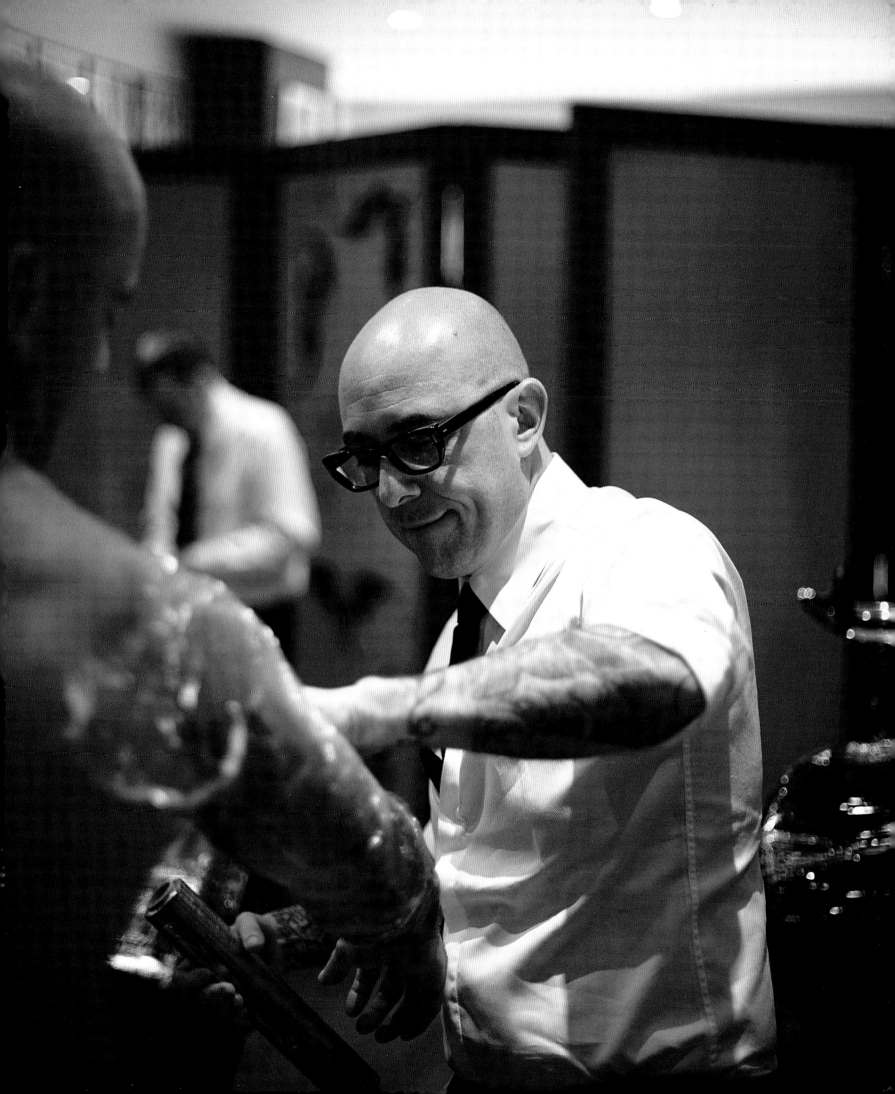

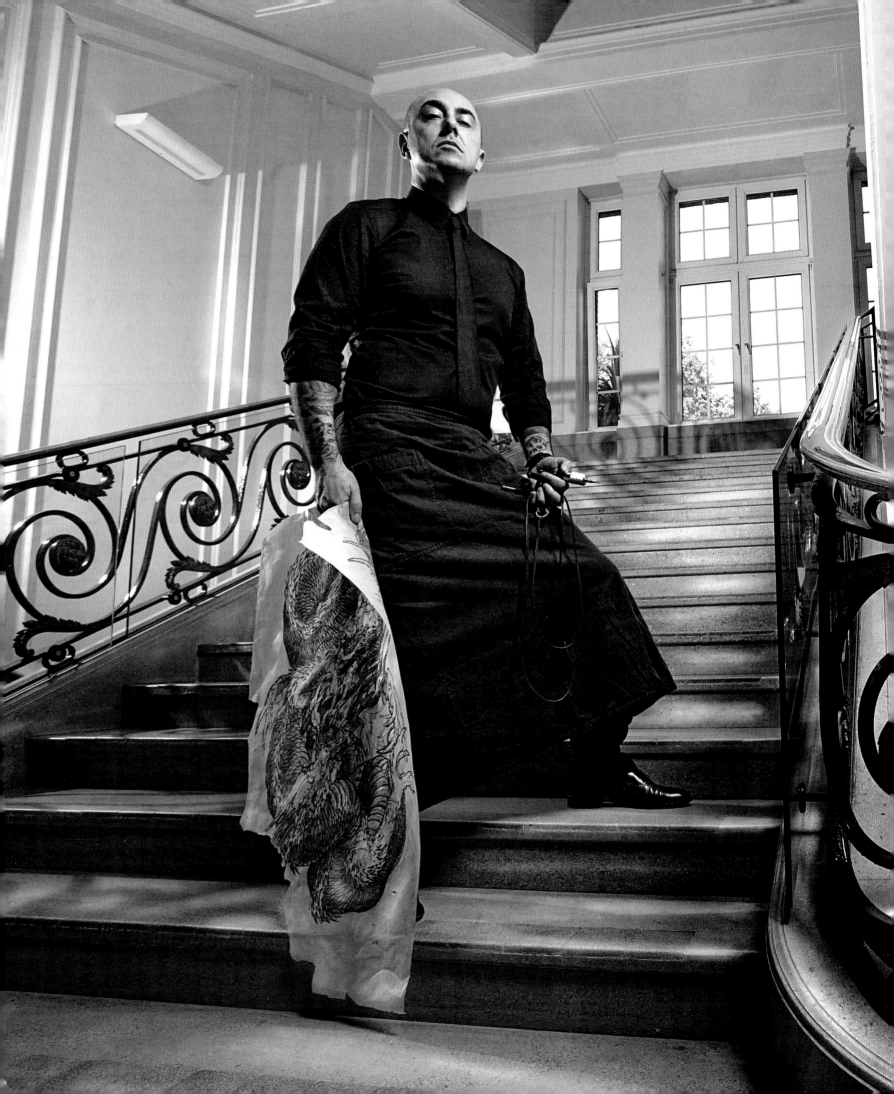

> "This is as indie as you can get in London, or anywhere in the world, for that matter. I like the feel of it. I feel like I belong."

the typical tourist trail. The almost ancestral pull the area has for Mo is certainly understandable: from about the 1850s to the 1960s Clerkenwell was the beating heart of London's Italian immigrant community, more Calabrese then Cockney. It still retains much of that feel, both architecturally (London's only Italian basilica-style church is just across the road) and in Exmouth Market's sidewalk café culture. Ignore the weather and you could easily be in Milan or Rome or Naples. "It made sense opening here," Mo says. "It is the old Little Italy of London; it gives off a Mediterranean feel. I like the idea of a pedestrianised street with a lot of independent shops. This is as indie as you can get in London, or anywhere in the world, for that matter. I like the feel of it. I feel like I belong."

Yet whatever the feel of the shop, and however welcoming, what really is the measure of the place is the quality of the tattoos. Mo's journey to opening the Family Business began in Verona in the early 1990s when, after playing in bands and even studying to be a lawyer, he became fascinated by tattooing during a revival of the art. "There was a big tattoo renaissance back then, a lot of it coming from America. I got into it with a few friends in Italy – we really jumped on the new tattoo wave. Then the interest got bigger and bigger for me, and started becoming something of an obsession. I am like that. When I start to do something, I just need to dive into it. If you want to succeed in tattooing, you need to breathe, eat, drink and smell tattooing."

Becoming a tattooist is challenging. It is not like other arts. There is no Royal Academy for Tattooing, and artists learn on canvasses than can talk, move, sweat – and even complain. Mo's first tattoo was back in Italy, a Sacred Heart on a rather trusting friend. "You learn on people's skin," he explains. "And there is no other way. It is up to you to moderate yourself and take one piece that you are able to deliver. That is the way it is. You can't do your first tattoo and have the ability to be able to shade it straight away. There are no schools, nothing like that. You just need to find your own way."

At the time, the scene in Italy was small, so his obsession took him to London, then and still, the epicentre of European tattooing. He briefly worked at a shop near Waterloo, then got a big break apprenticed at Evil from the Needle in Camden to the Frenchman "Bugs", perhaps the most celebrated of the tattooists from the Continent who were piling into London to tap into the scene. Next, he moved to Into You, another Clerkenwell shop, where he worked with Alex Binnie. He was allowed to create and refine his style – which can be best described as a mix between Westernised Asian influences combined with Catholic iconography – in the two years he spent at Into You. "Tattooing as a business is a bit like the music industry," Mo says. "It is not institutionalised, still not regarded as a 'proper' job, still a pirate thing. So a lot of people are restless, move around. But I have been very lucky. The artists I always looked up to as a fan, I ended up either working for them, becoming friends with them, or working with them in my shop. It has been a bit surreal and it didn't happen overnight, but I wanted to get there as quick as I could."

He not only perfected his style, but has developed a firm tattooing philosophy. The blend of old and new is not just the aesthetic of the actual physical shop, it is what he thinks constitutes a good tattoo. As any quick glimpse at the plethora of websites devoted to bad body art can attest, following fashion and trends can be a recipe for disaster. Mo uses the word "classic" frequently when enthusing about tattoos, but emphasises firmly that it does not mean to be stuck in the past: "However novel it is as a concept, a tattoo always has to look like a classic. Something that makes it evergreen. A tattoo, by its very definition, stays quite a long time, you might

as well not follow fashions or trends but get something that can stand the test of time. There is always a way to introduce new things but still make it look a classic."

Vintage with a modern look, is how he sums it up. That is that is the essence of the Family Business, a core philosophy that has influenced a generation of tattoo artists. It is dancing a fine line between being retro, but not totally so as to be stuck in time. There is a wink to the past, references and influences that are plain and recognisable, but with an updated twist.

This convergence of the old and new can perhaps be achieved more readily in tattooing than any other art form, because its power relies upon the well-established iconography and the repetitive weight of symbols. Tattooing by its very nature is not just retro – it is positively ancient. Body art has been found on the mummified remains of people from the Neolithic period. The tribal tattooing techniques of Polynesia and New Zealand have remained largely unchanged for two thousand years. Even the engine of the shops, the modern electric twin coil tattoo machine that provides the background buzz in parlours the world over, is relatively old technology; an early prototype of the machine was patented by American Sam O'Reilly in 1891.

> "The artists I always looked up to as a fan, I ended up
> either working for them, becoming friends with them,
> or working with them in my shop."

Mo goes on to explain that tattooing is more about "reinvention than invention". Tattooing is about operating within those well-established influences and rules that have been codified by tens, hundreds, perhaps thousands of years, yet discovering fresh things to say. "We find ourselves doing the same twenty to thirty images, over and over, either some sort of flower or foliage, or some sort of bird, or skulls or dragons. And it is because these are the images that retain the most meaningful, symbolic power."

He takes the example of one of the more frequently tattooed images: the rose. Its symbology is varied and almost unendingly complex: love, desire, sex, chastity, the Virgin Mary and the national symbol of England, to name but a few of its connotations. As there are an almost infinite number of meanings, there are an infinite number of ways a good tattooist can draw and reinterpret it.

Some of the more powerful symbols that permeate the Family Business are the Catholic icons that cover the walls, hang from the ceiling and sit atop counter tops. They are there not necessarily because of Mo's faith. "I haven't got to the point in my life where I question my moral beliefs," he says. "But the strength and power that religious iconography has is very important. I like to study why they are there and what they mean. I like the strength, austerity and severity." This does contrast with the definite sexiness of the shop, evident both in the colour scheme and the fact that tattooing is an art form that is undeniably erotic. It is, by definition, carnal, of the flesh. A marriage to a piece of art that, barring laser removal, is a 'til-death-do-us-part commitment. "I like that idea of an old Italian grandmother's bedroom mixed with a boudoir. Red velvet and statues of Jesus Christ," Mo laughs. "I don't know what that means subliminally; one day I'll get into analysis."

Tattoos have long stopped being the provenance of bikers and sailors and have shed their whiff of criminality. The meaning of new celebrity tattoos – from Johnny Depp's to David Beckham's to Angelina Jolie's, are earnestly debated in the press. Some estimates put the percentage of the population in the UK with at least

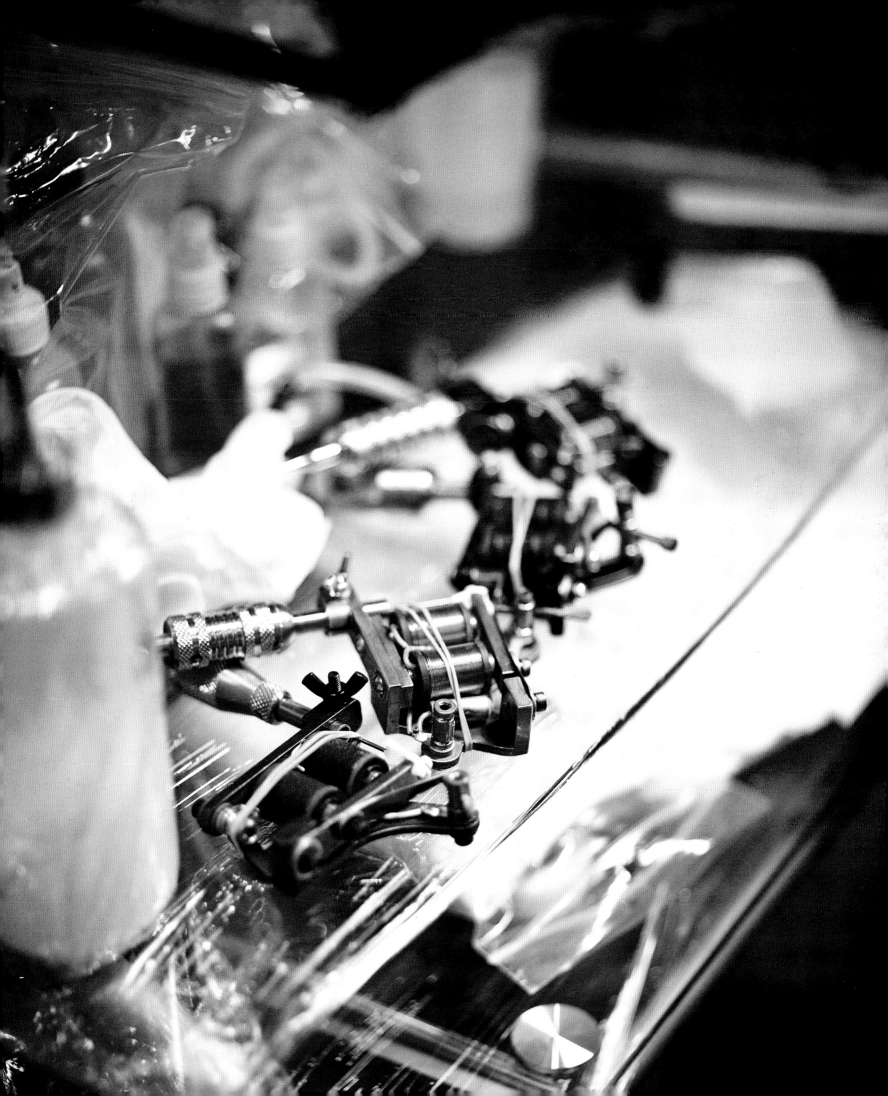

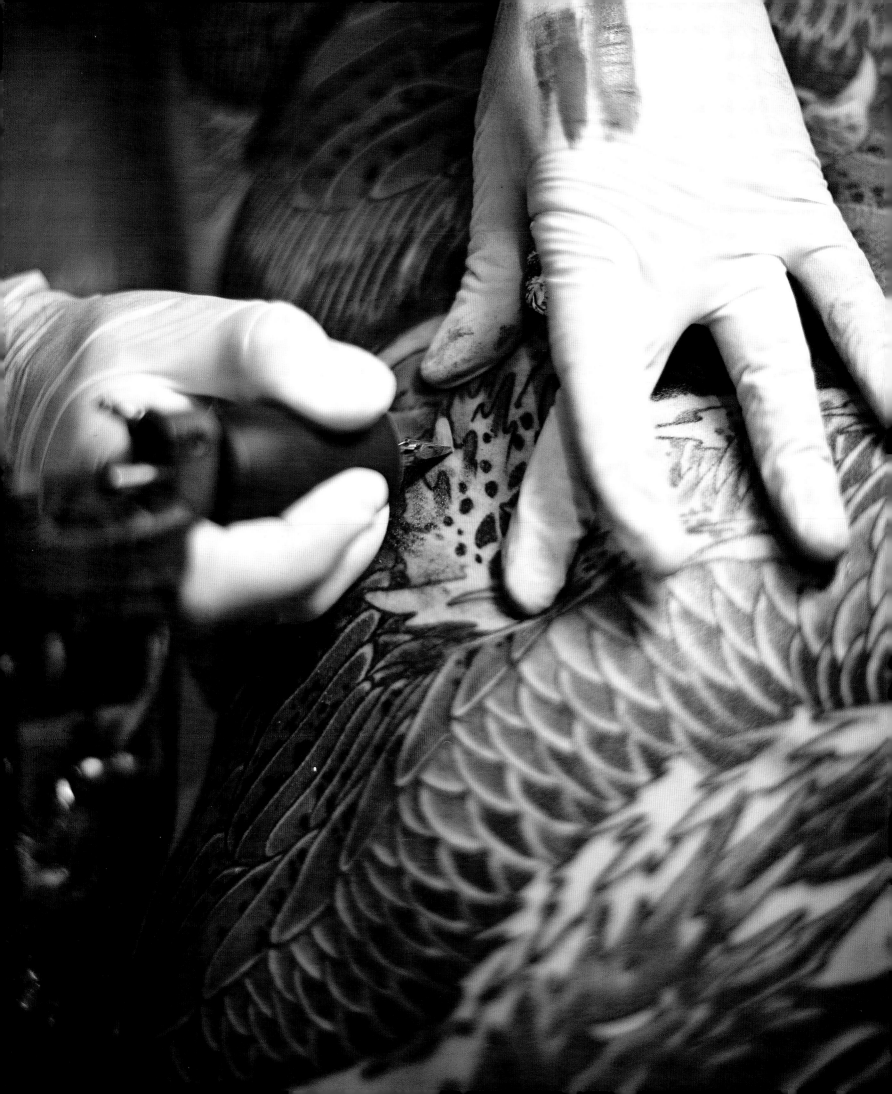

one tattoo at 15 per cent, which translates to about nine million people. To put that in context, that means there are more people who have tattoos than who voted for the Tories in the 2005 election, and is about the average viewing numbers for *Coronation Street*. You can't get more mainstream than that.

The increasing ubiquity of body art has certainly been a boon, at least financially, for the industry as a whole. Yet, as with any essentially underground art movement which gains wider acceptance, there are concerns in the tattoo community that there has been a loss of the soul and spirit from the artform. For Mo and the rest at the Family Business, this is really not a concern. No matter how many people climb on board the bandwagon – or, for that matter, fall off it, if the trend wanes – the shop has attracted followers who share their passion and commitment for intricate craftsmanship and the quality of the art. Mo says: "A lot of our customers are not really 'out there' with their tattoos. We are looking for a certain clientele, people who simply want beautiful decorations on their bodies. We wanted a boutique for tattooing and, thankfully, people responded." And because the vibe is so unconcerned with any scene, whichever way the winds of fashion are blowing, the Family Business will continue to attract these enthusiasts. It will stay classic yet modern; retro but up to date.

Ultimately, deliberately getting oneself scarred – no matter how beautifully drawn and shaded – is still an act that takes some measure of courage. The joy of getting a tattoo from a place like the Family Business is its chrysalis-like transformation. Getting photographed by the tattooist just after you get it done. Leaving the shop with the designed swaddled like a newborn. That first 24 hours or so of that slick slimy sheen forming over the tattoo. The days of meticulous after-care, with the scabbing, the peeling. Then after about a week, it emerges, transformed, healed and just as you imagined, and you think, "This is me."

And then, you start thinking about the next one.

THE FAMILY

• AMA ET FAC QUOD VIS! •

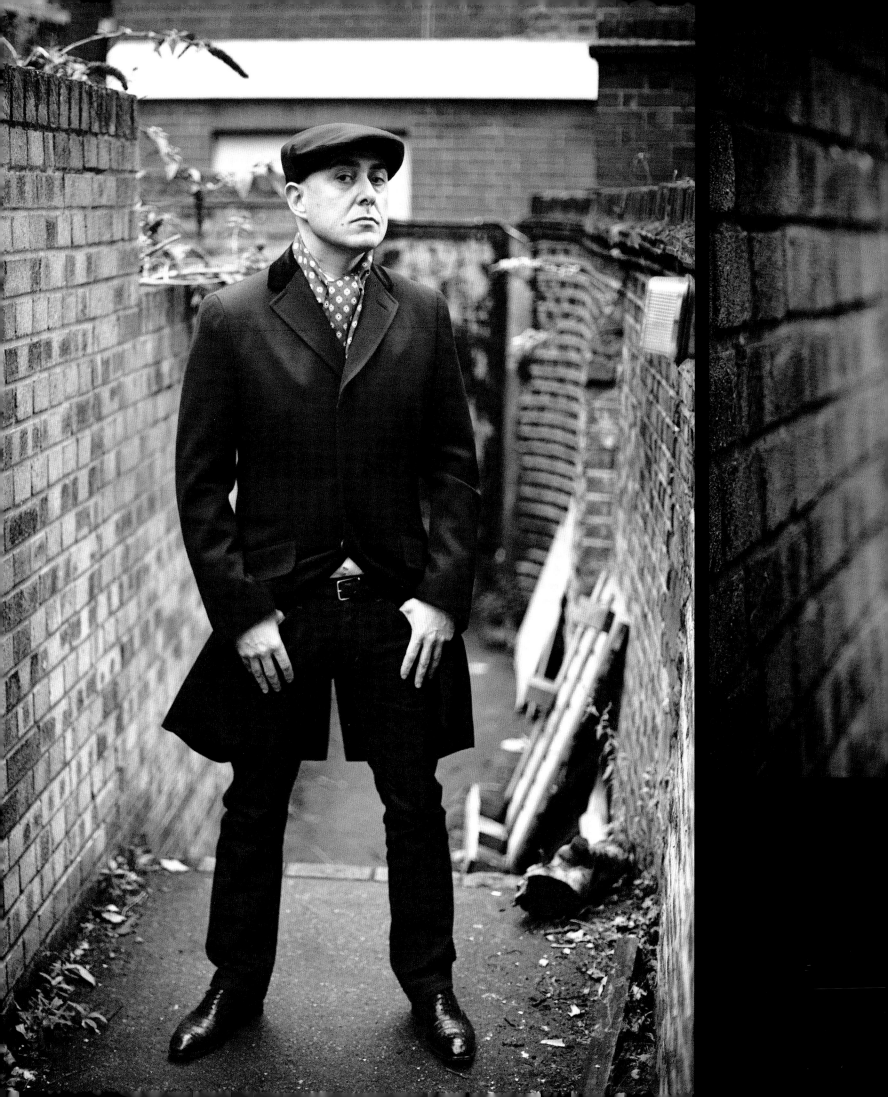

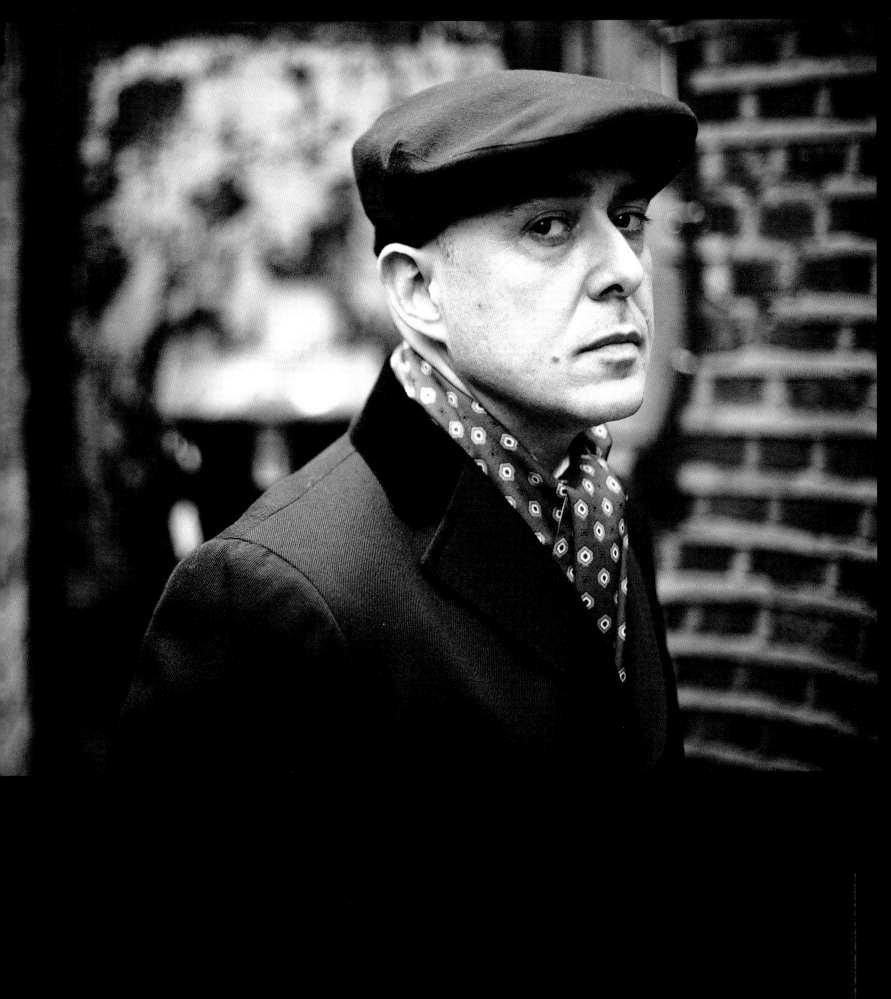

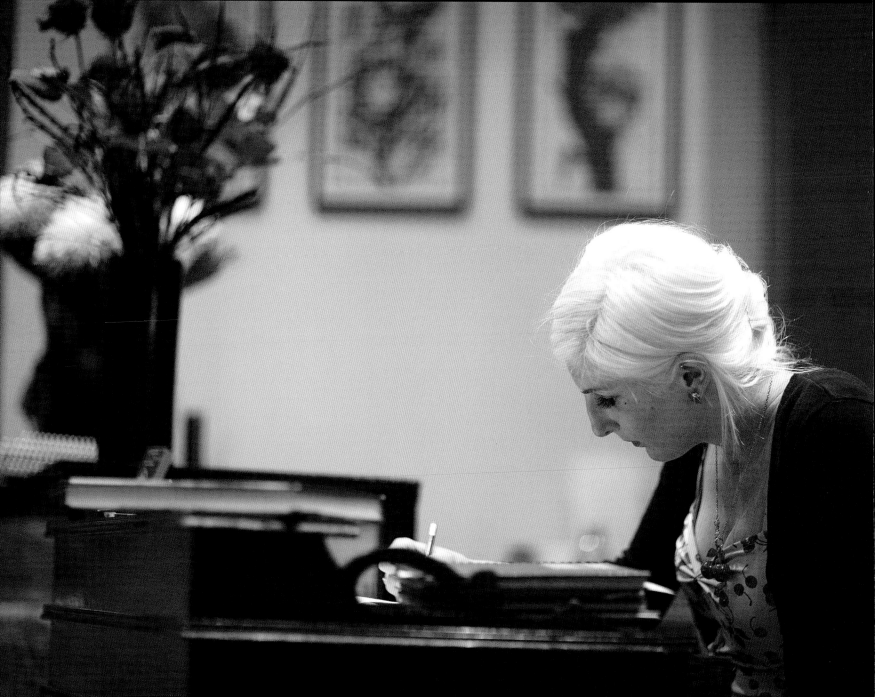

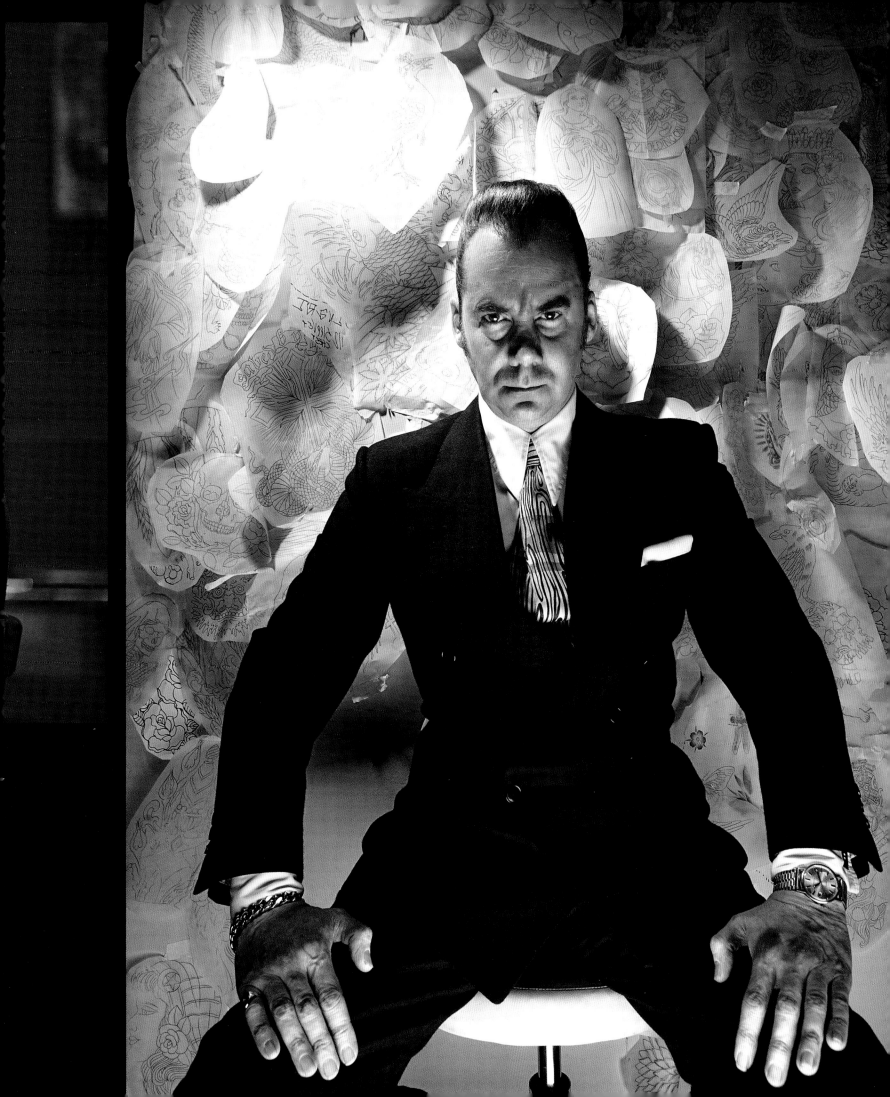

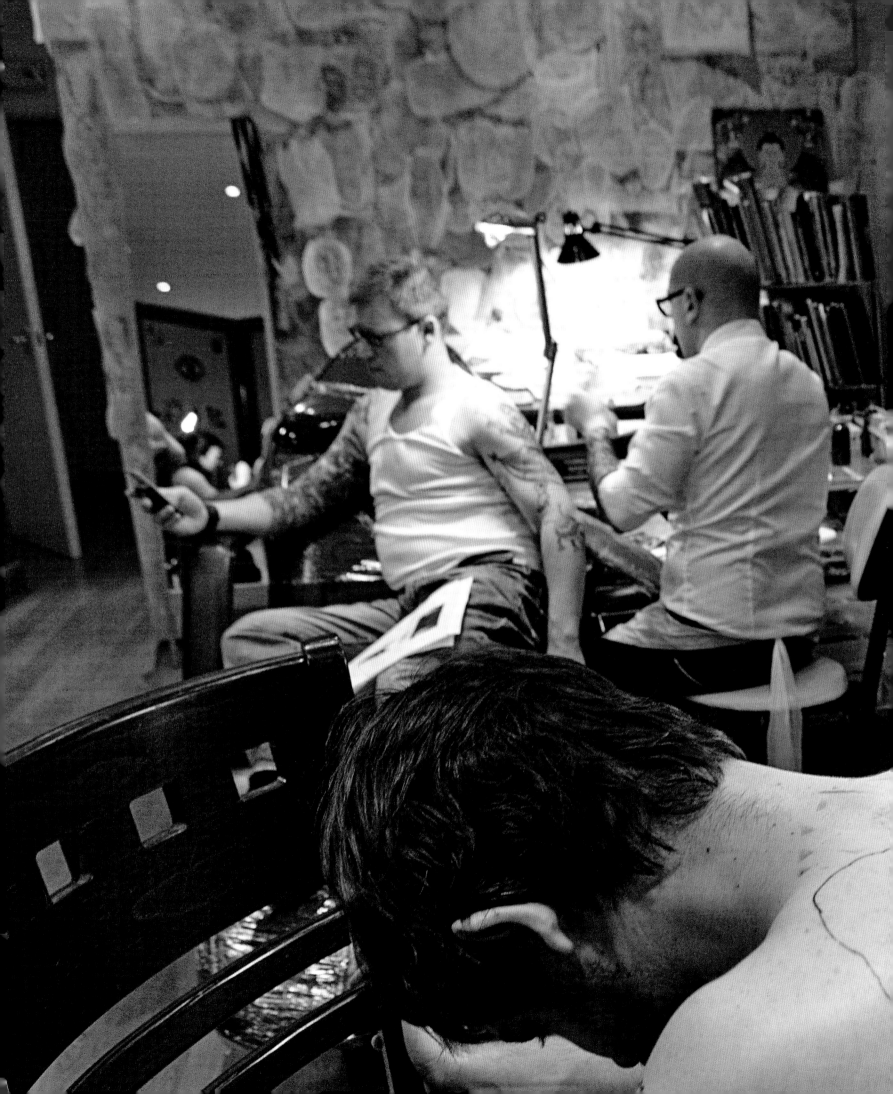

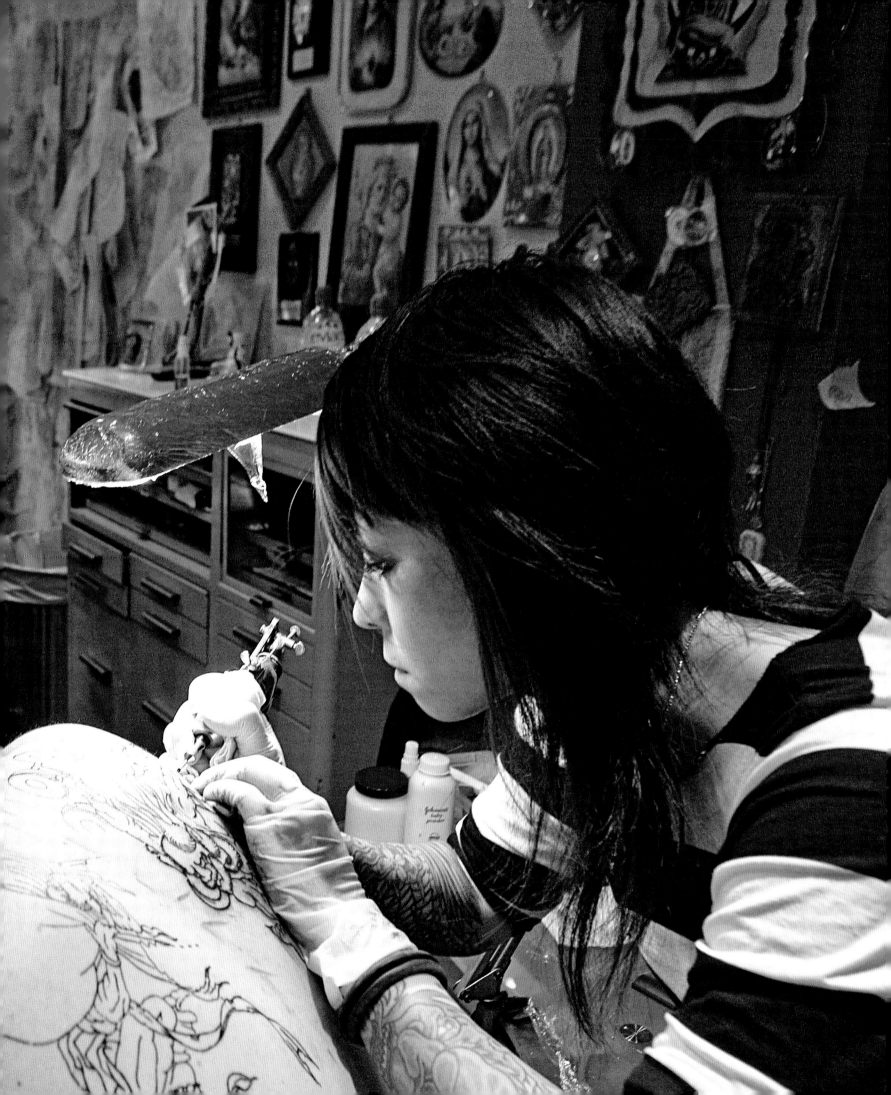

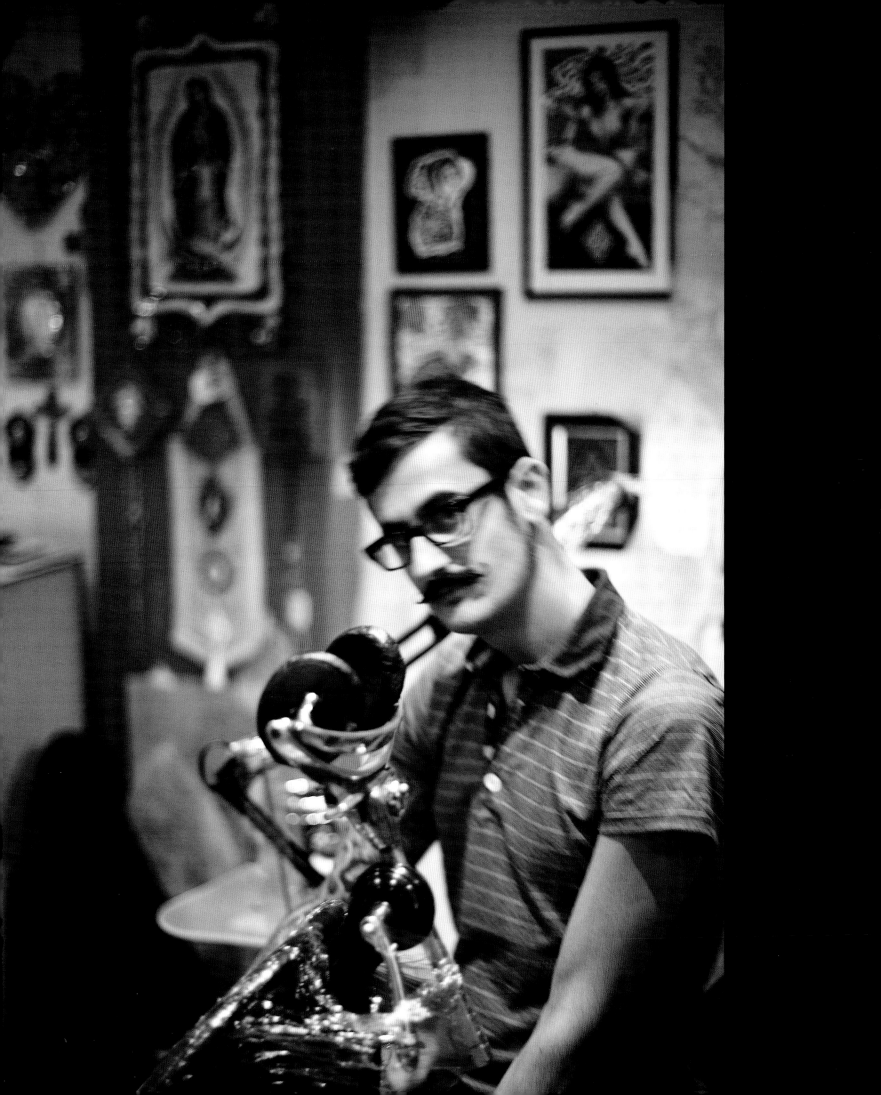

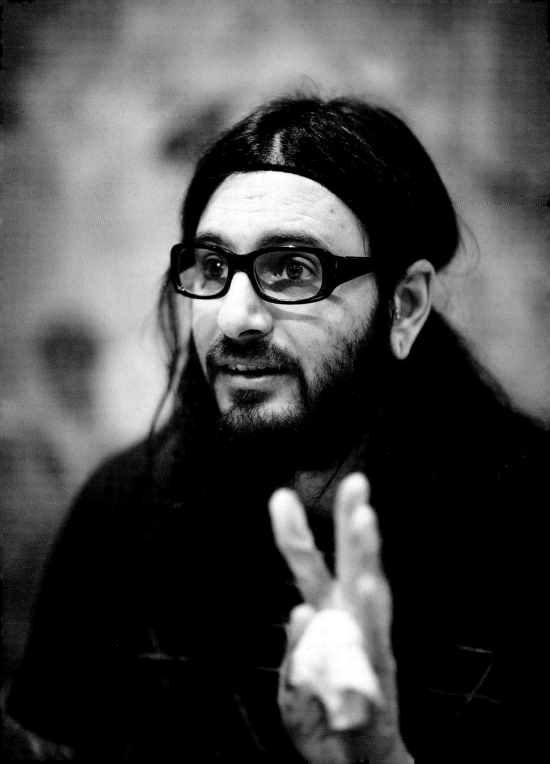

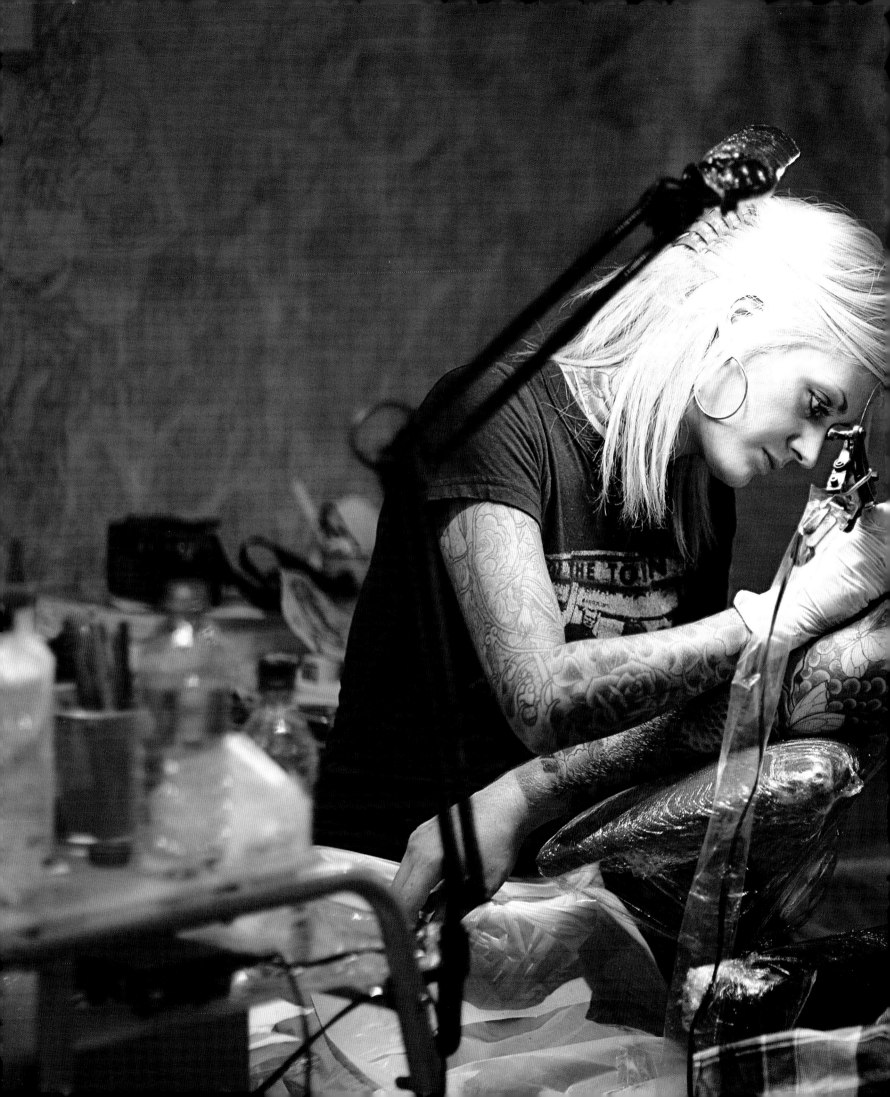

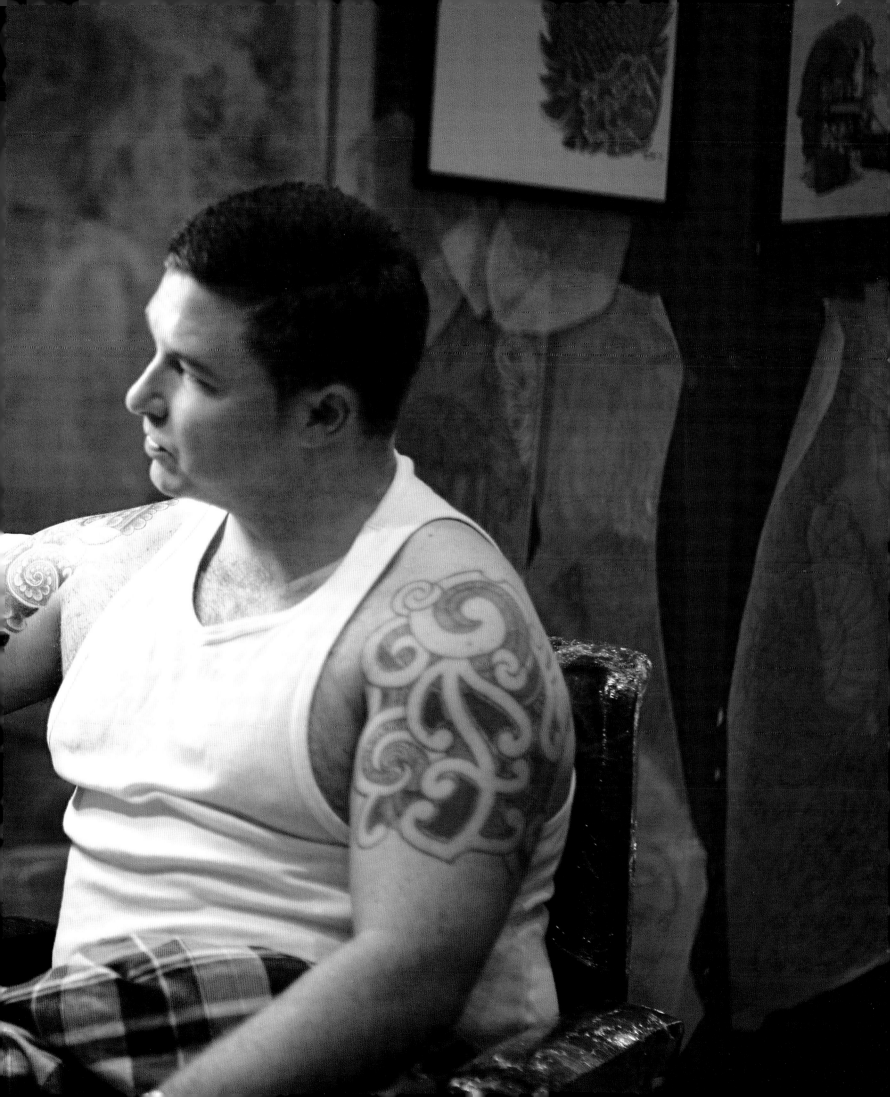

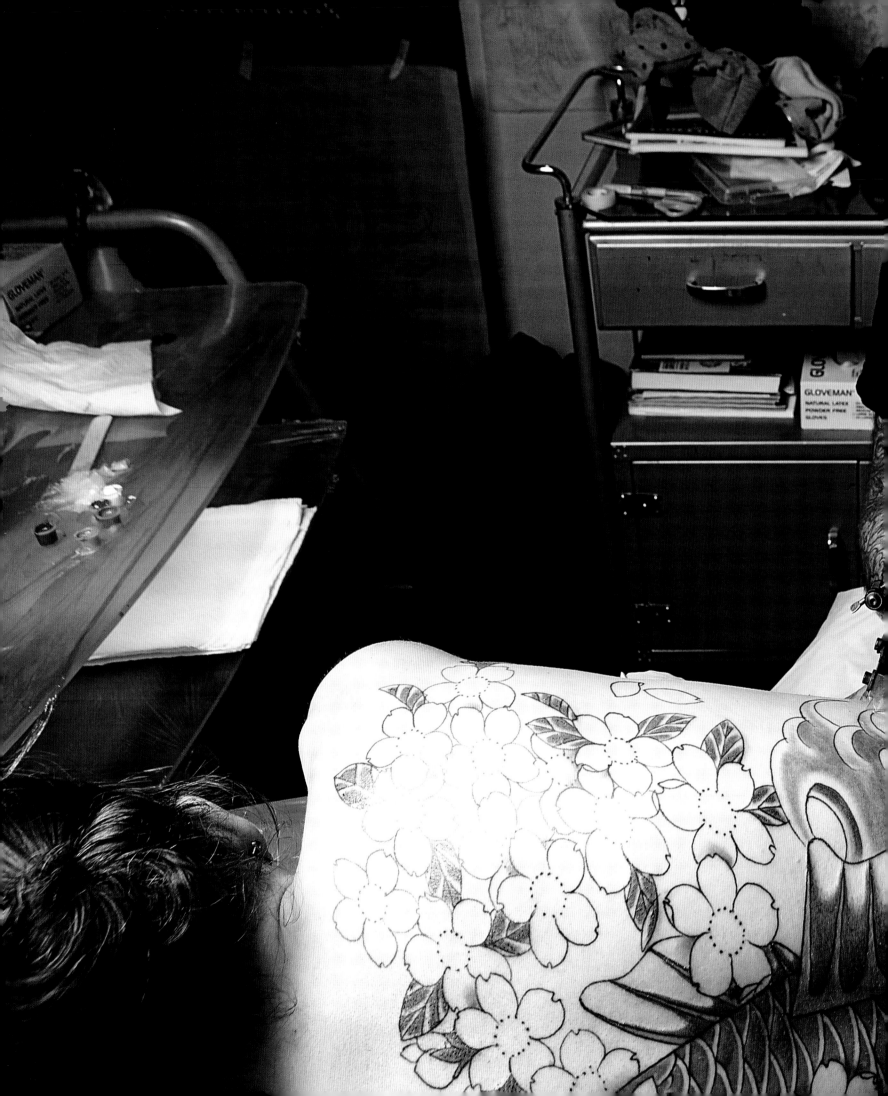

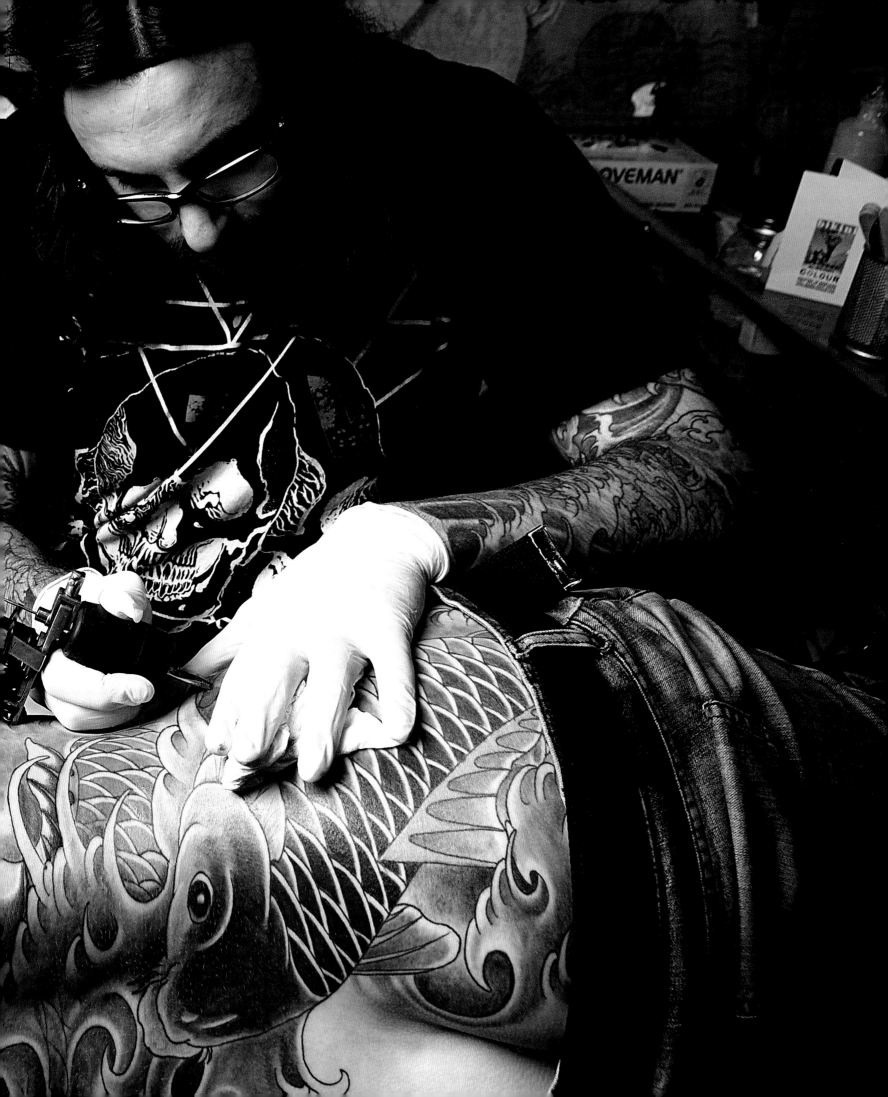

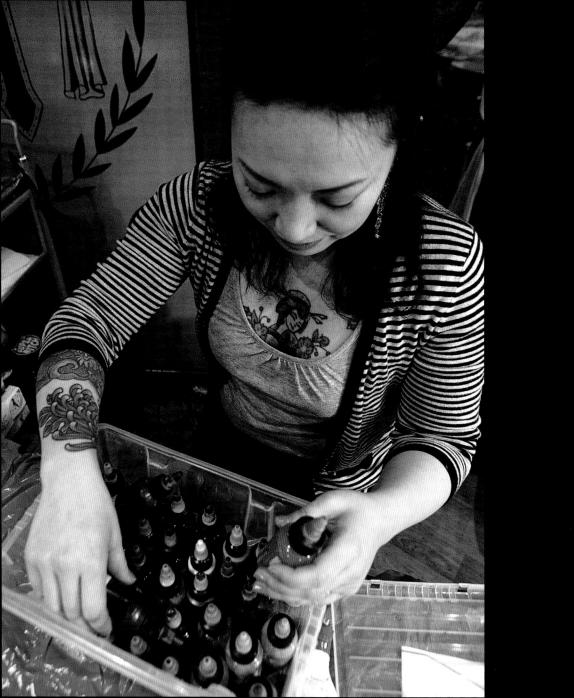

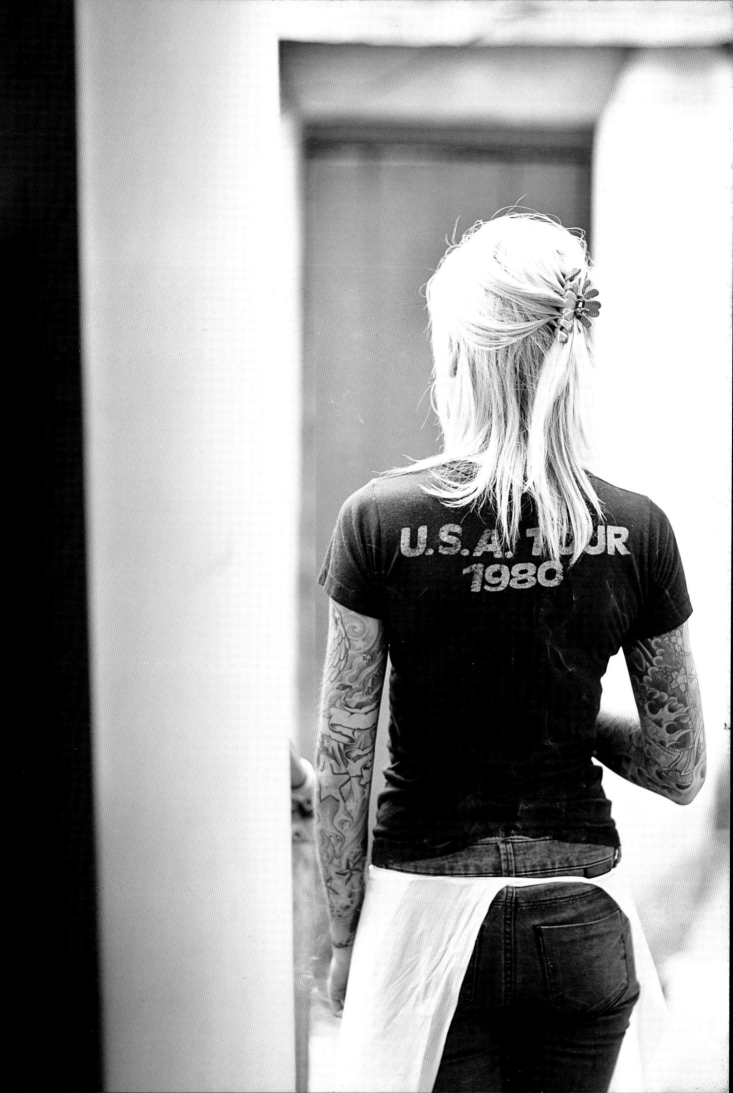

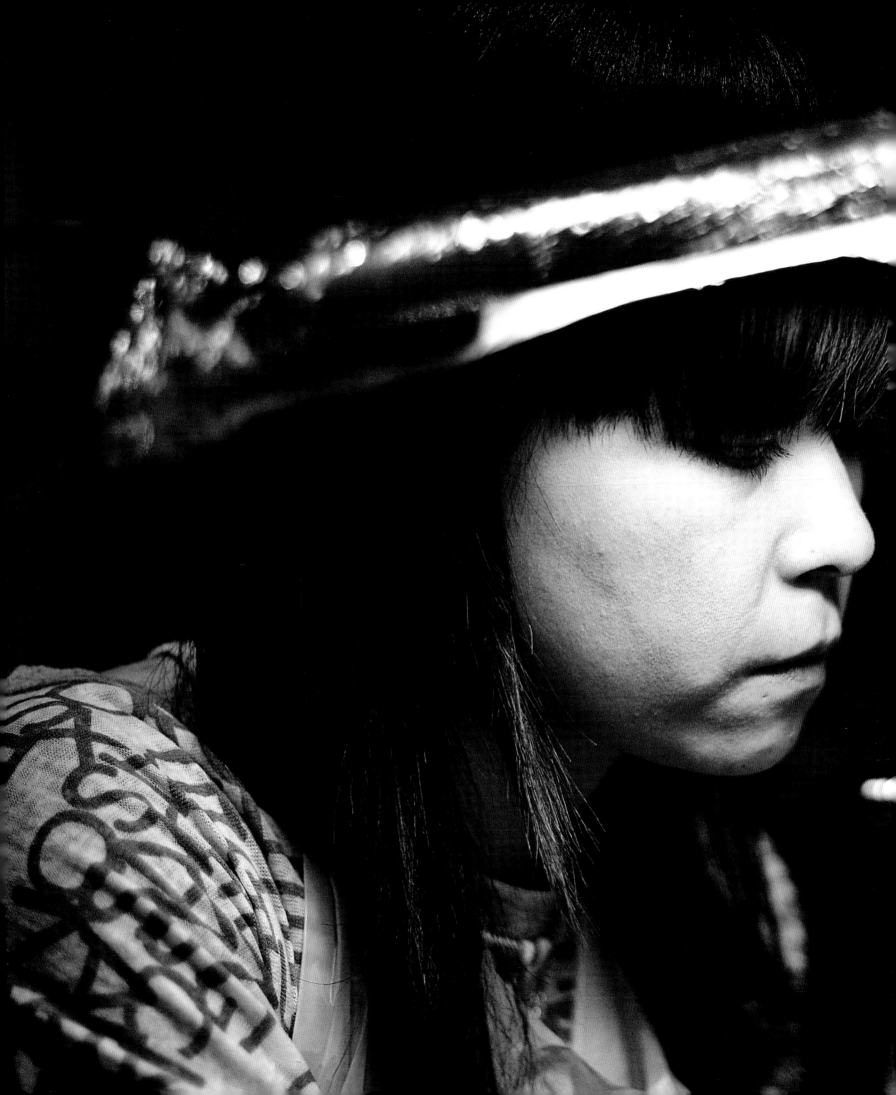

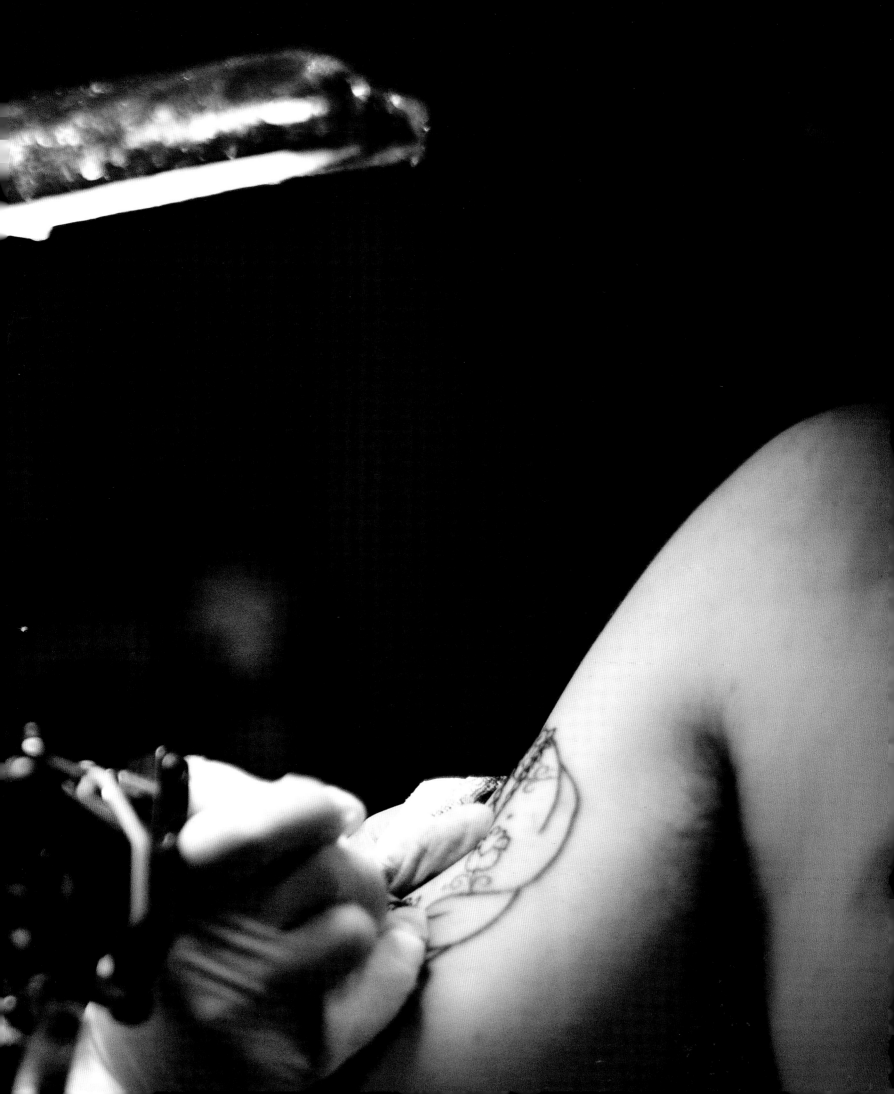

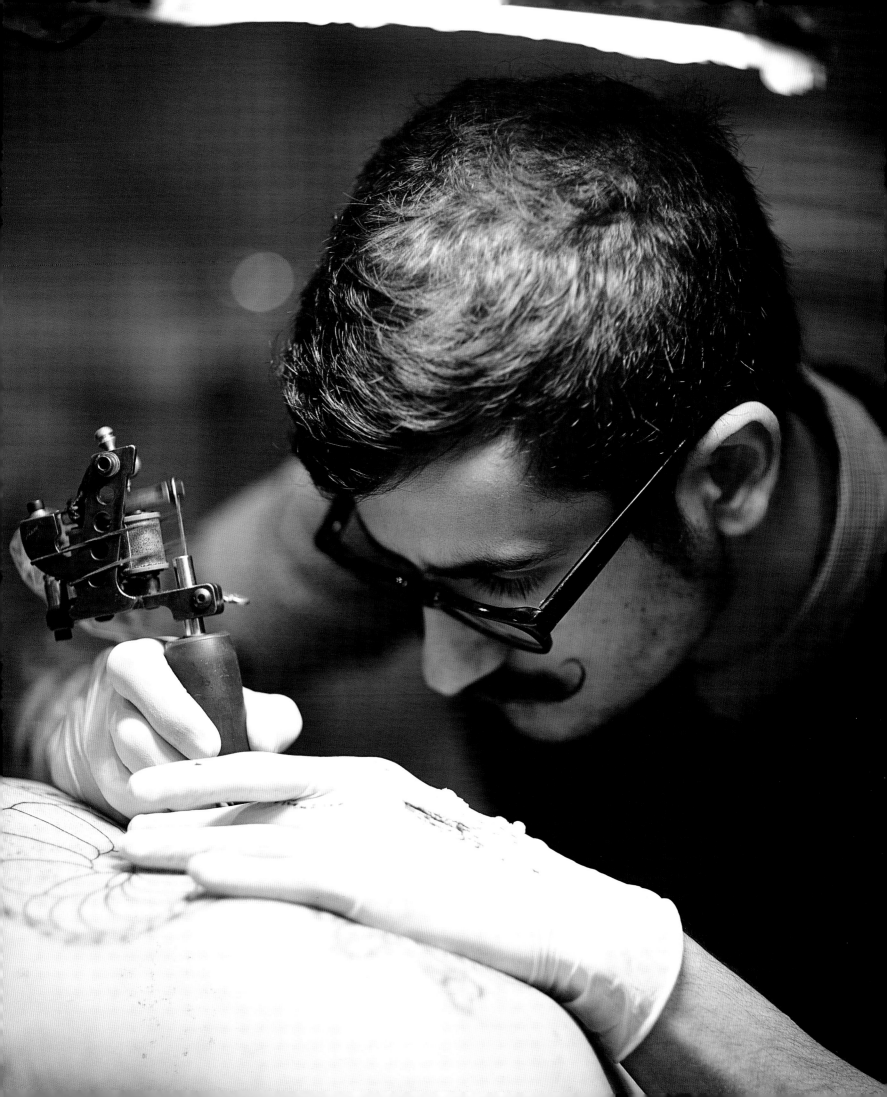

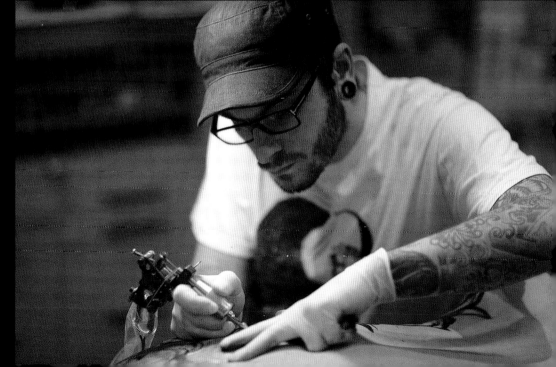

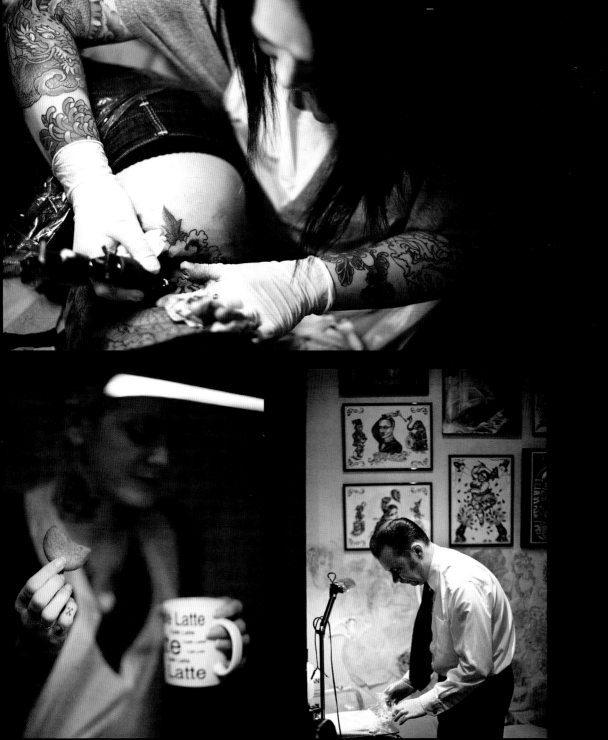

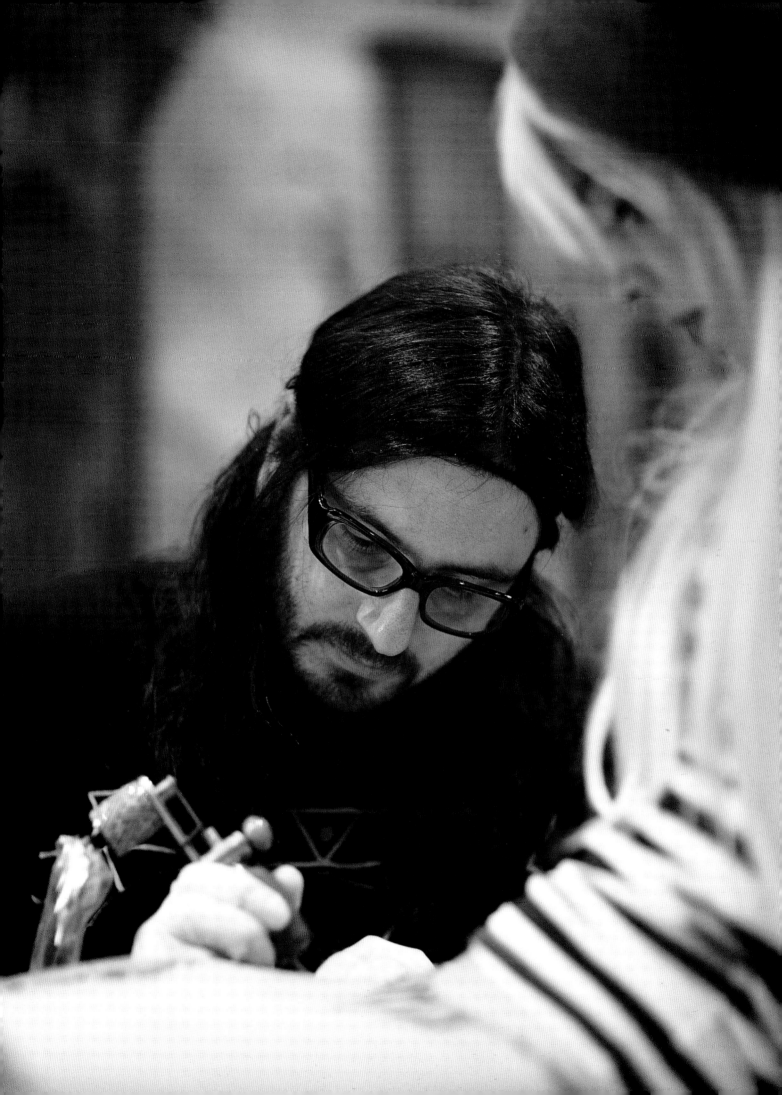

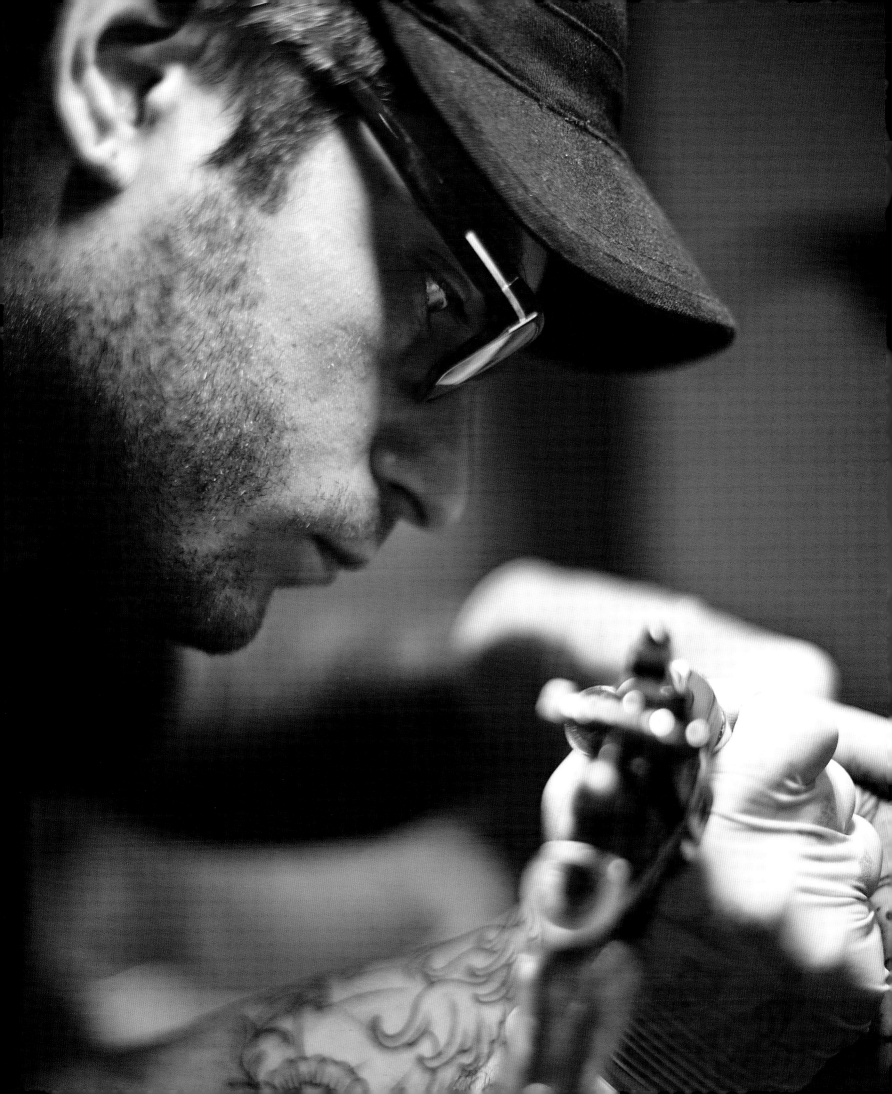

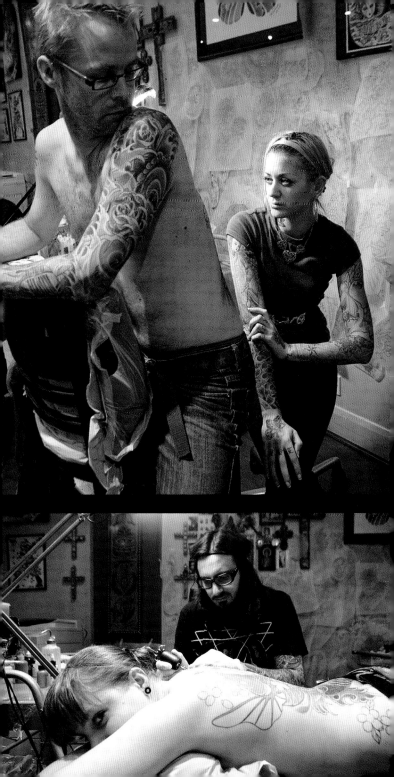

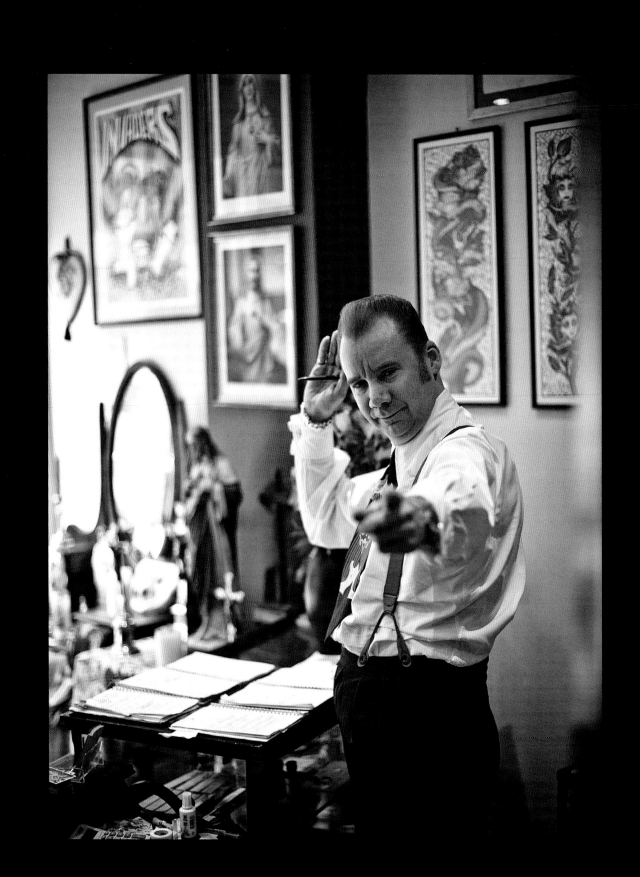

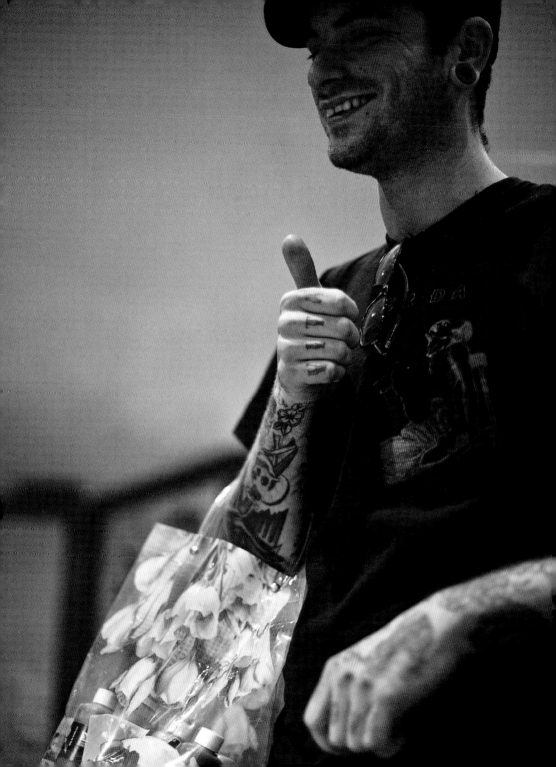

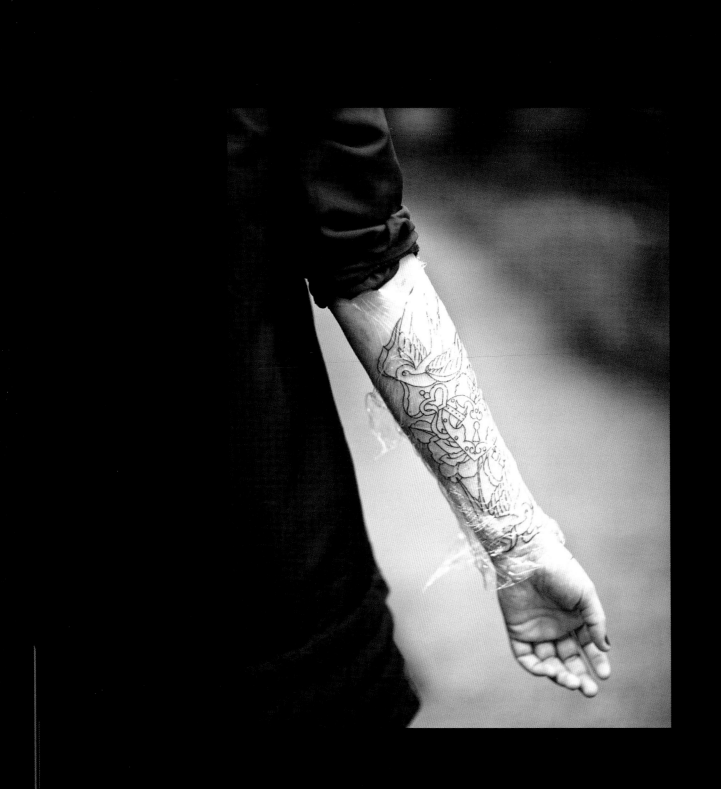

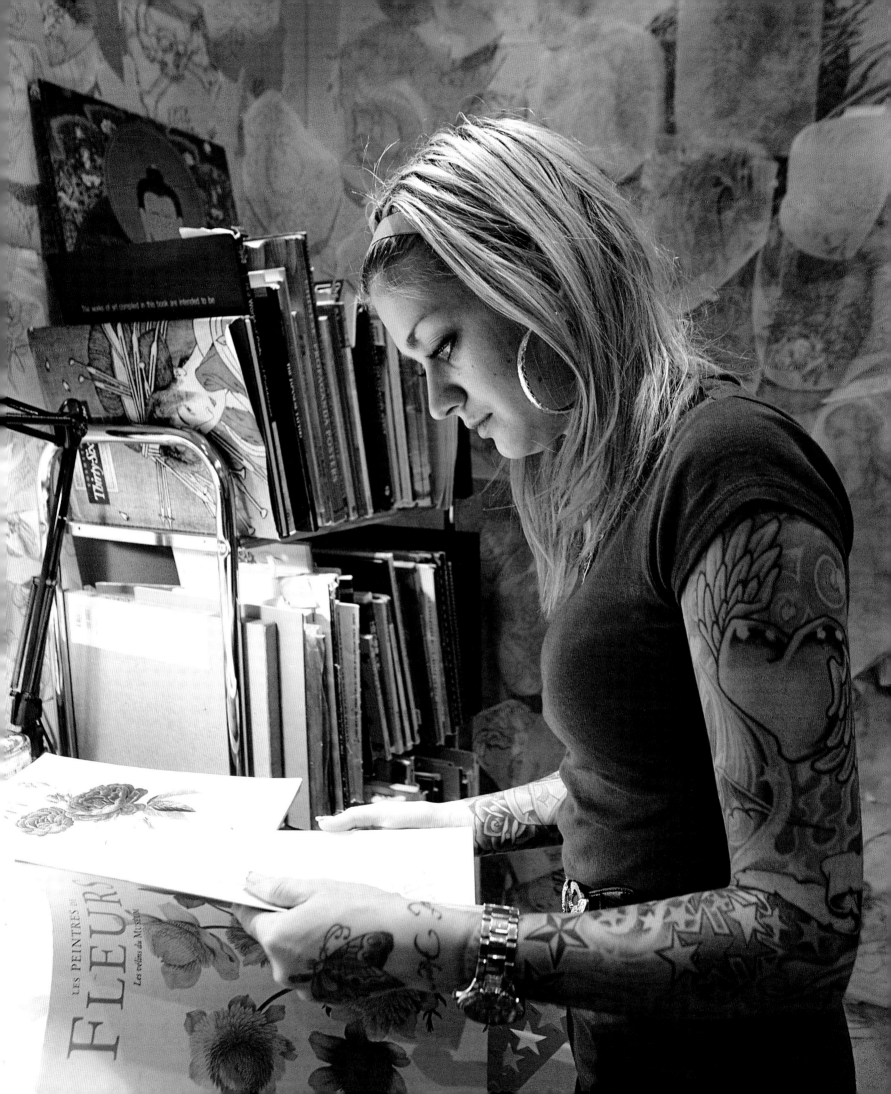

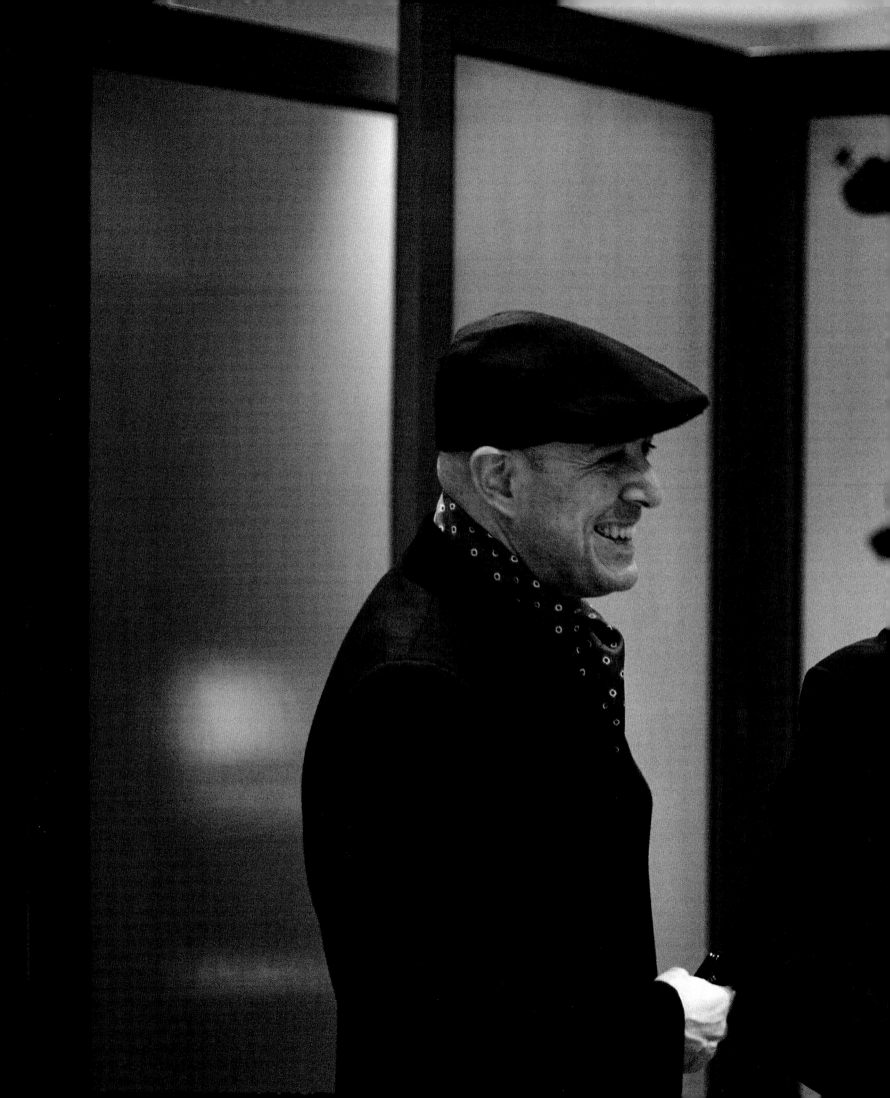

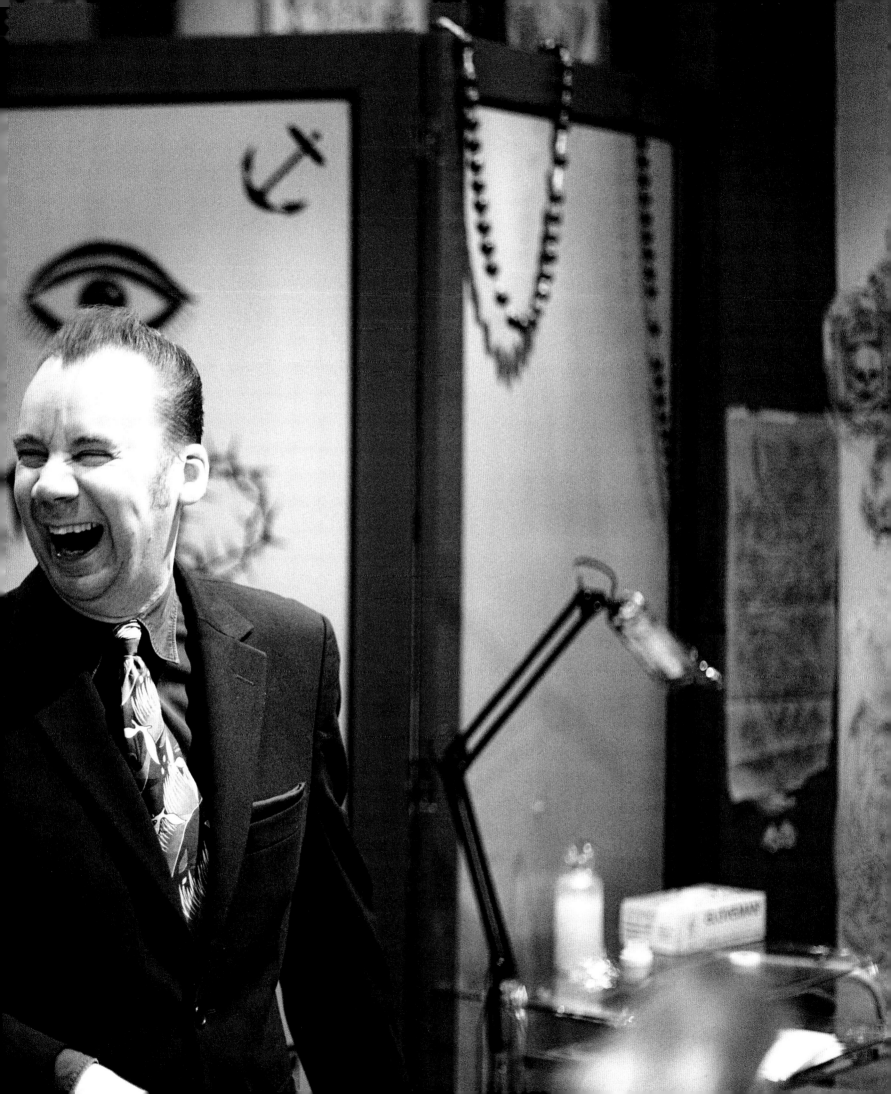

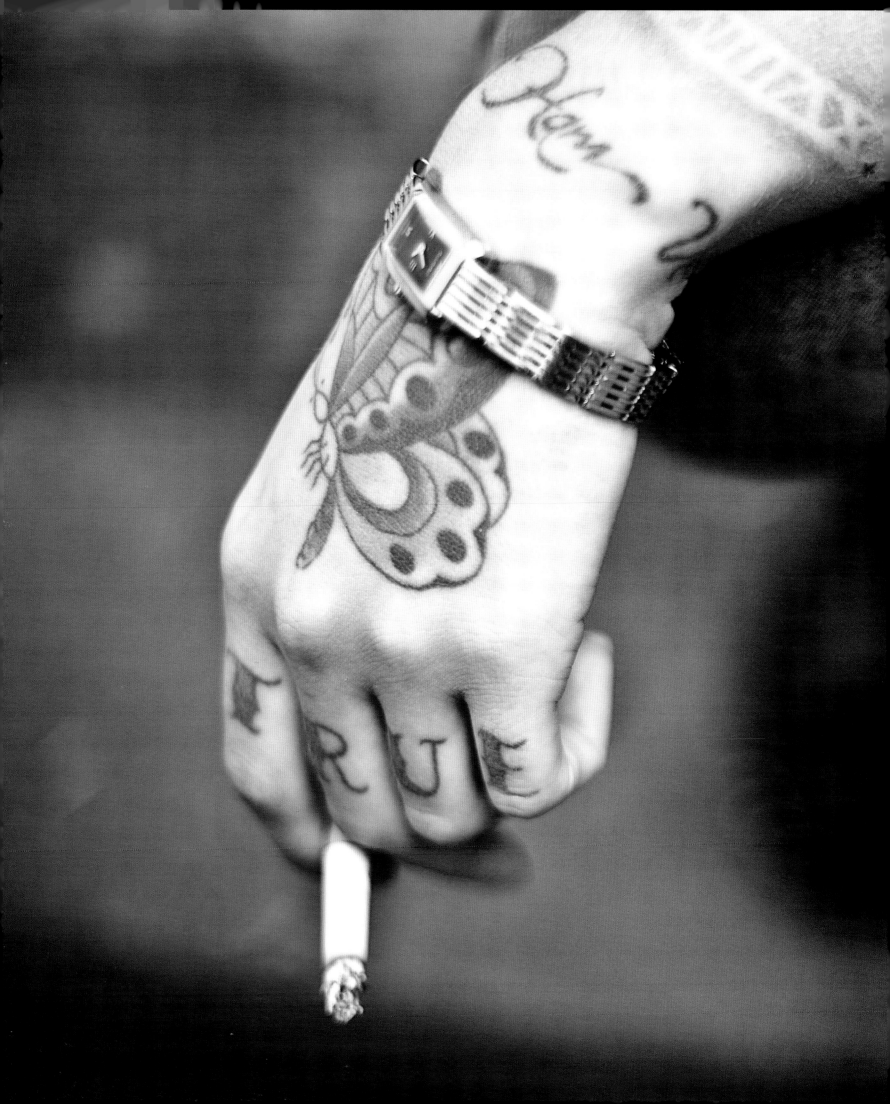

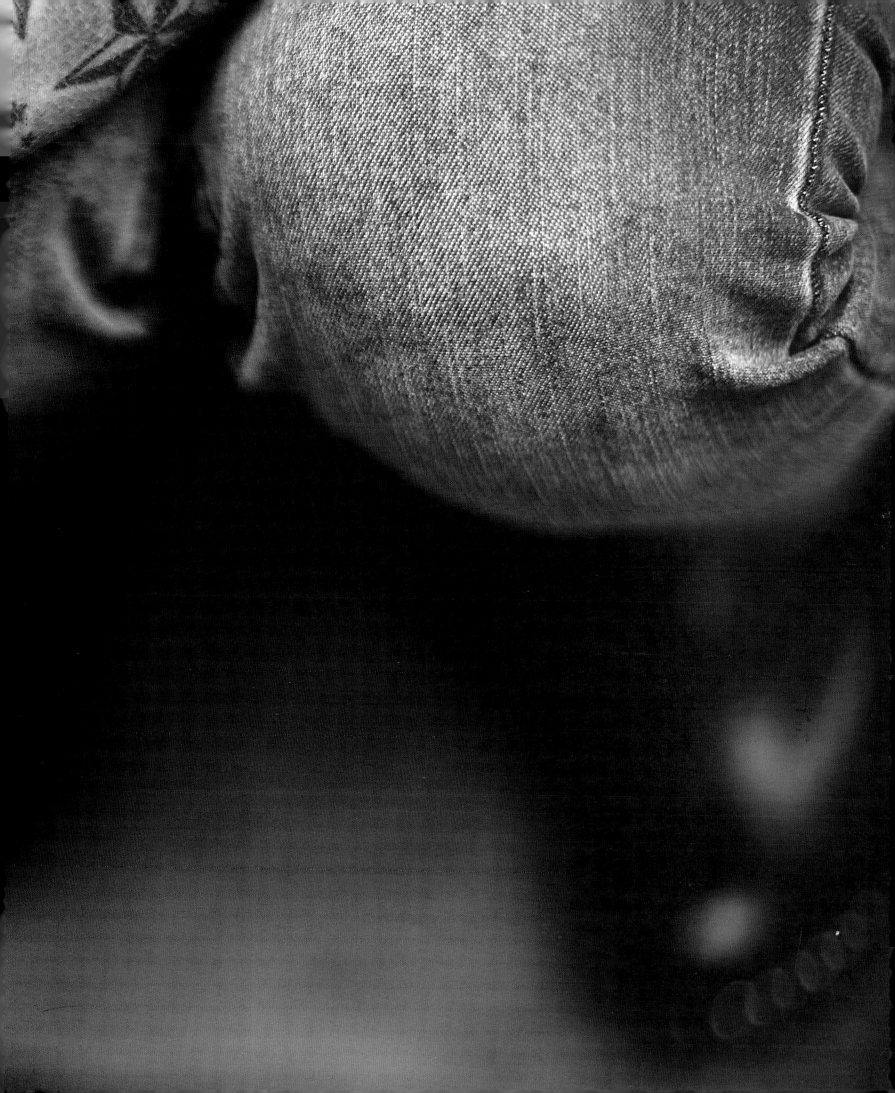

THE BUSINESS

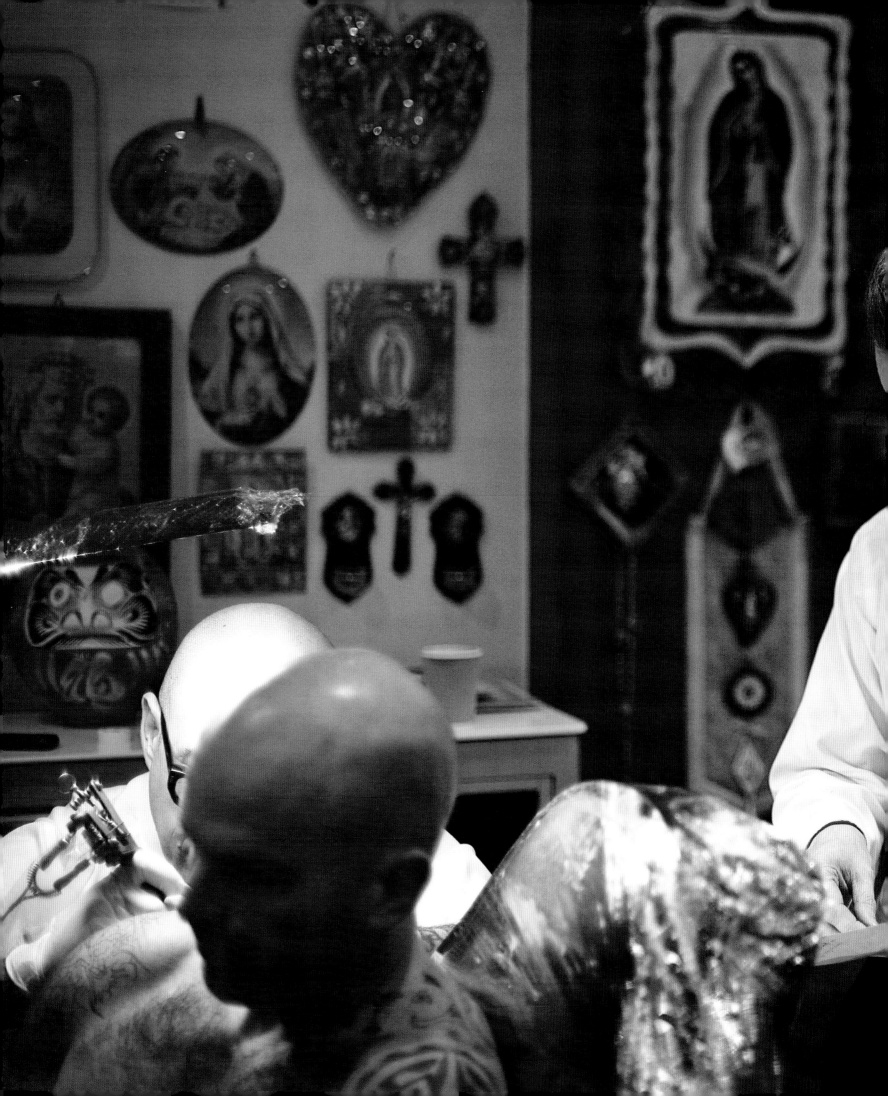

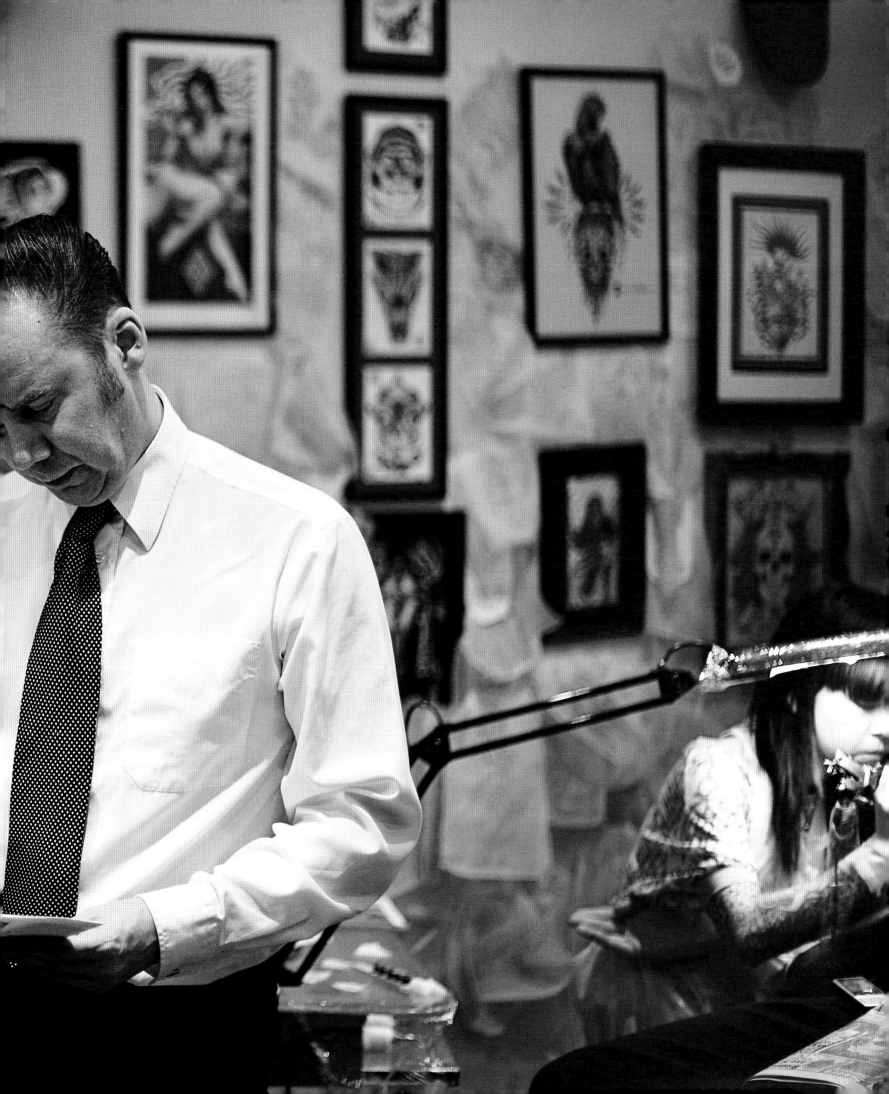

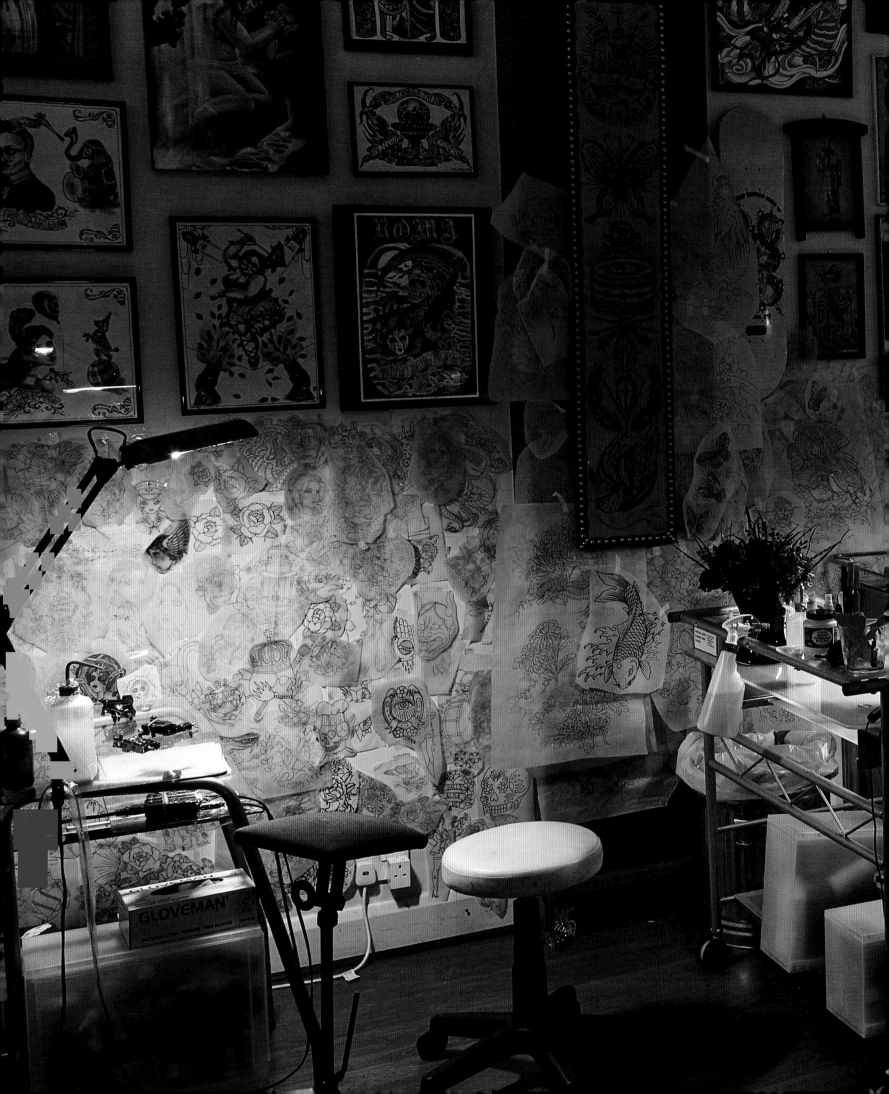

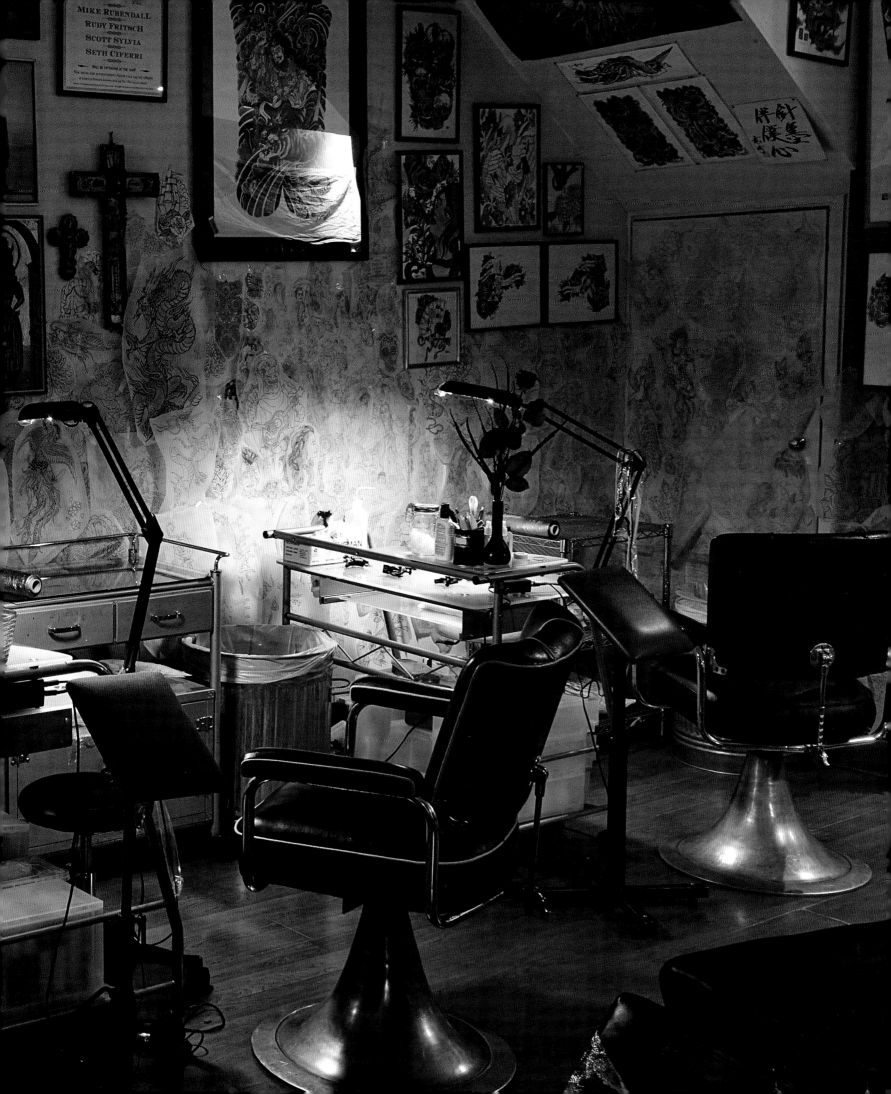

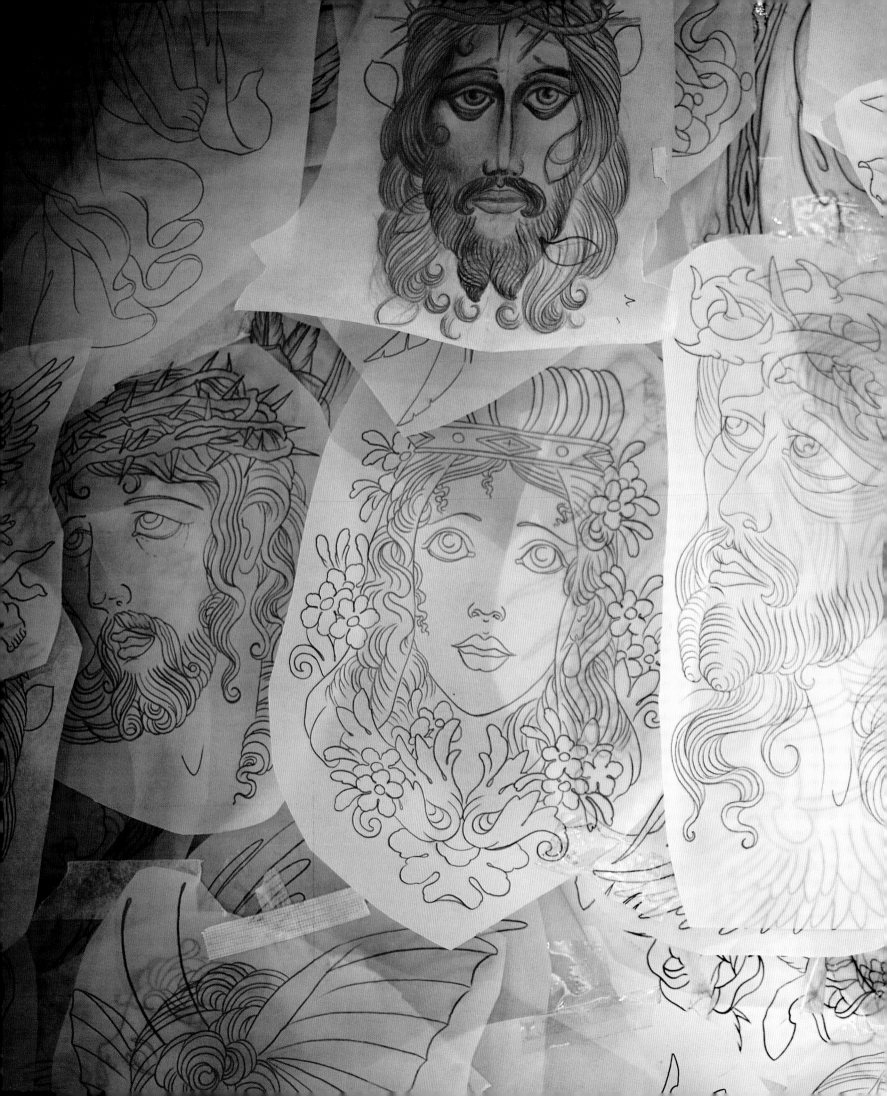

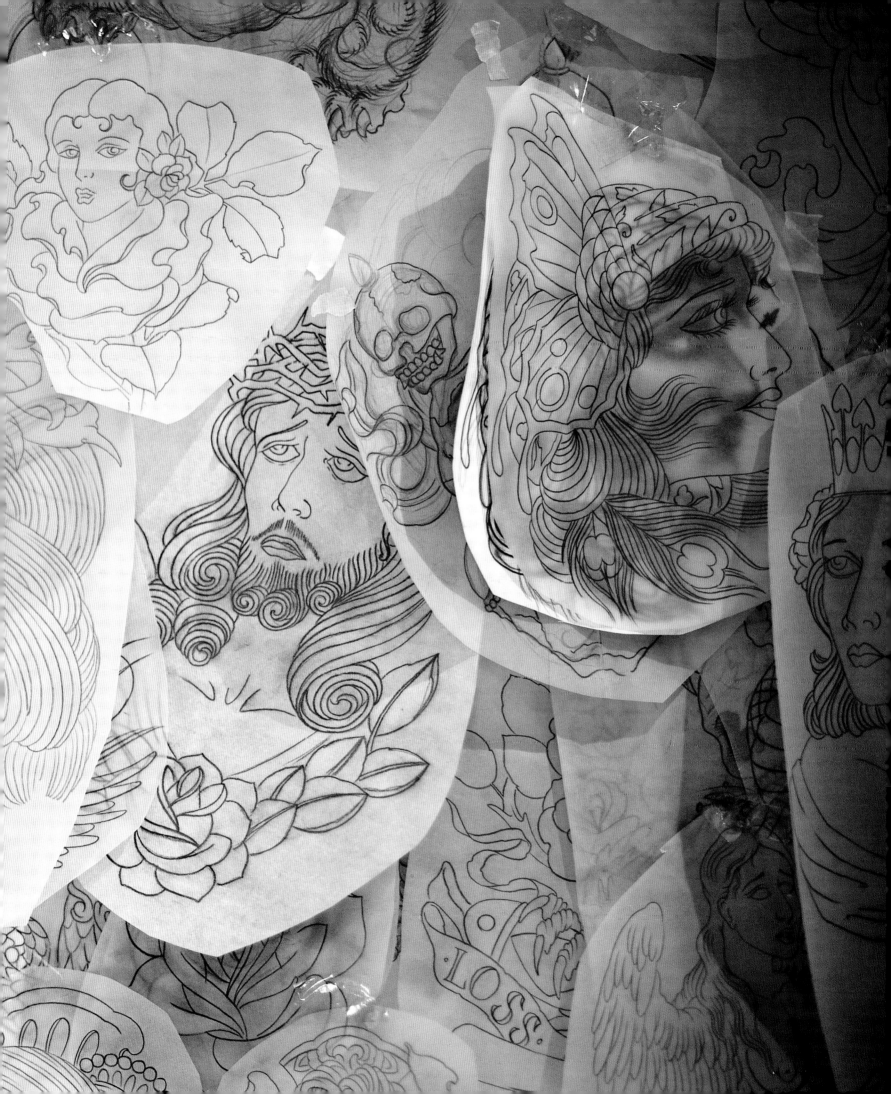

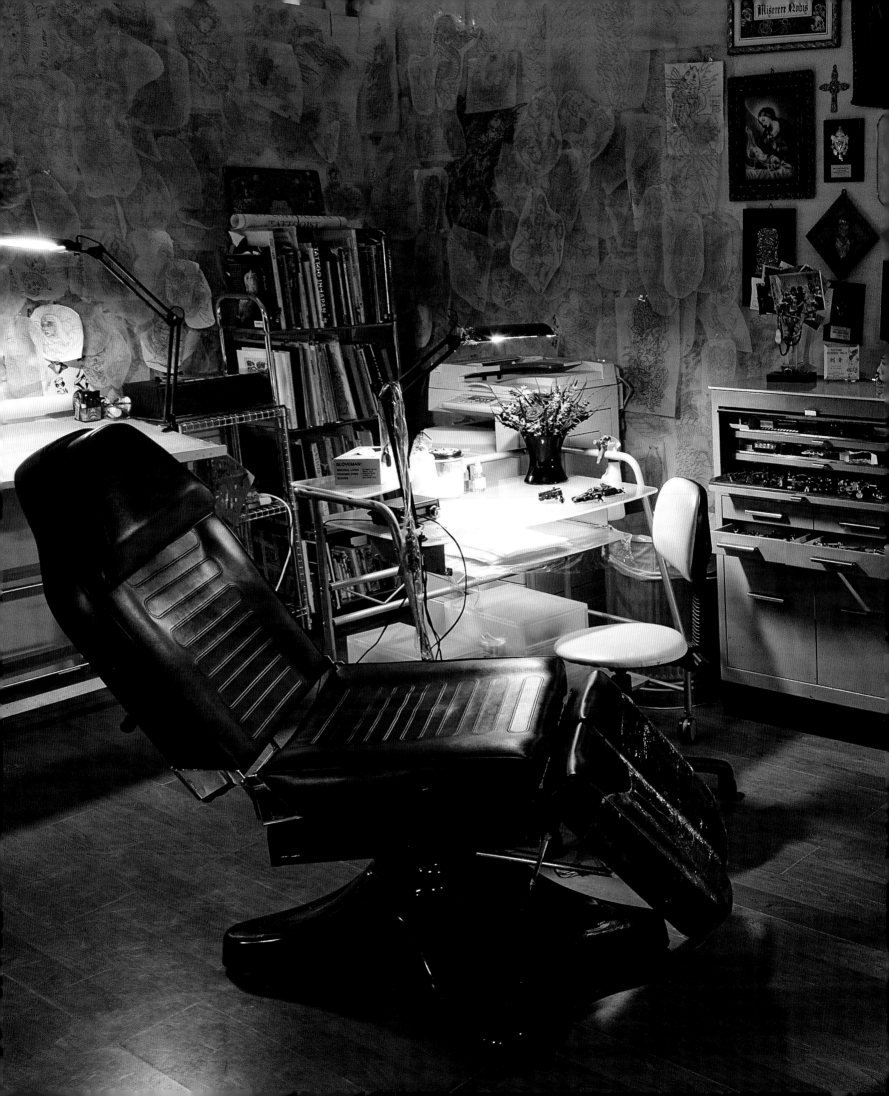

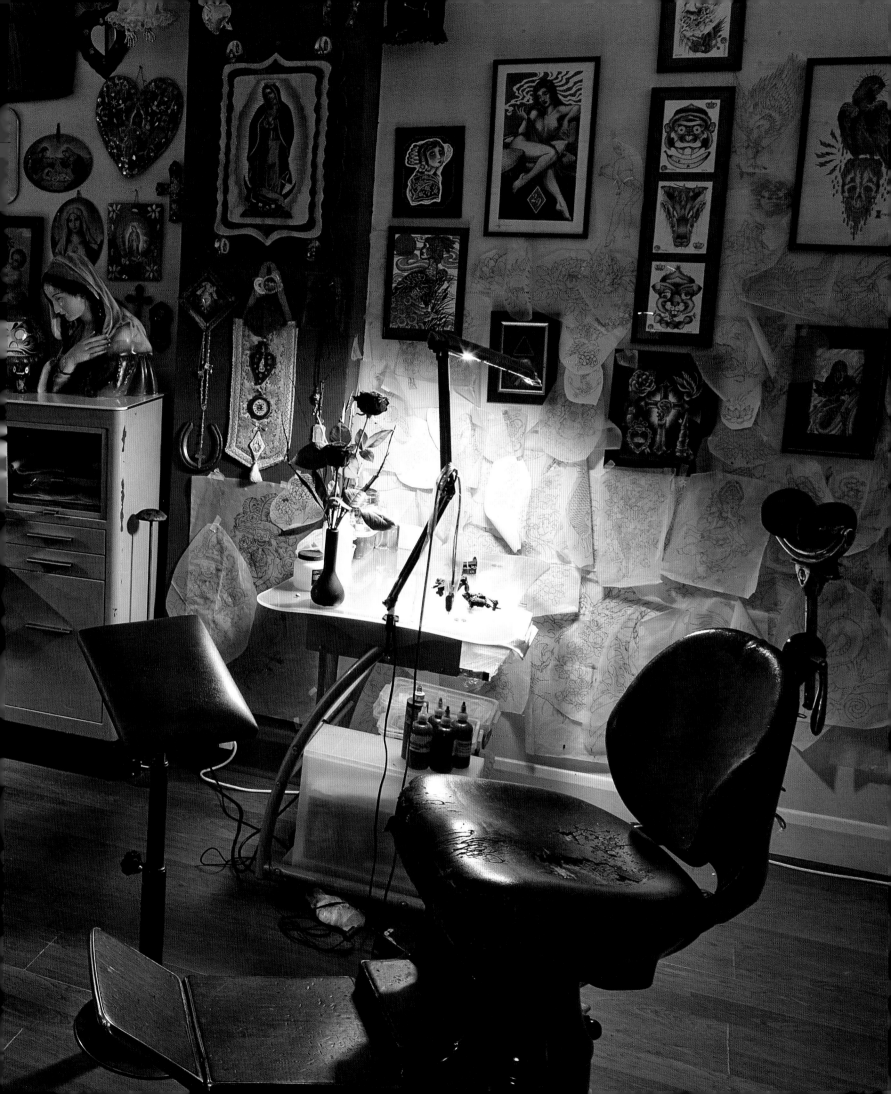

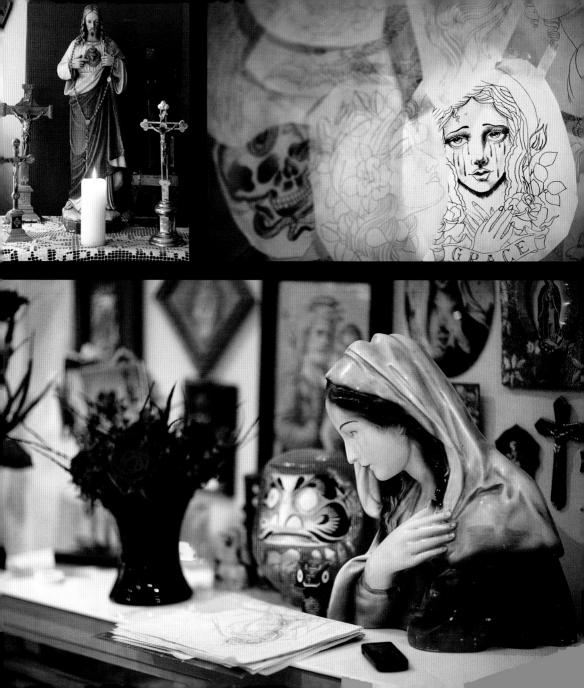

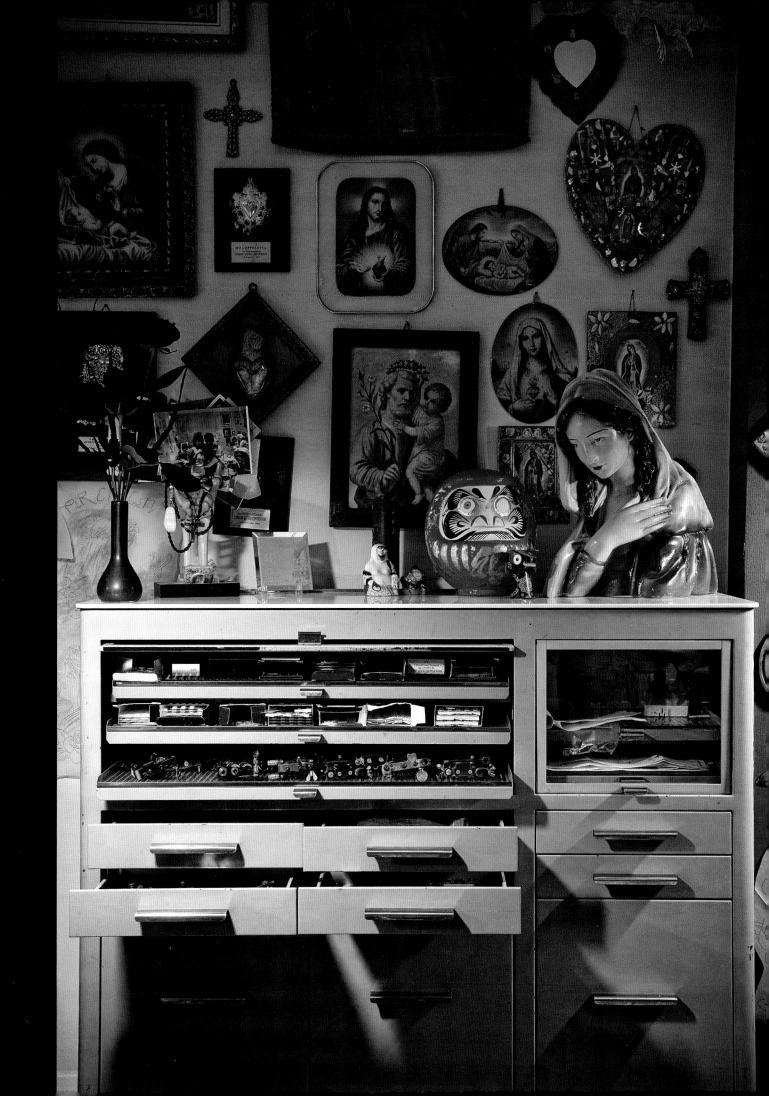

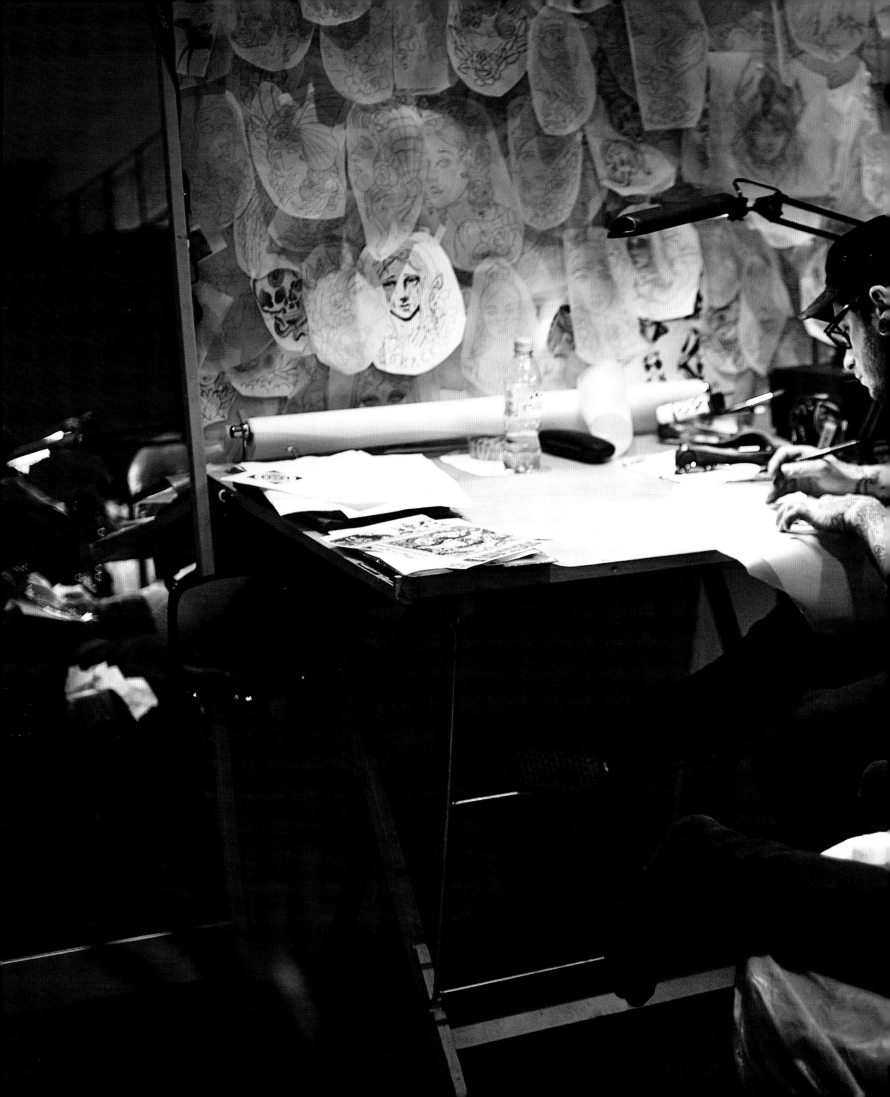

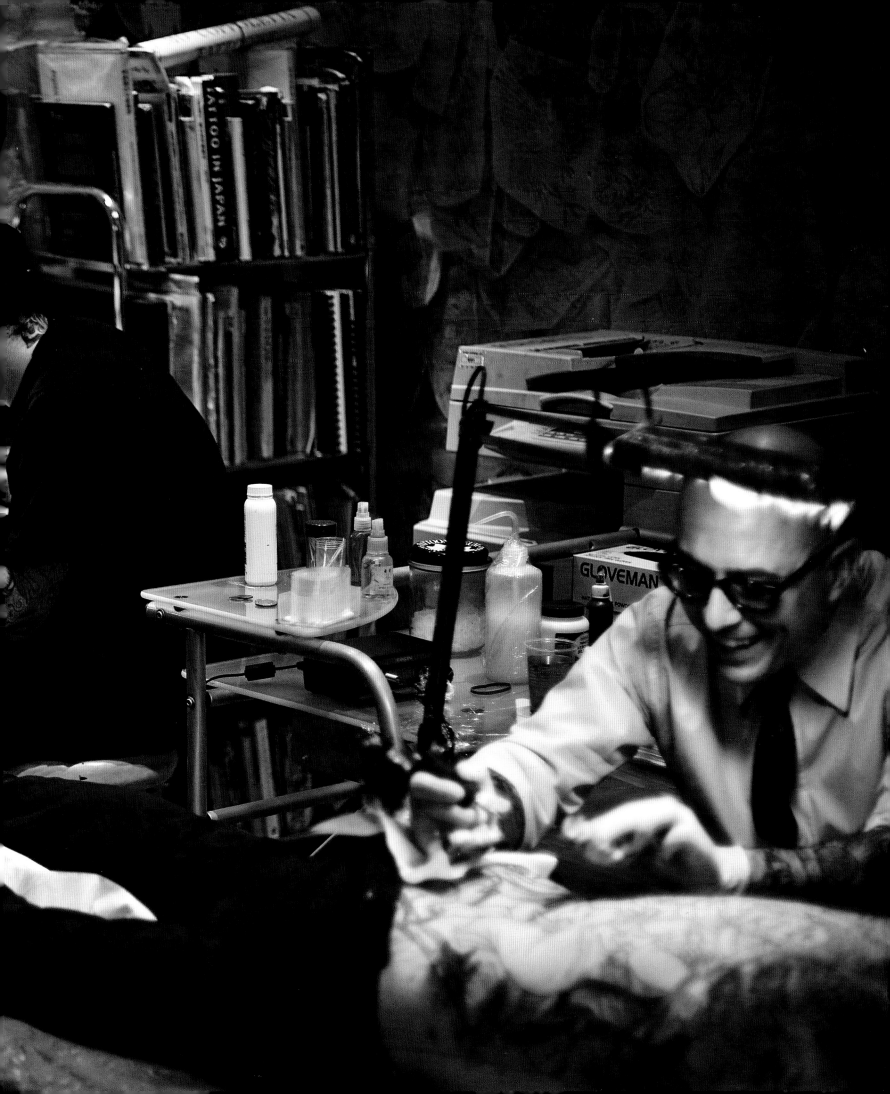

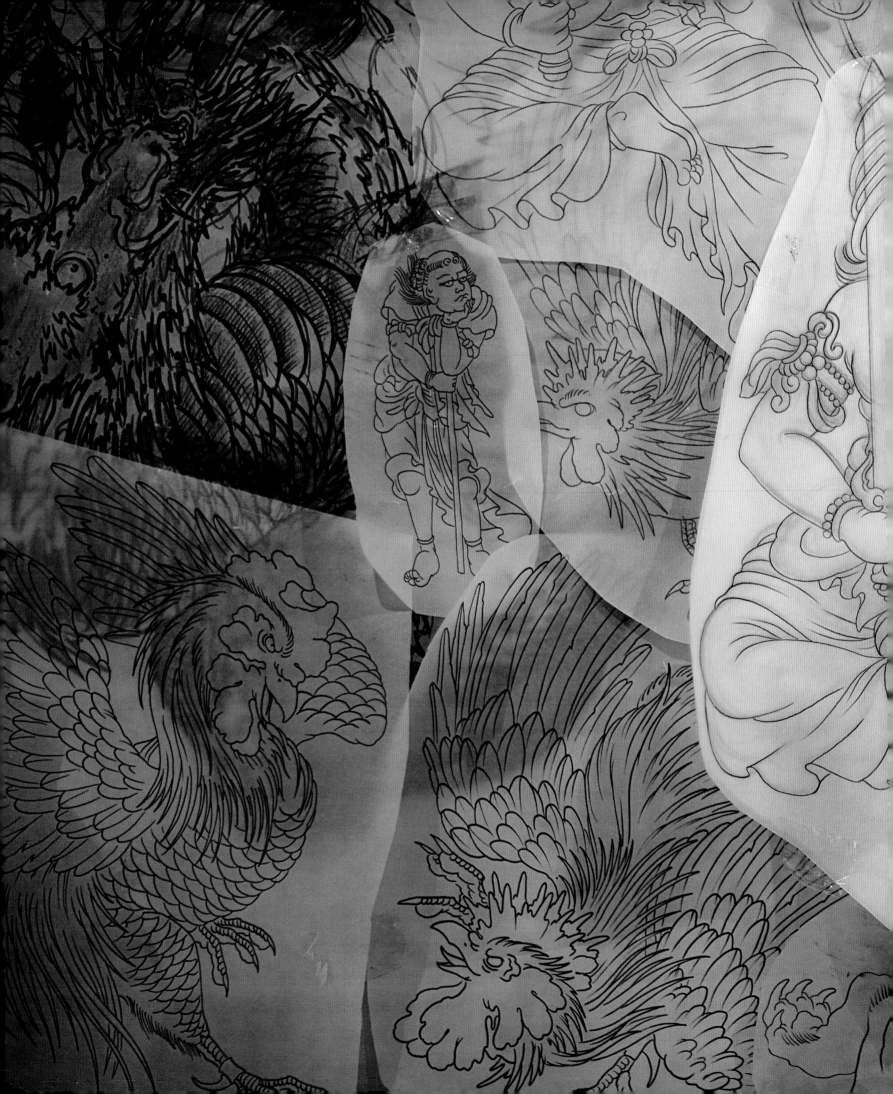

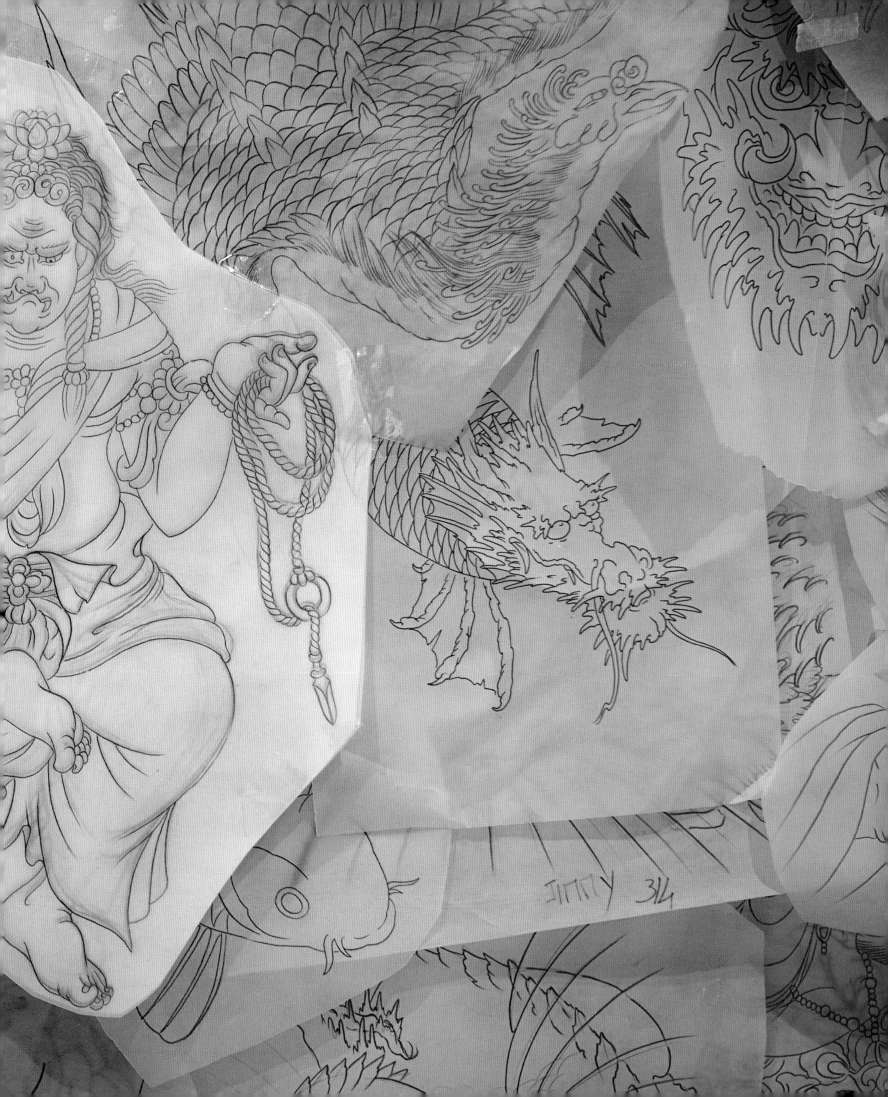

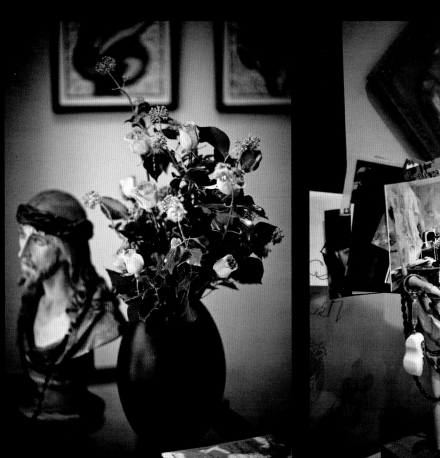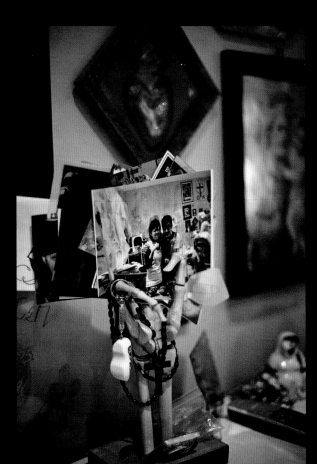

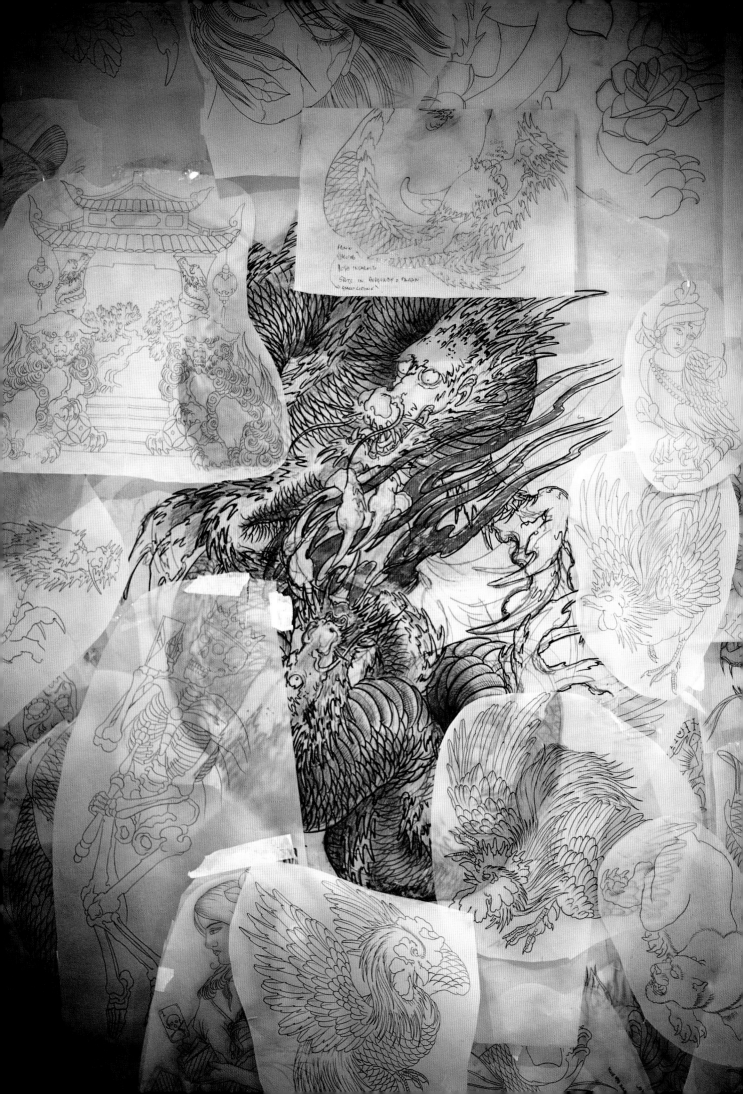

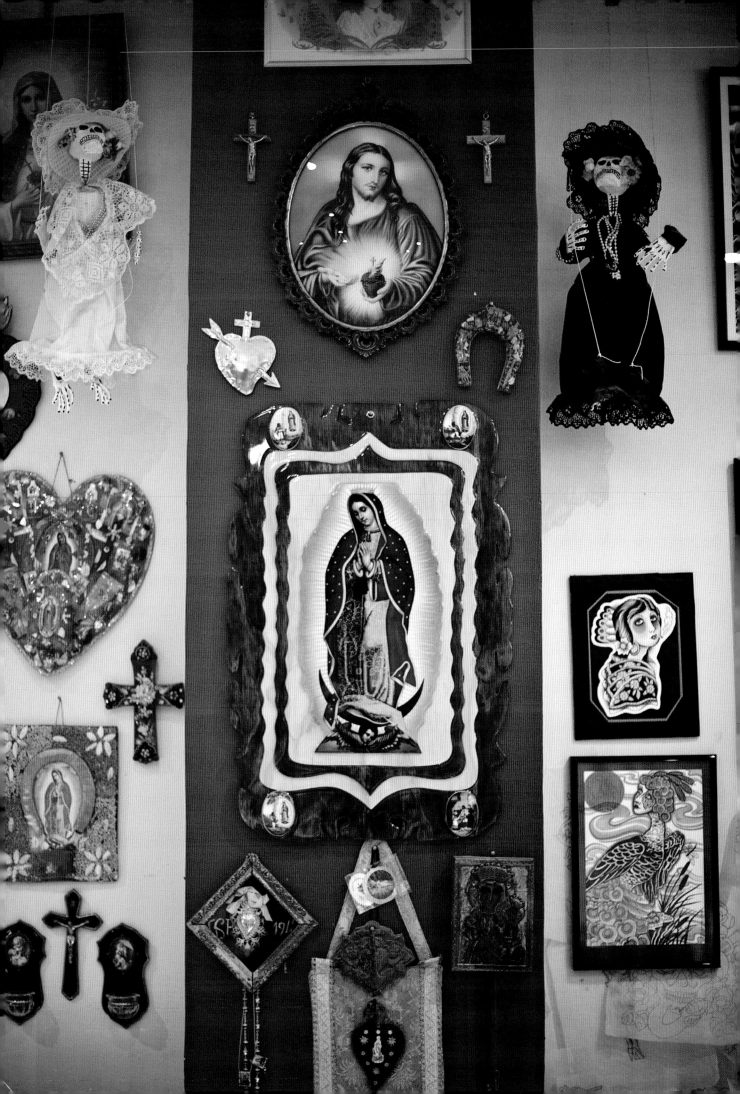

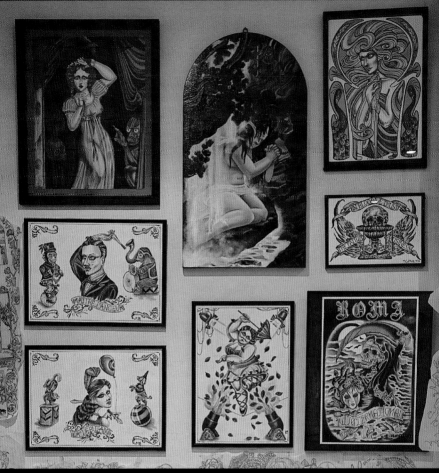

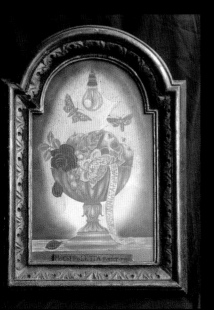

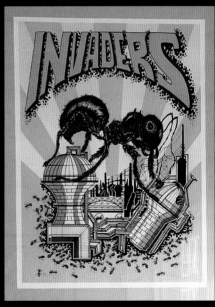

ARTWORK BY MO COPPOLETTA

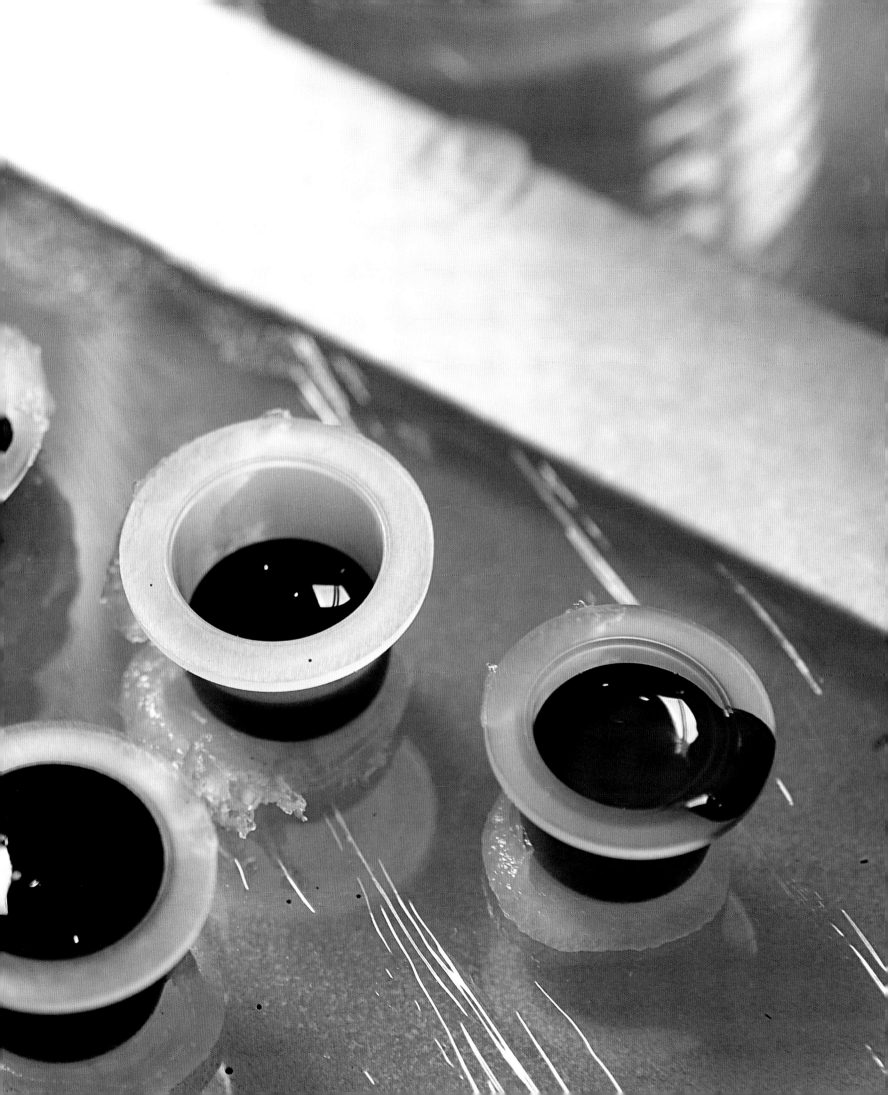

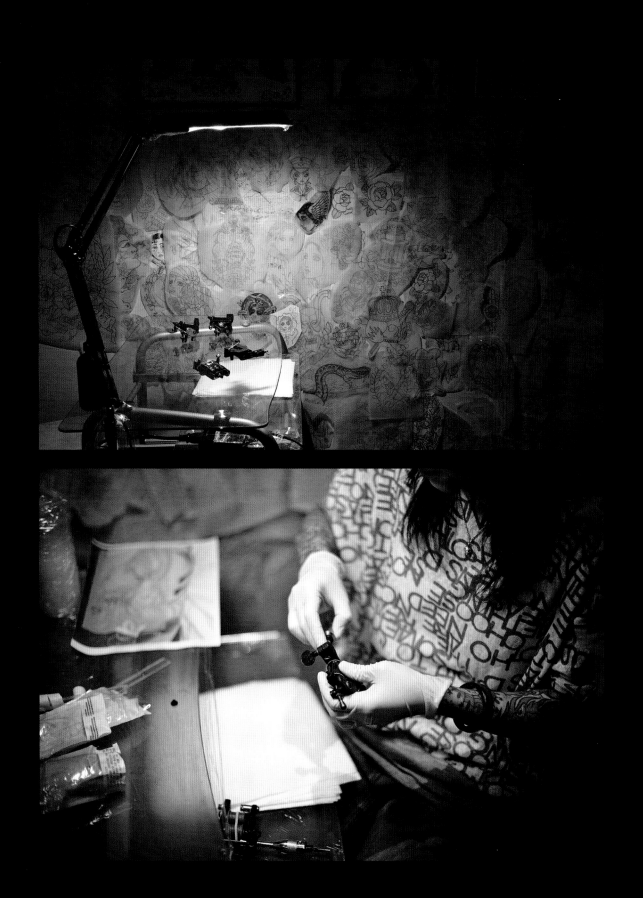

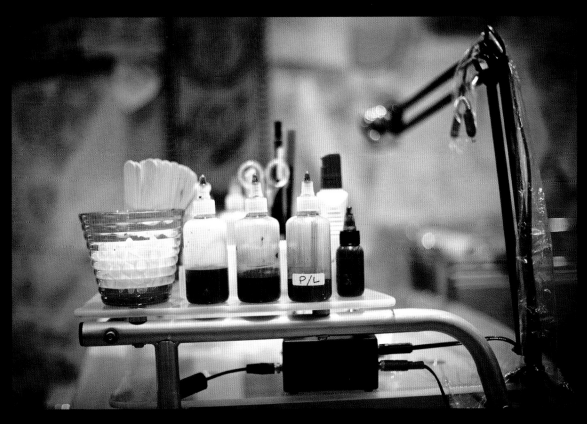

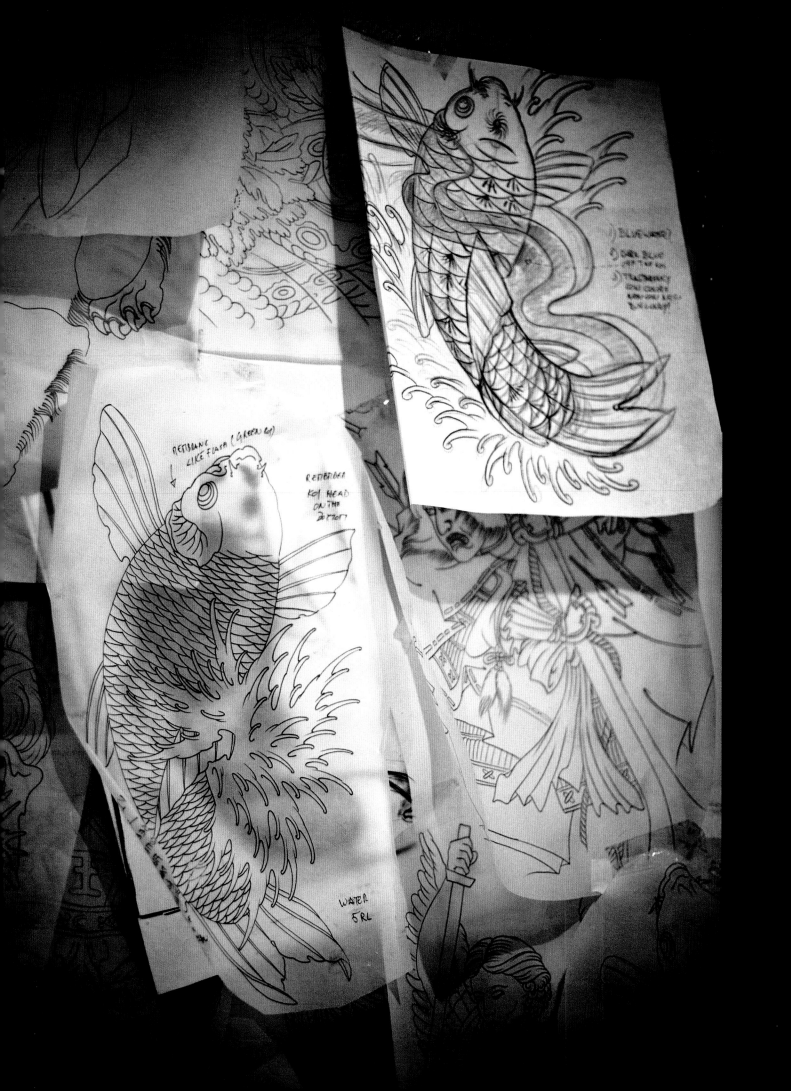

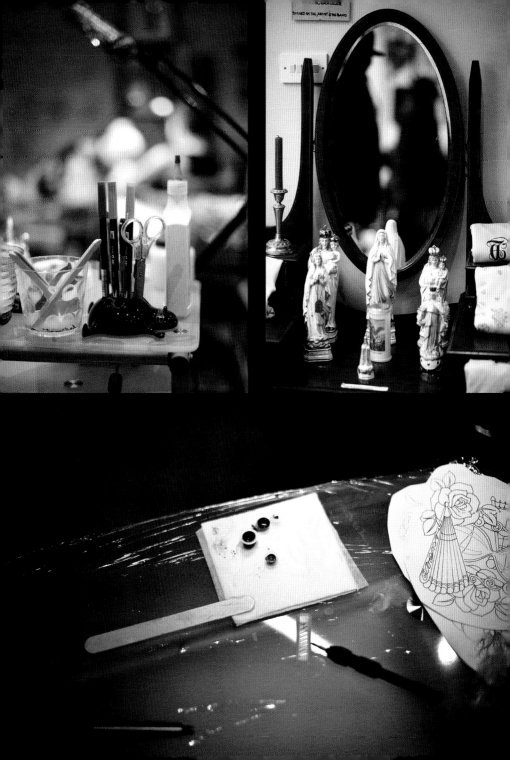

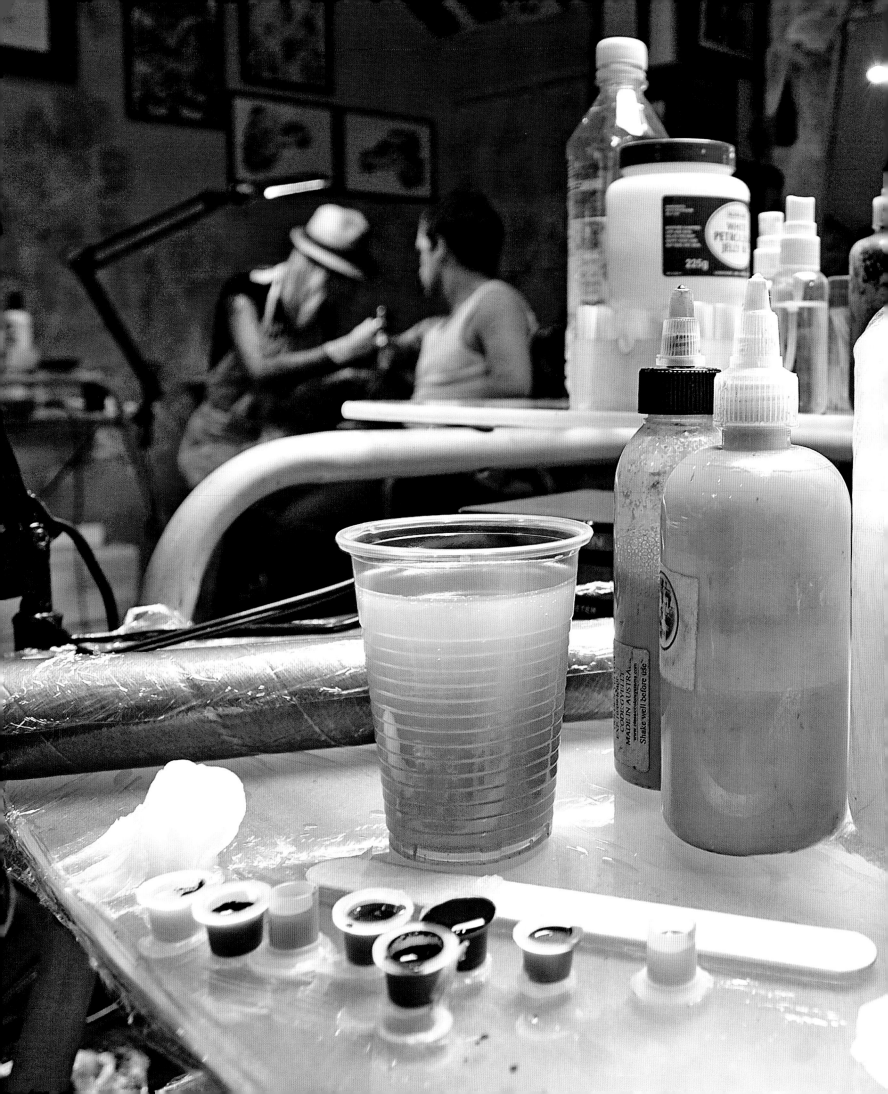

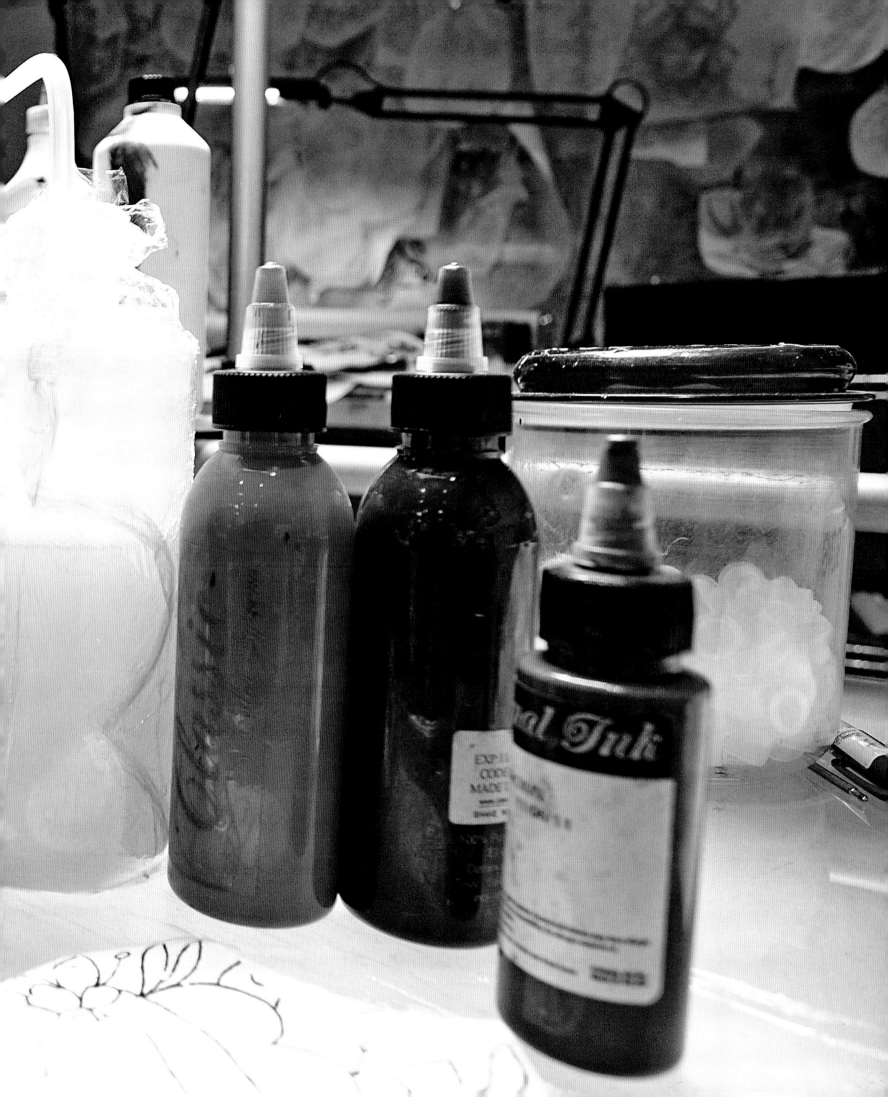

THE ART

• PER CRUCEM AD LUCEM •

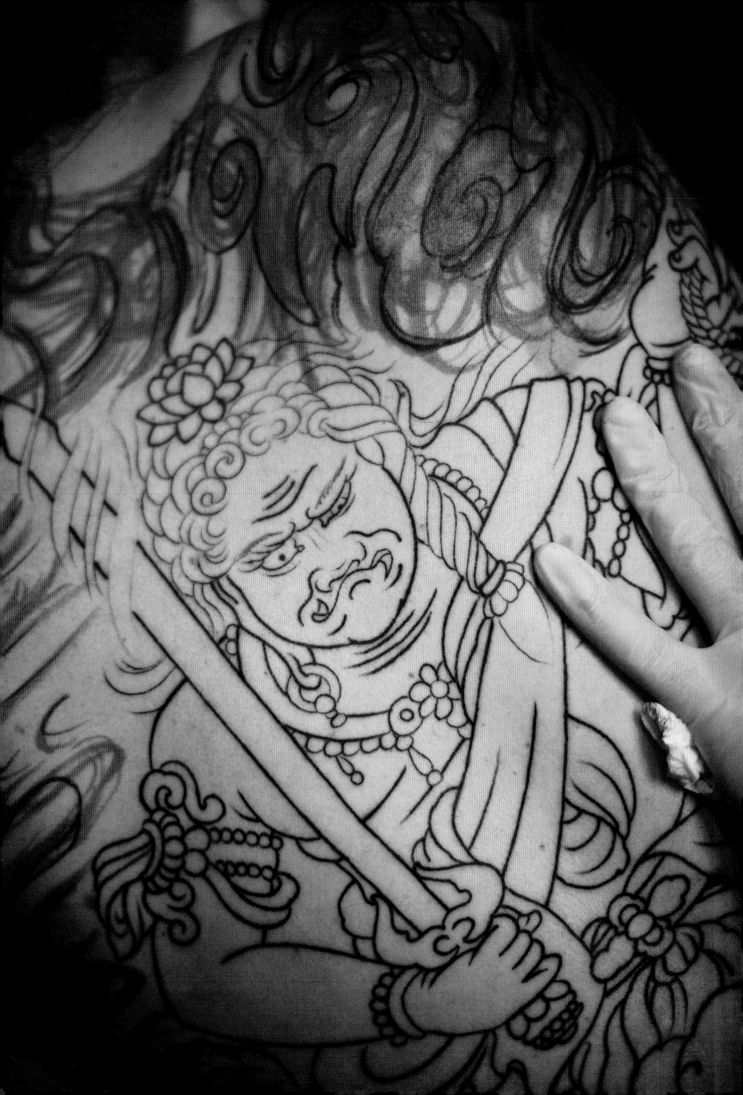

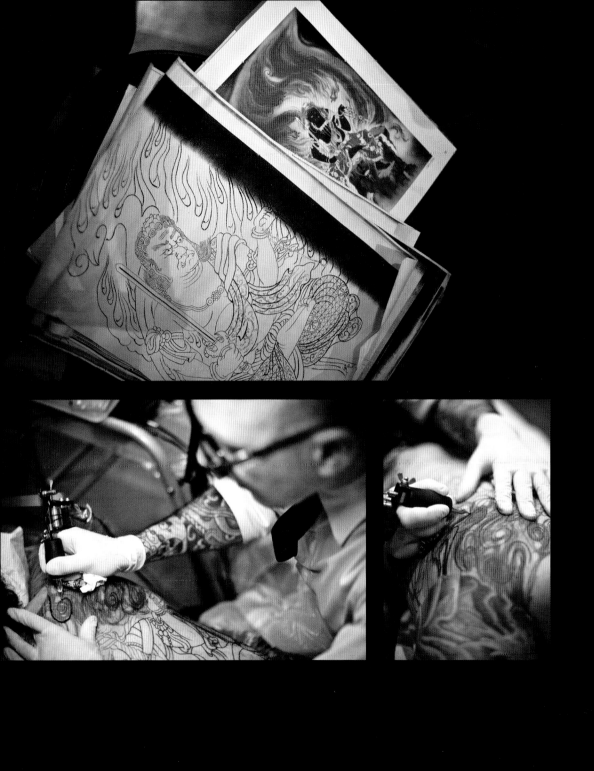

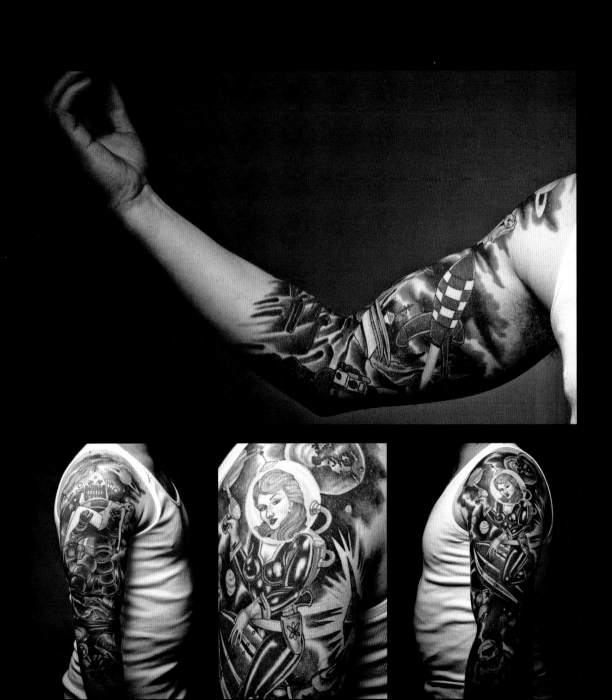

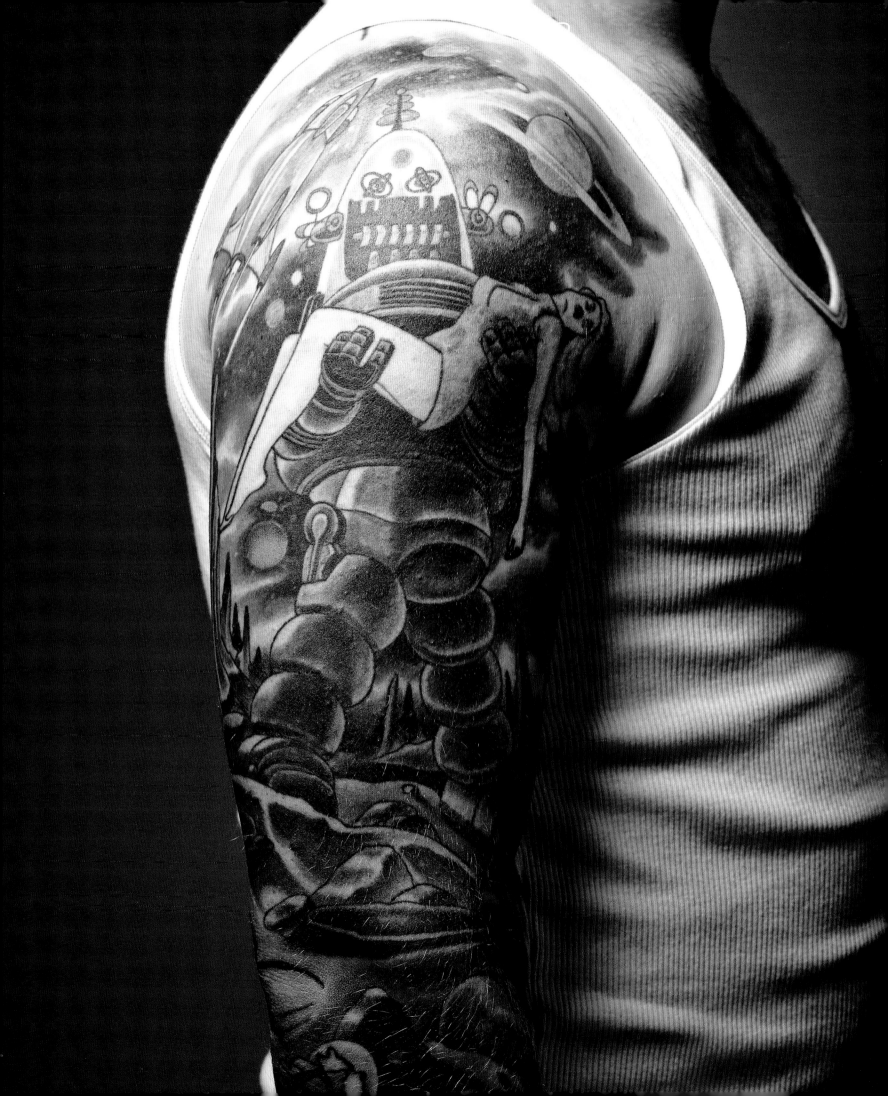

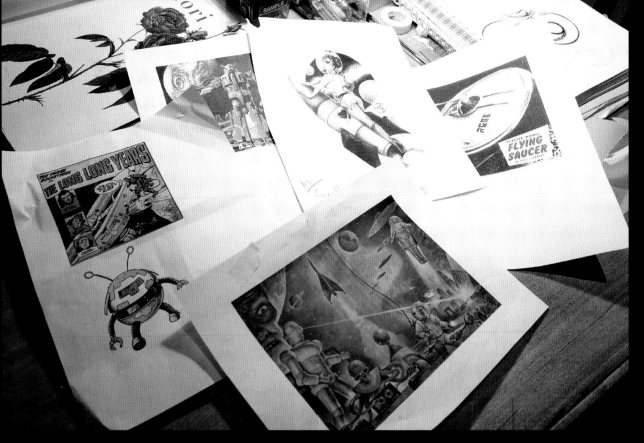

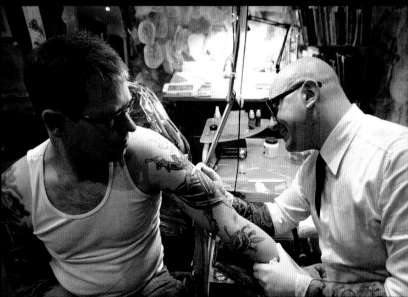

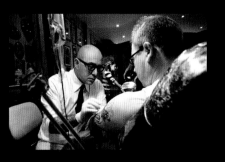

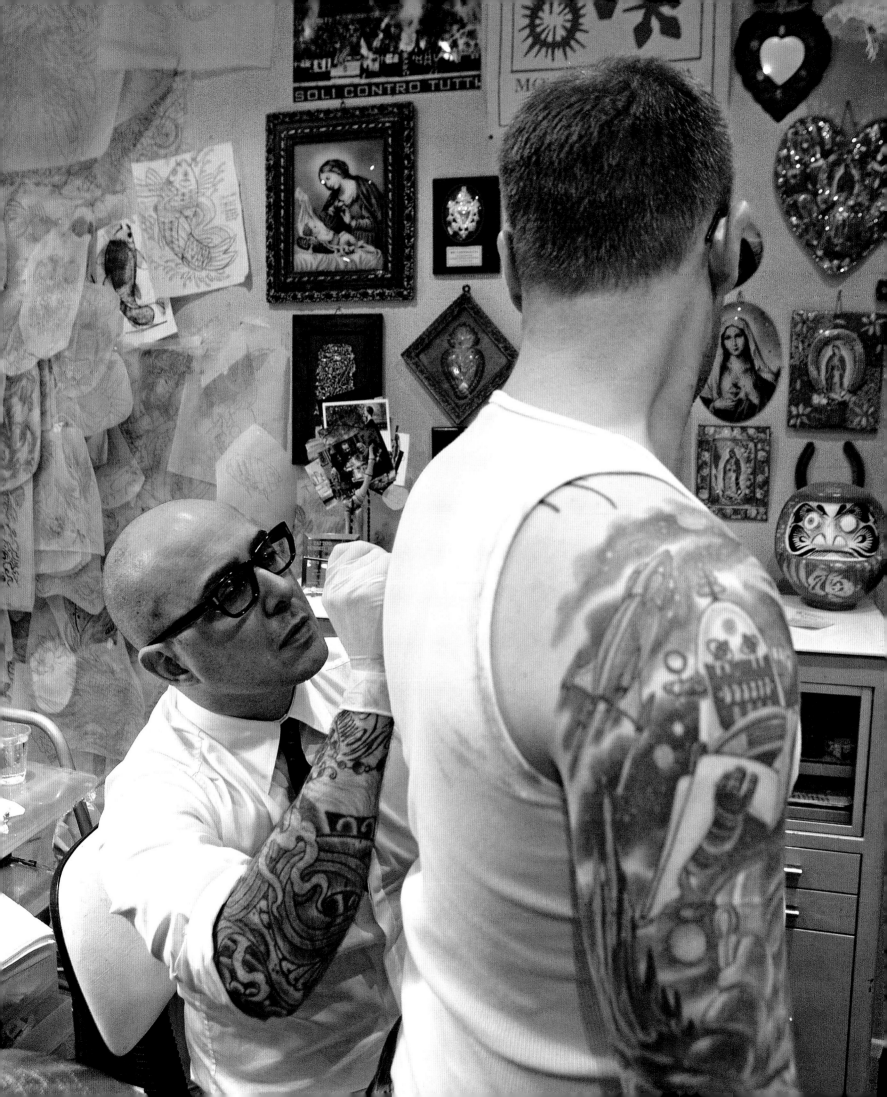

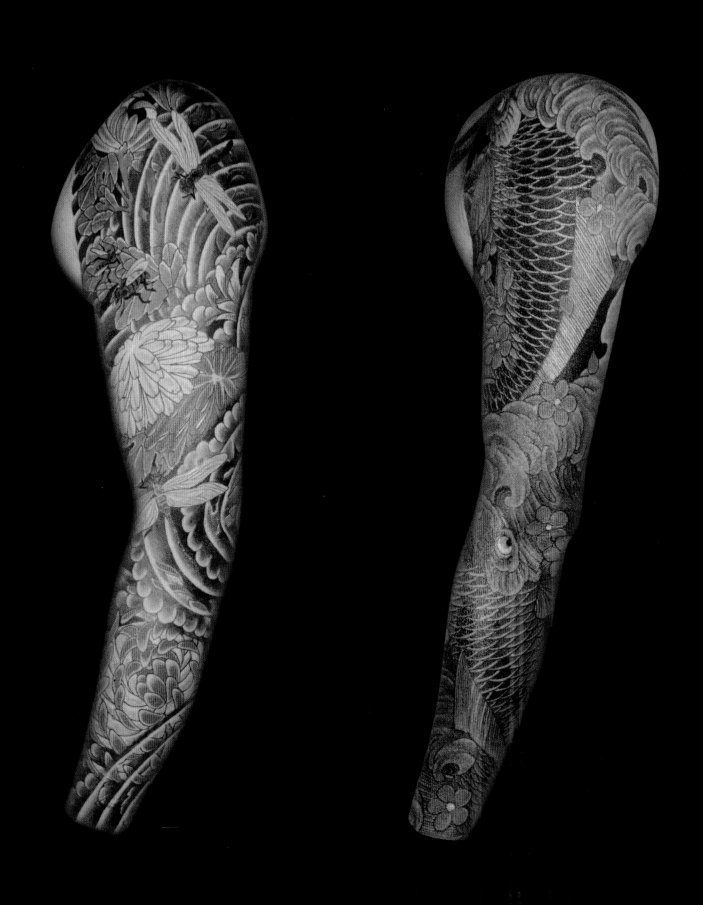

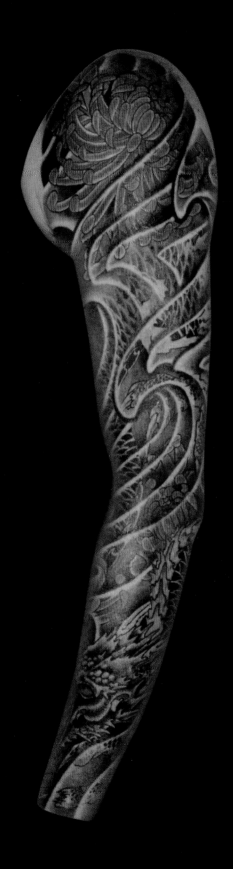
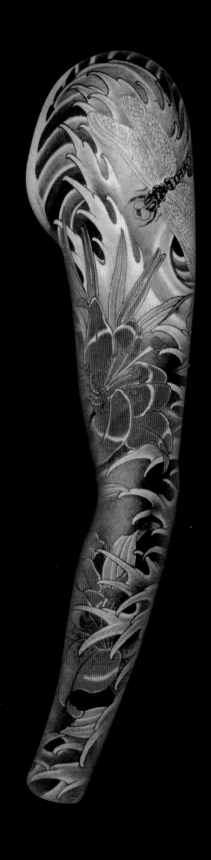

SLEEVES BY MO COPPOLETTA

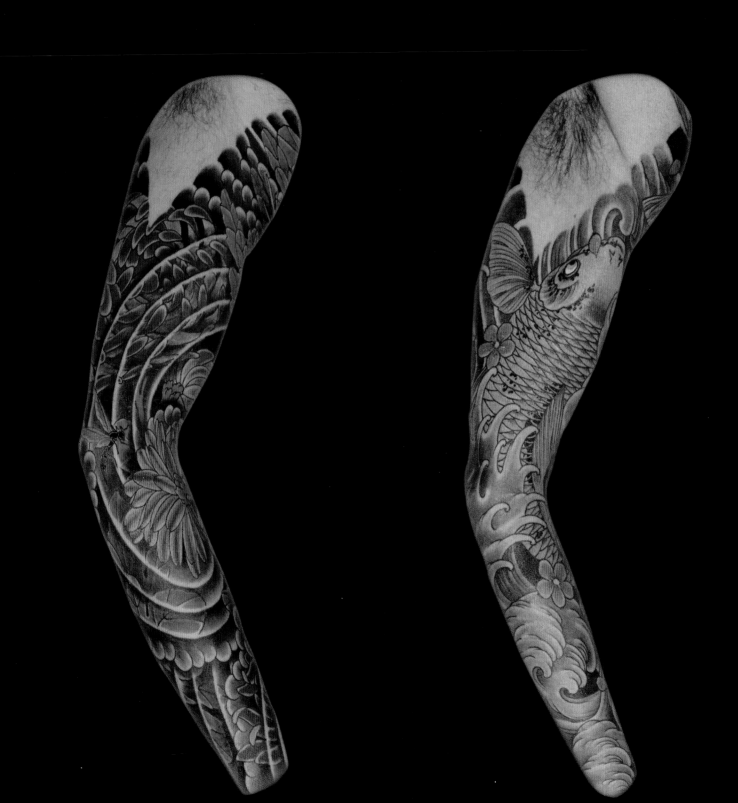

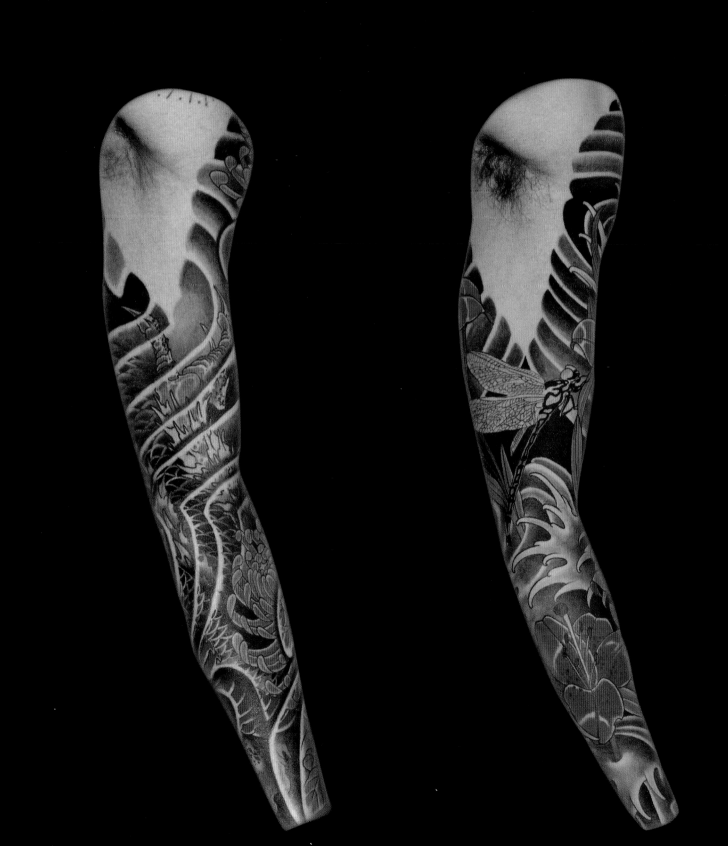

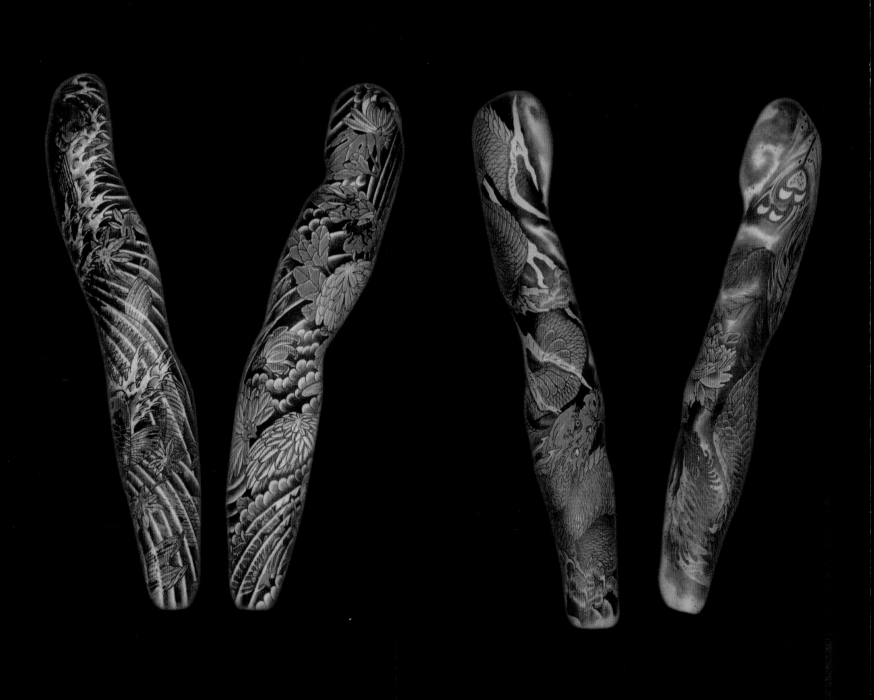

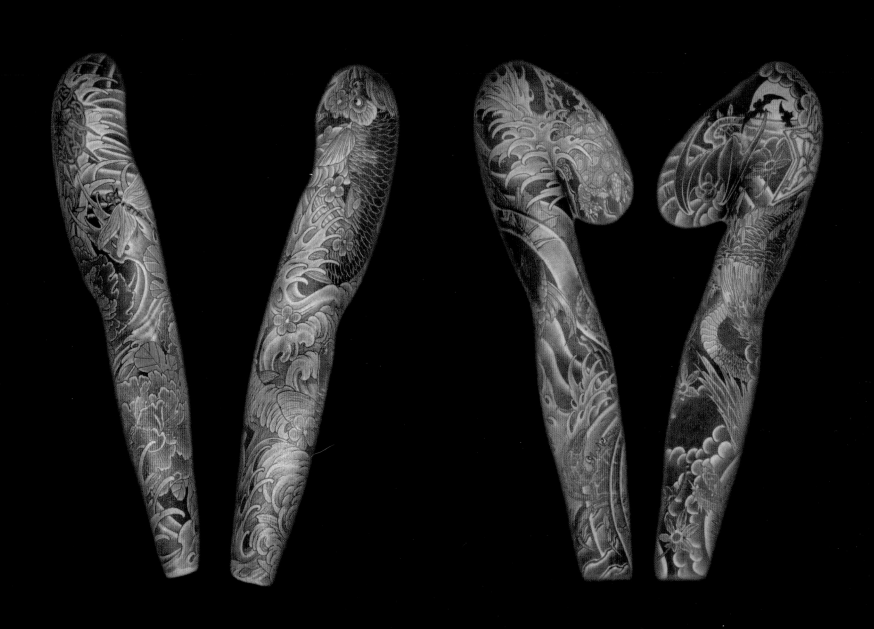

SLEEVES BY MO COPPOLETTA

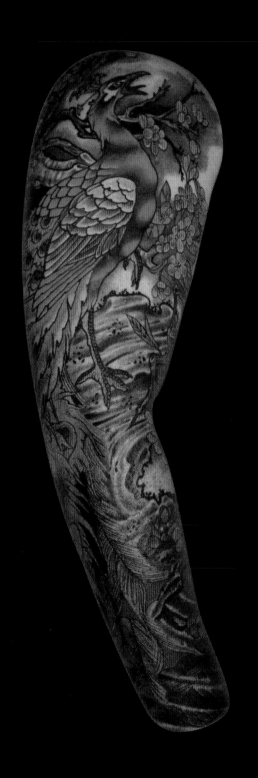
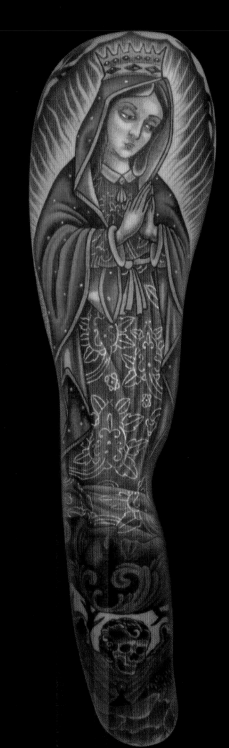

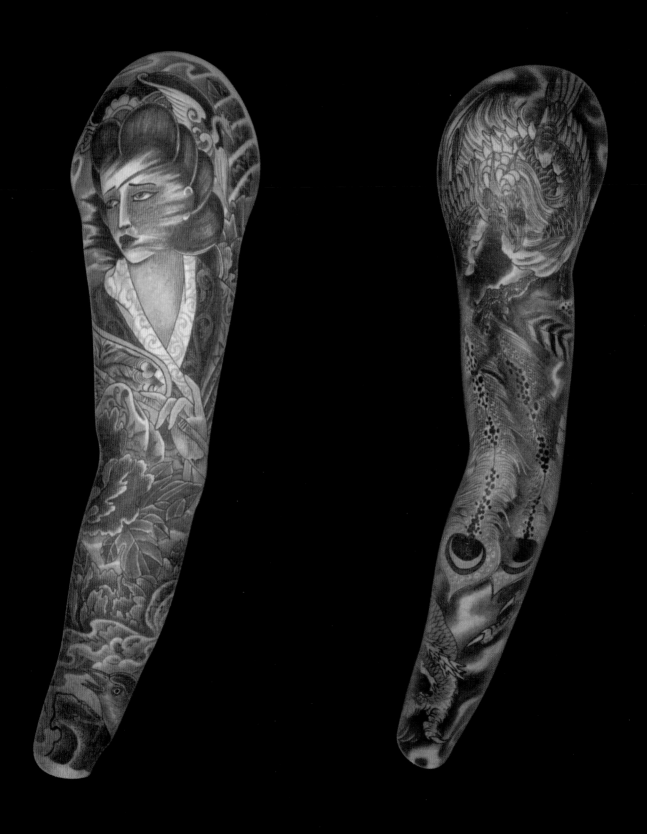

SLEEVES BY MO COPPOLETTA

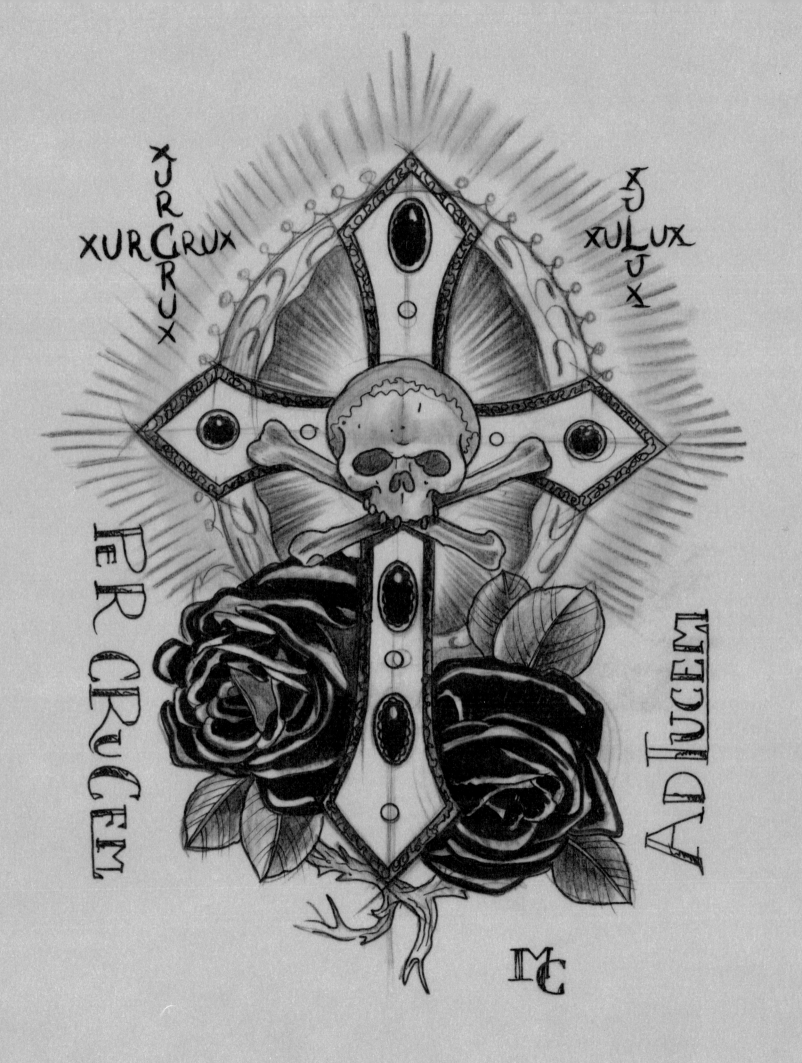

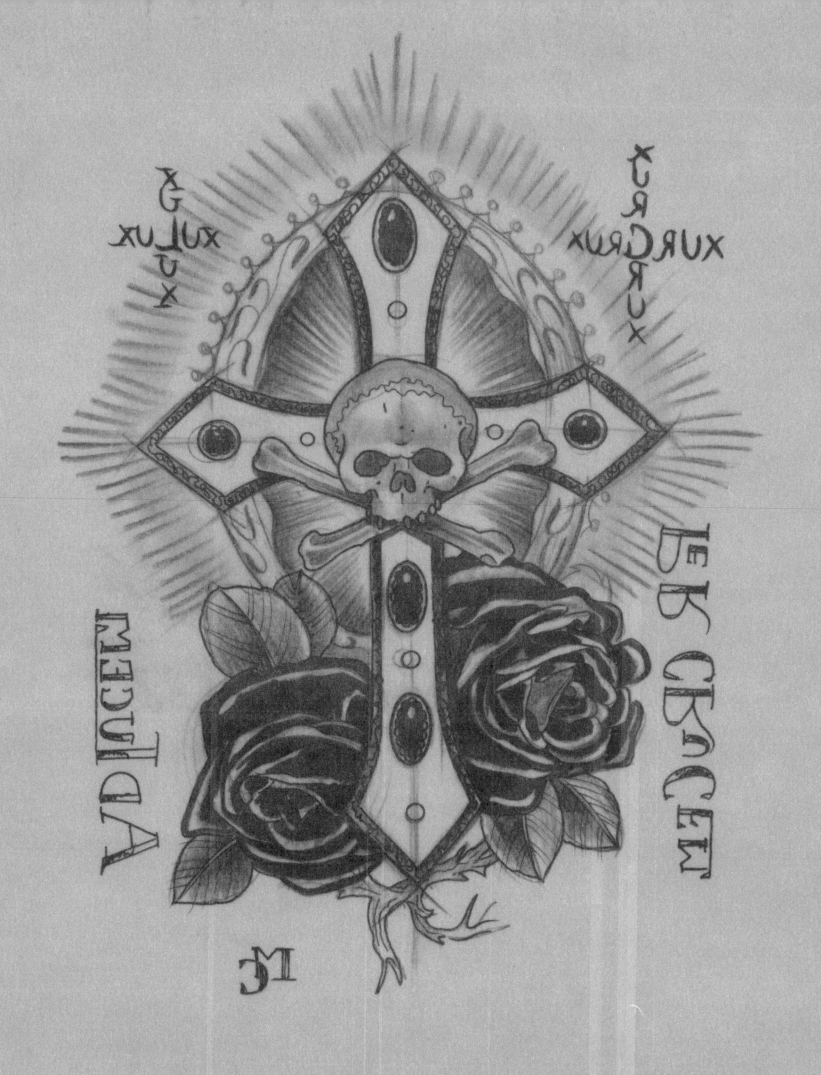

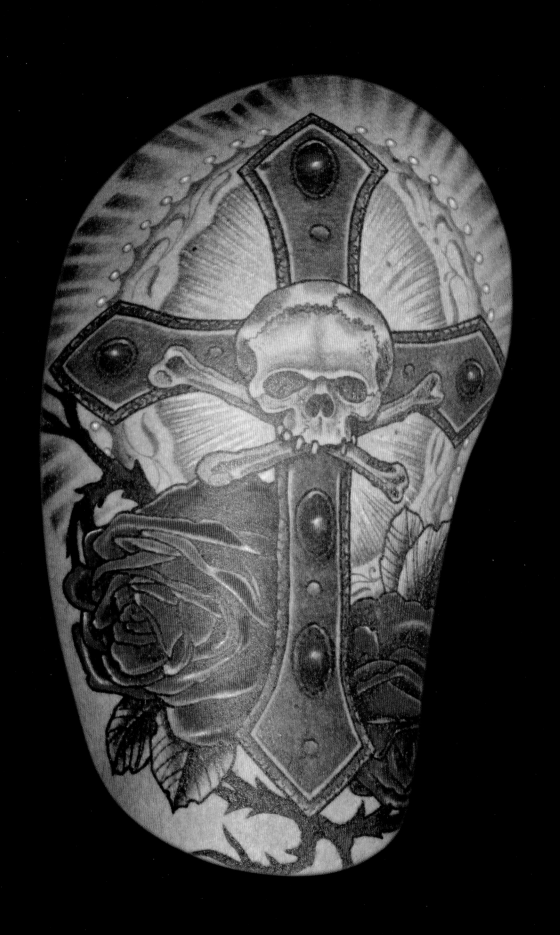

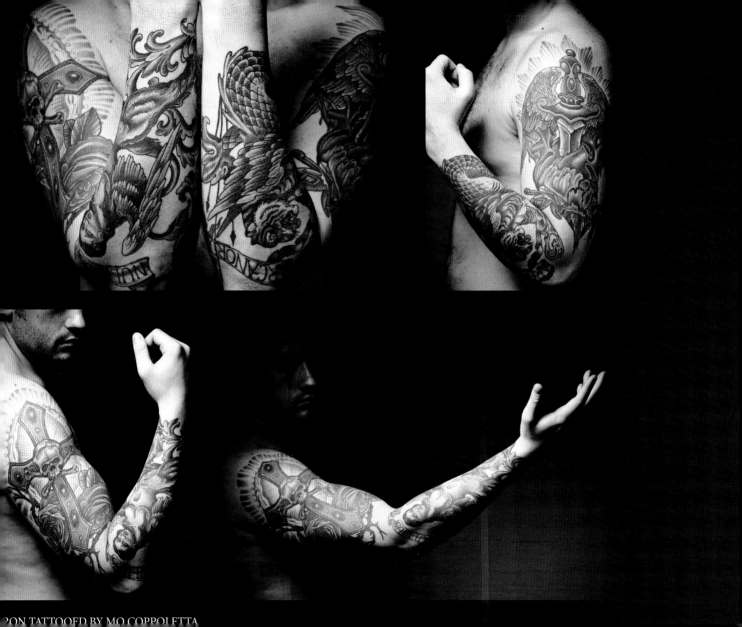

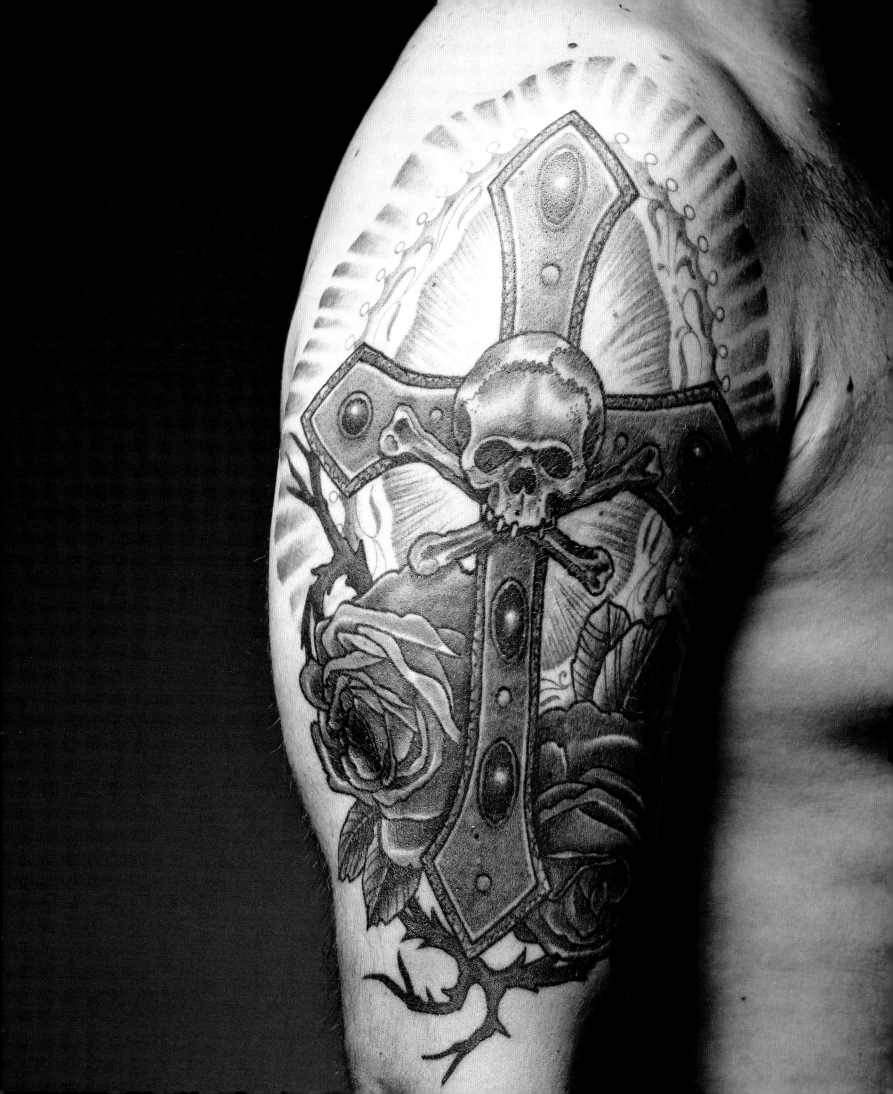

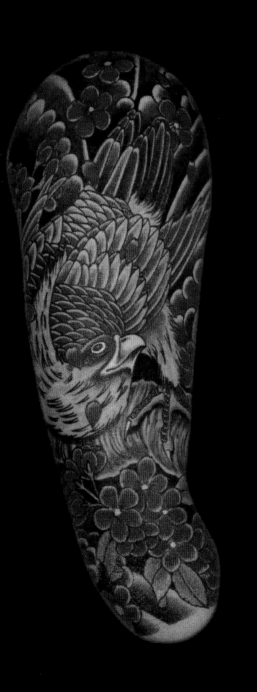
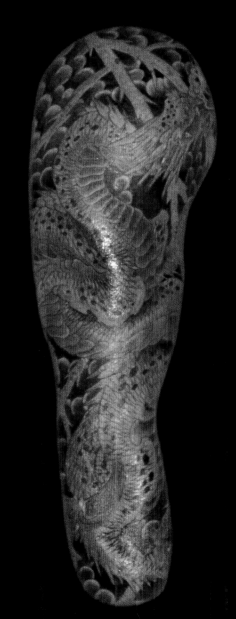

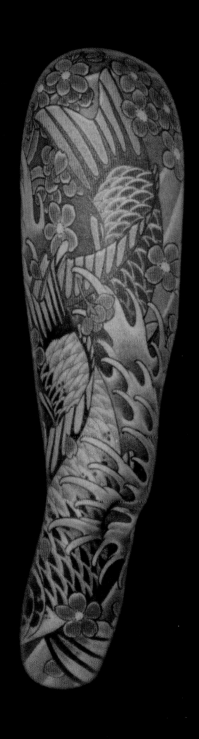
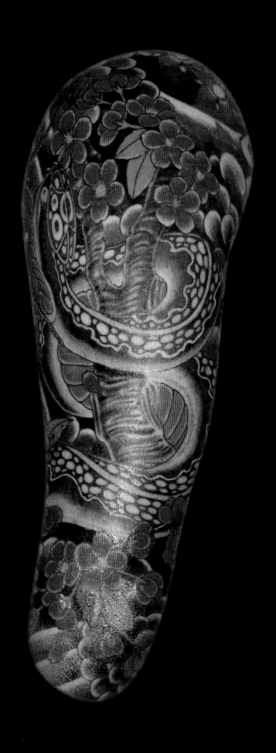

SLEEVES BY MO COPPOLETTA

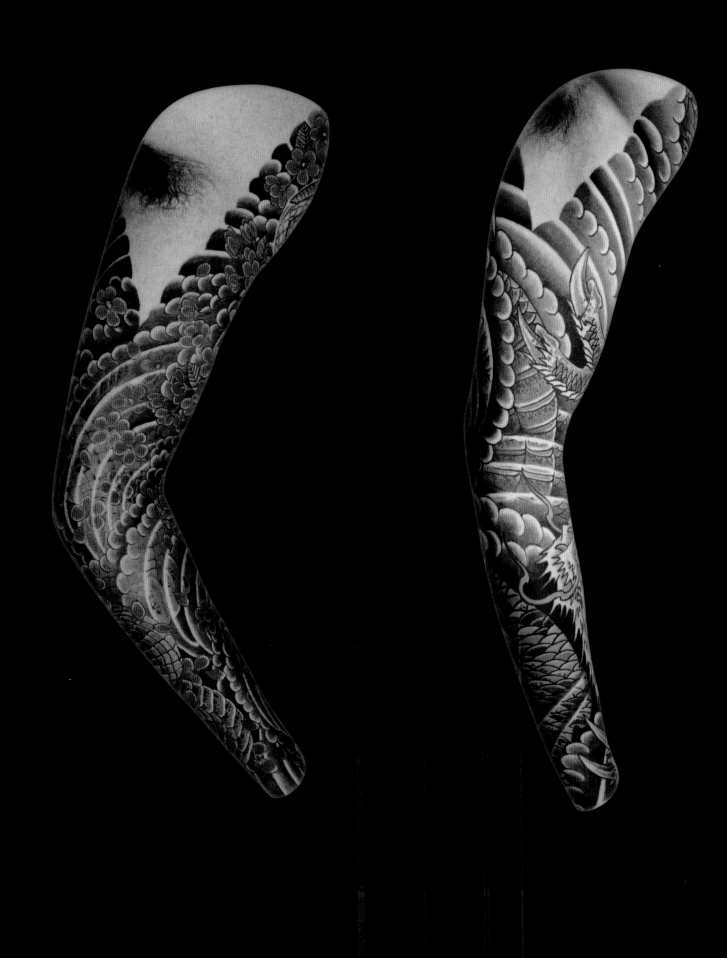

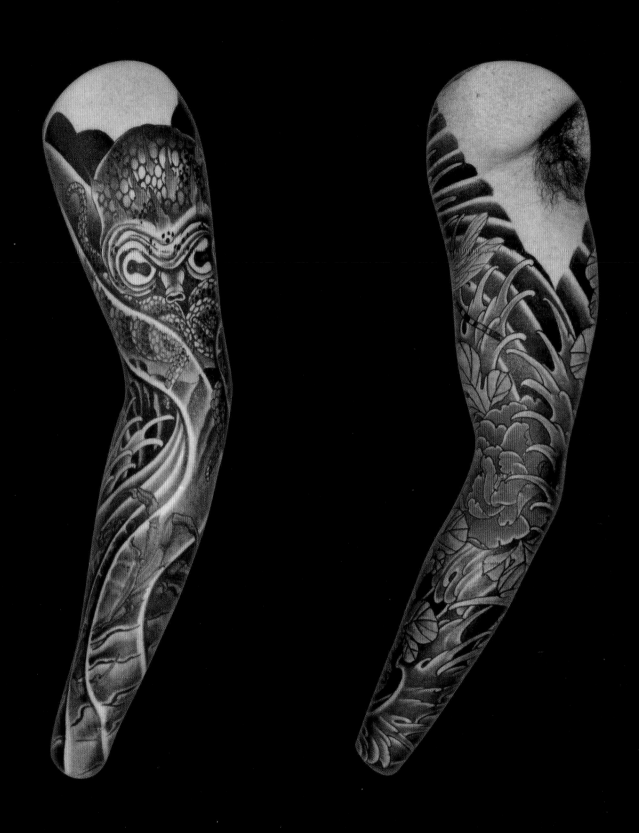

SLEEVES BY MO COPPOLETTA

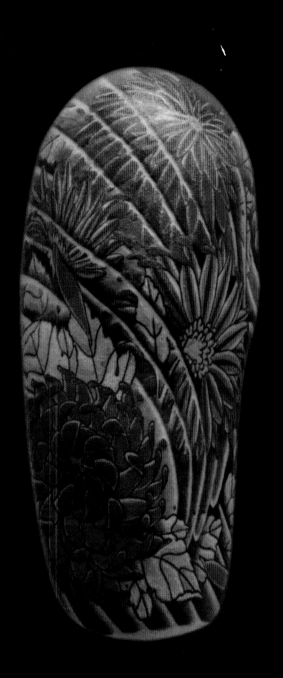
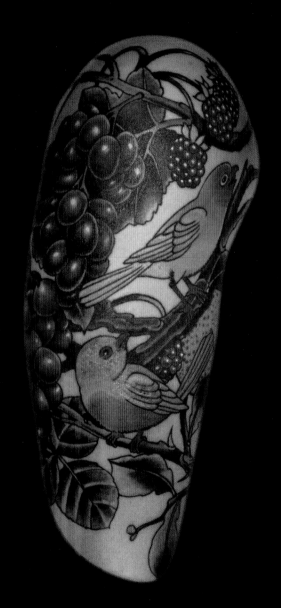

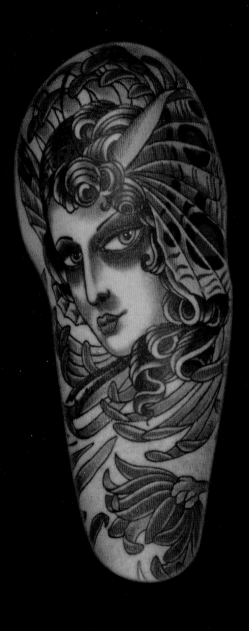

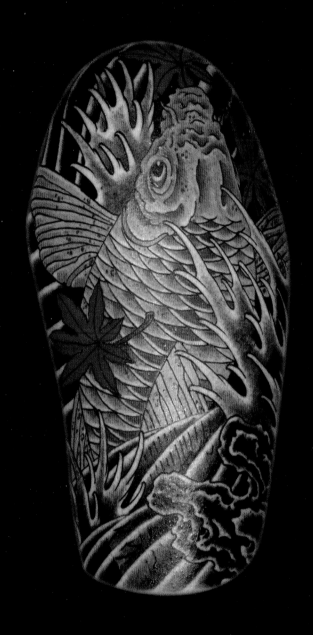

SLEEVES BY MO COPPOLETTA

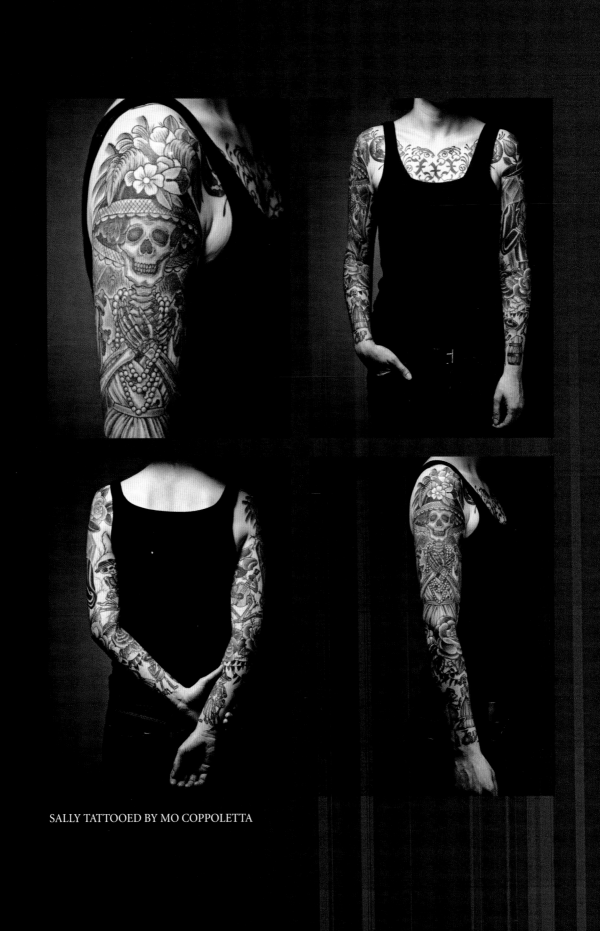

SALLY TATTOOED BY MO COPPOLETTA

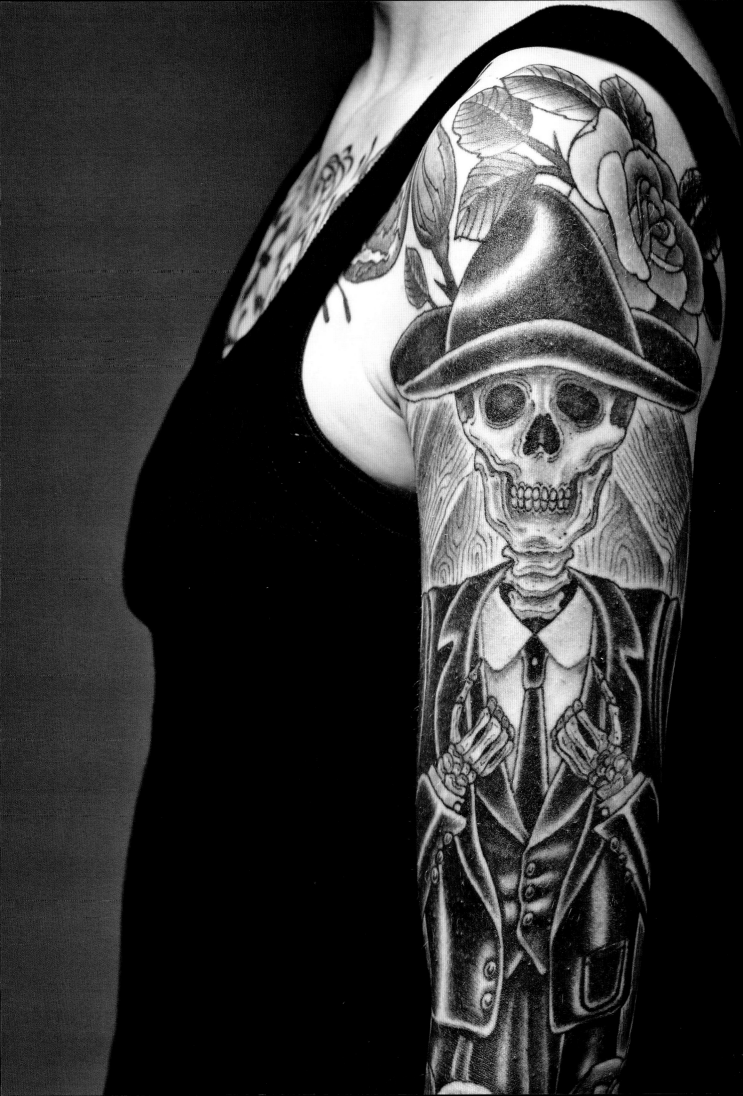

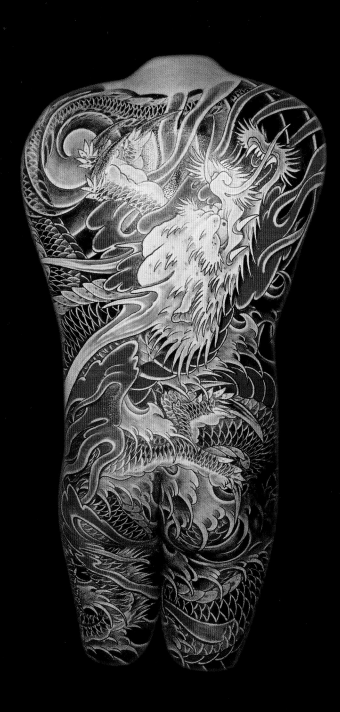
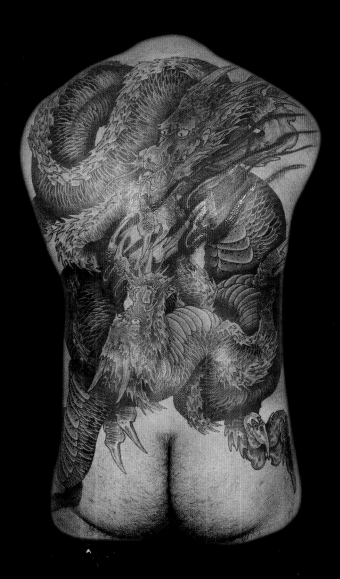

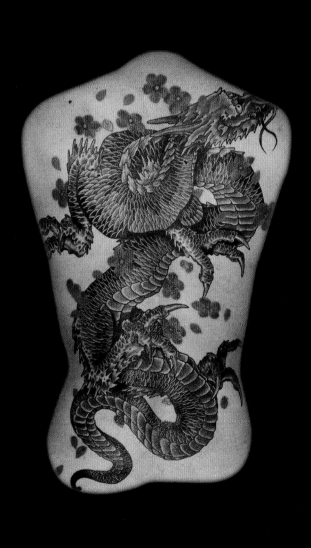
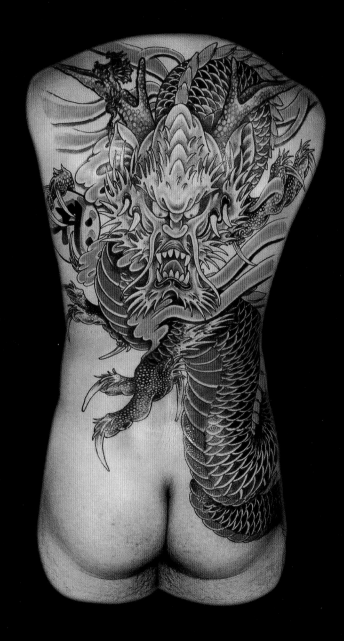

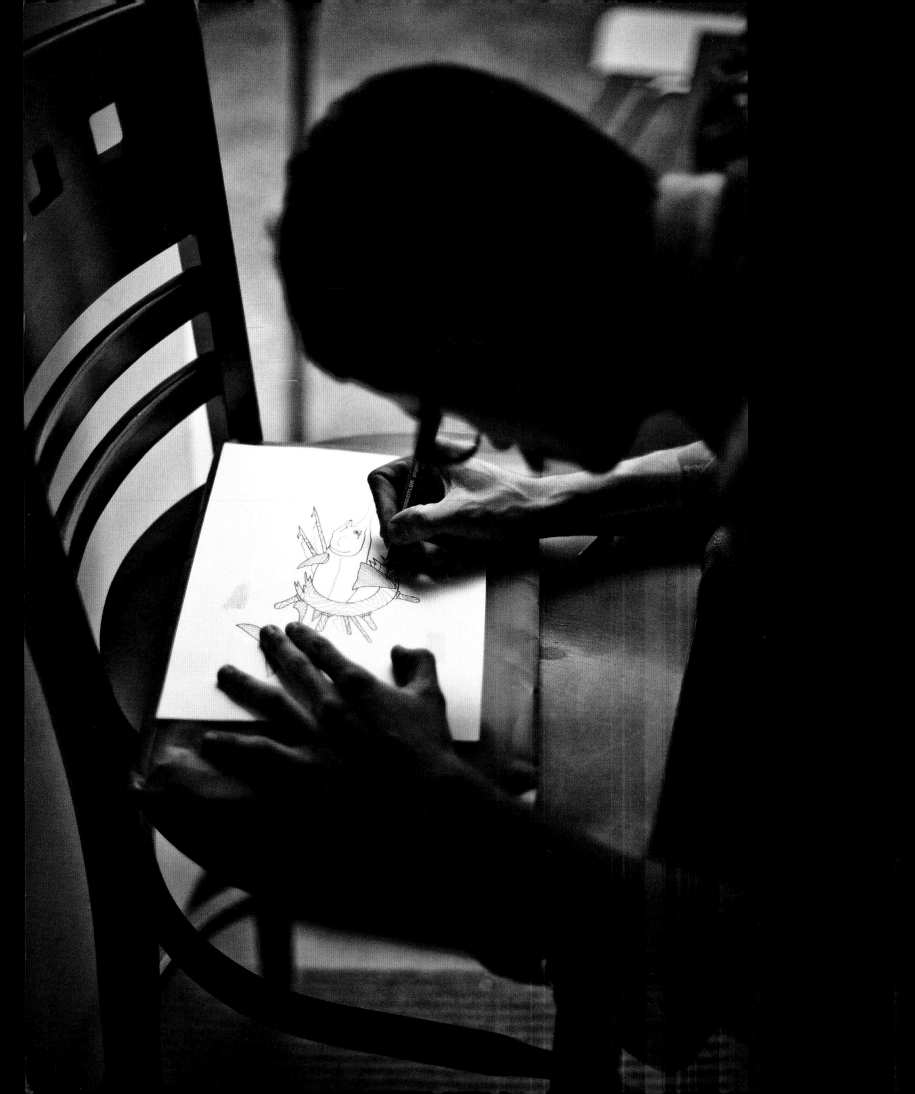

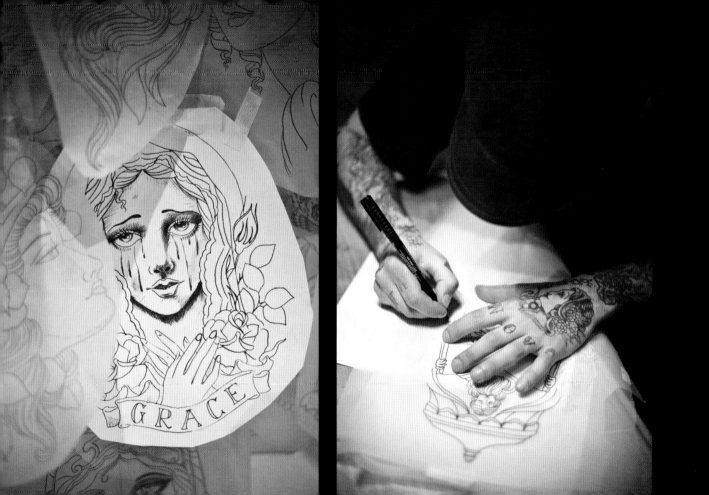

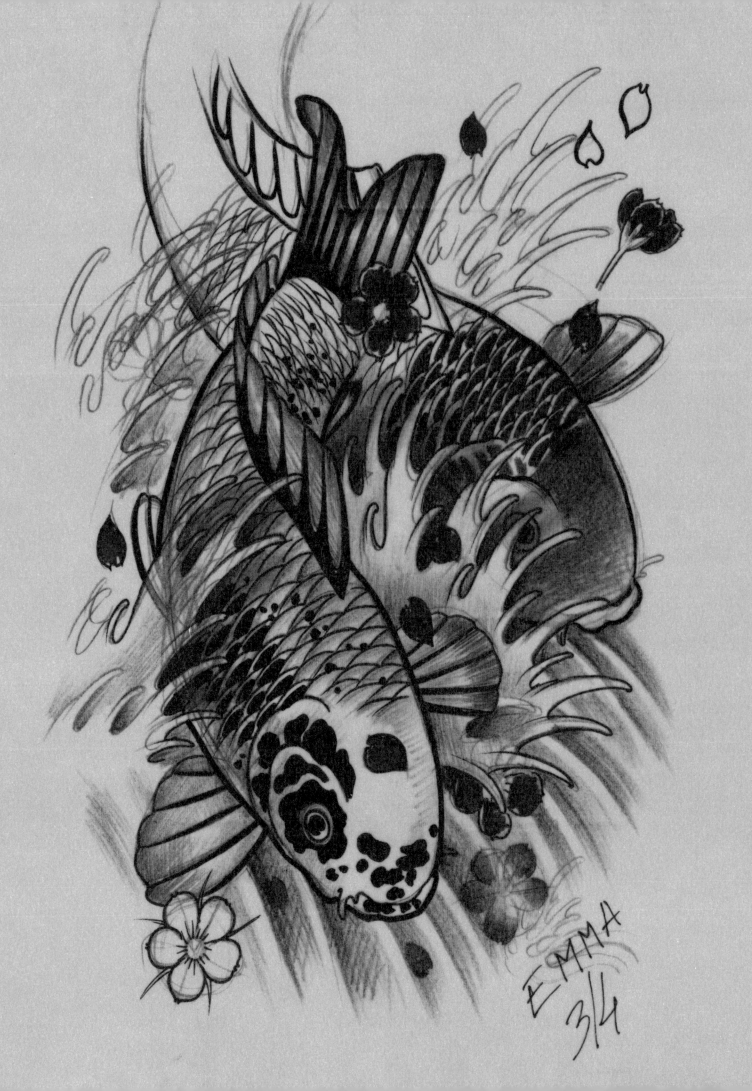

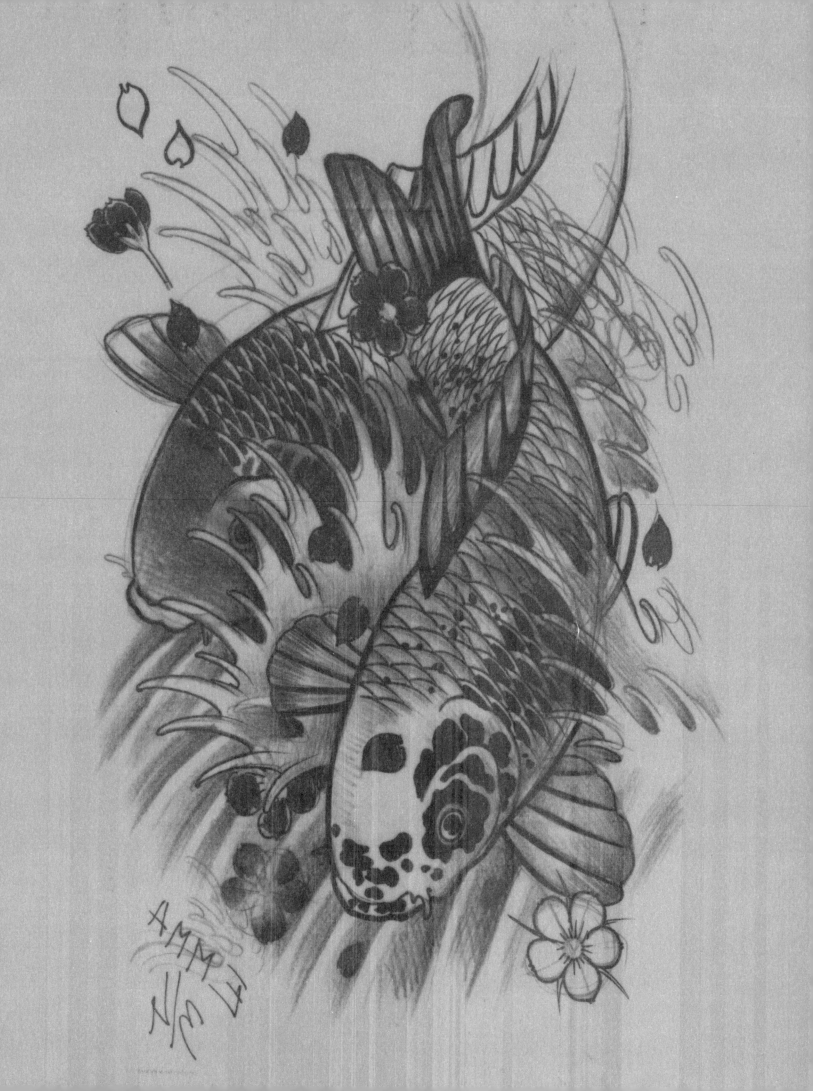

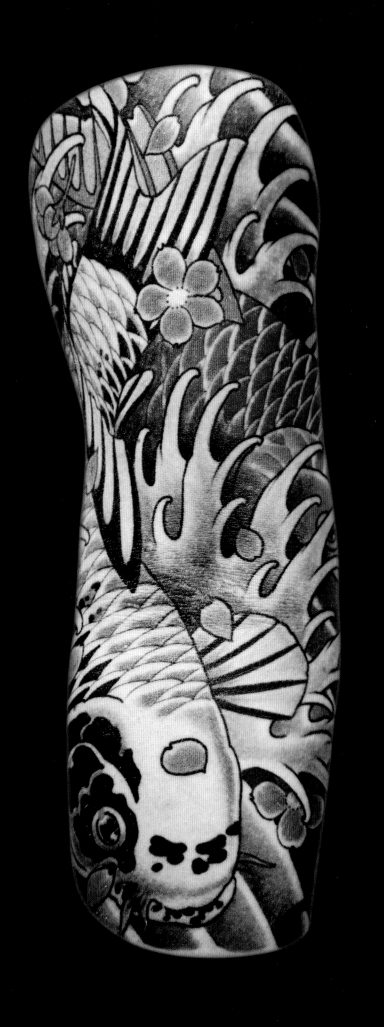

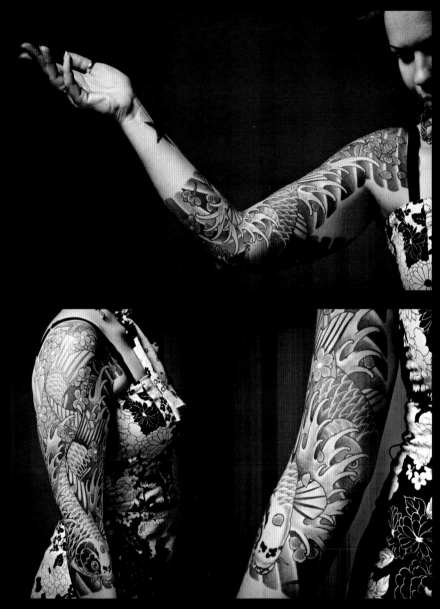

EMMA TATTOOED BY MO COPPOLETTA

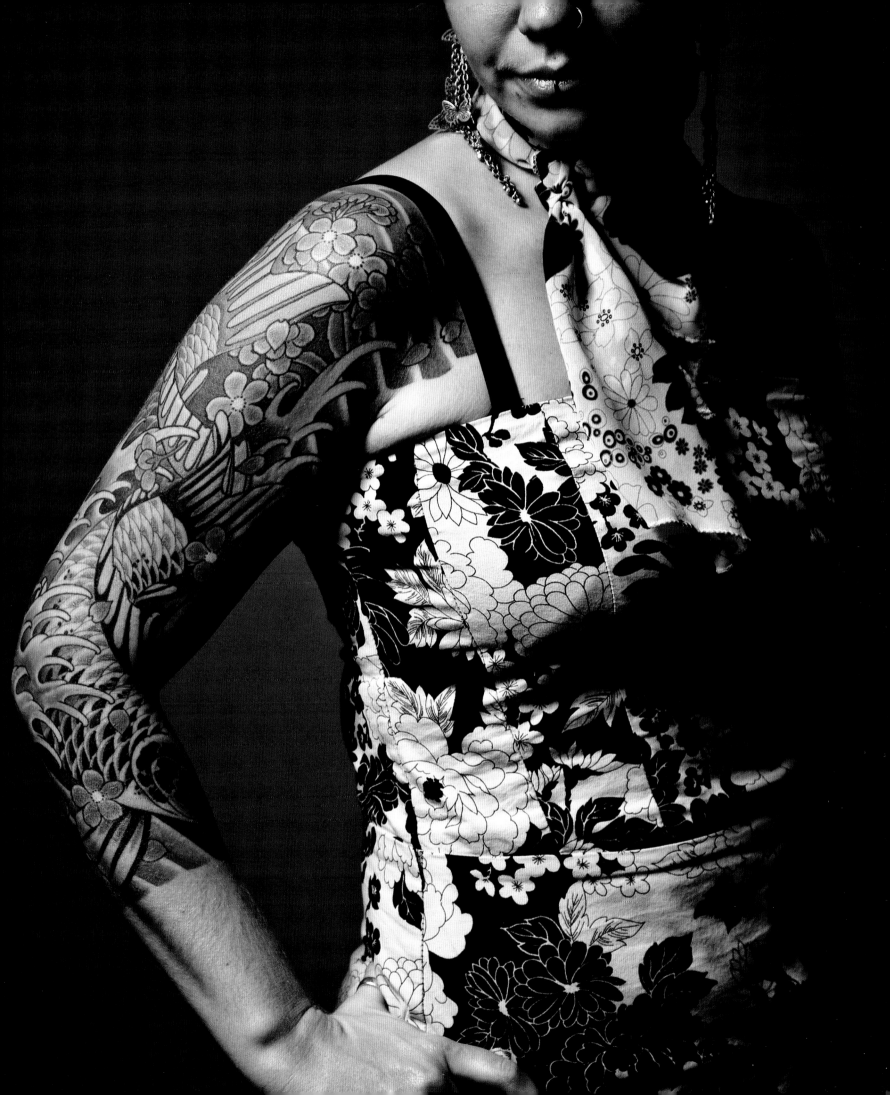

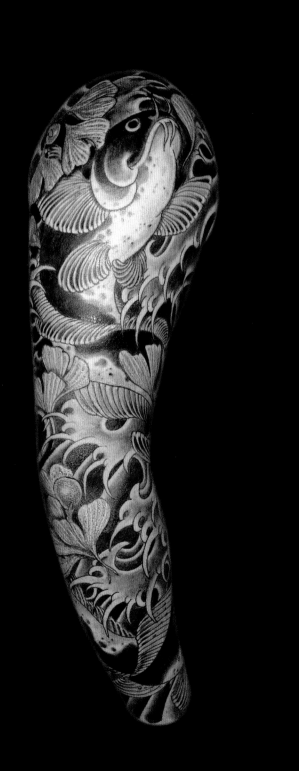
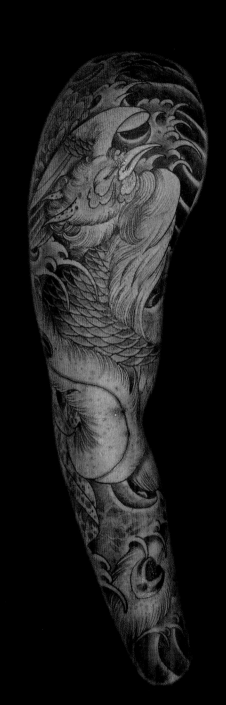

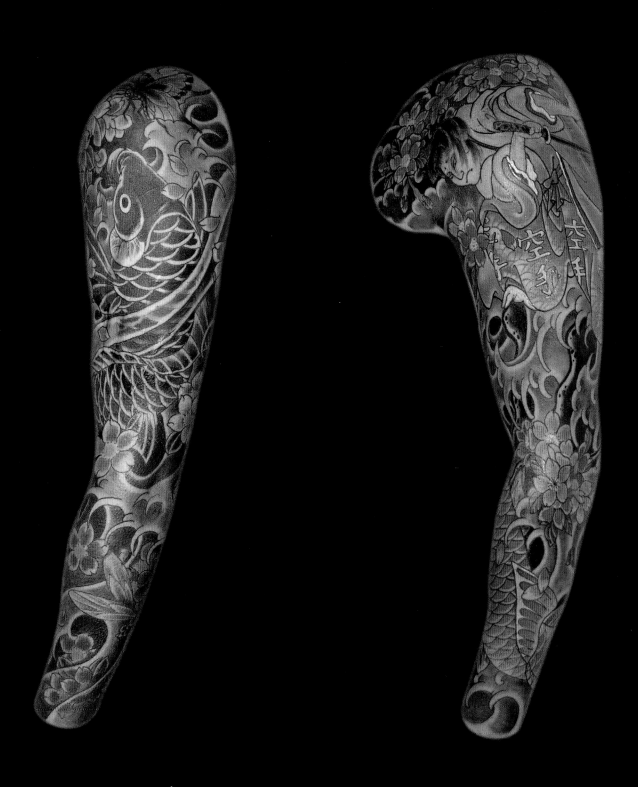

SLEEVES BY DIEGO AZALDEGUI

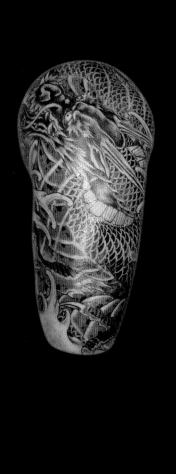
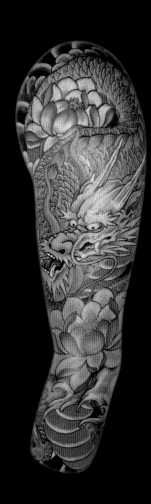
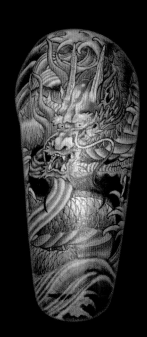
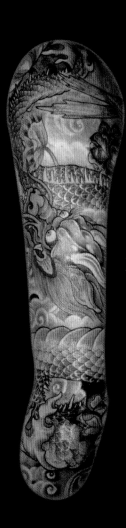

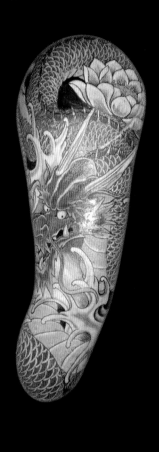
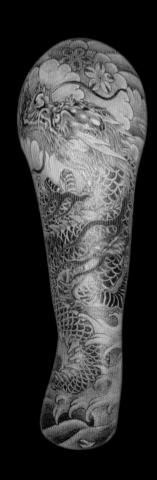
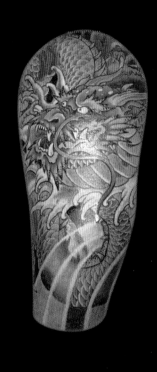
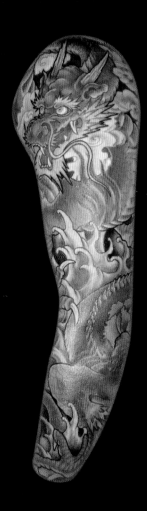

DRAGONS BY KANAE

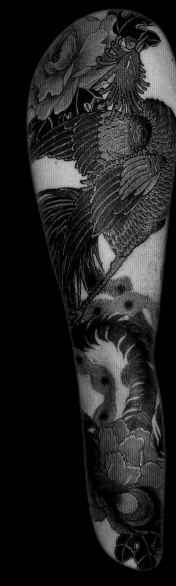
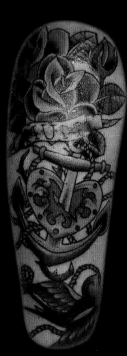
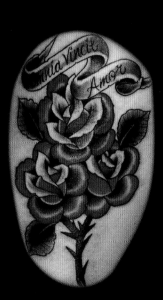

TATTOOS BY MIE SATOU

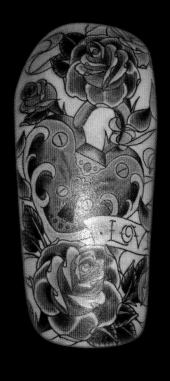
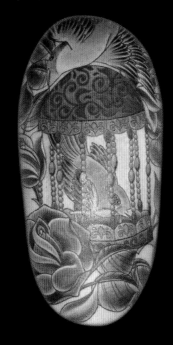
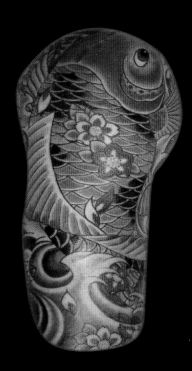
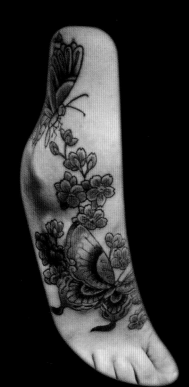
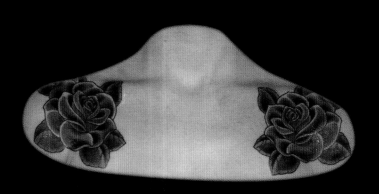

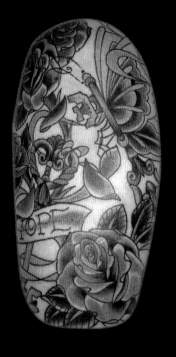
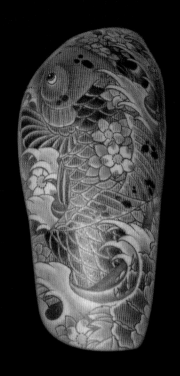
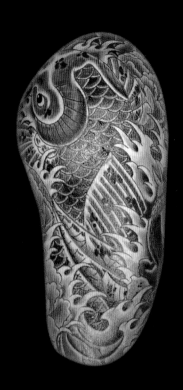
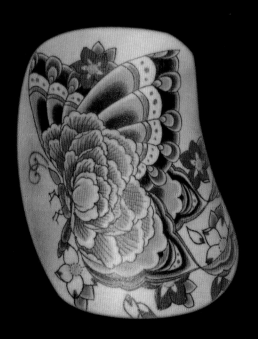
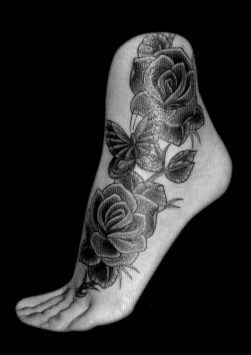

TATTOOS BY DOMINIQUE HOLMES

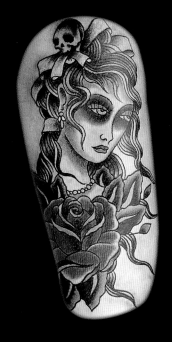
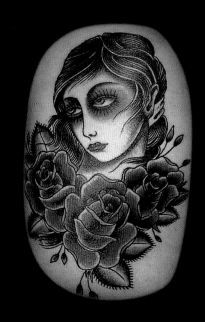
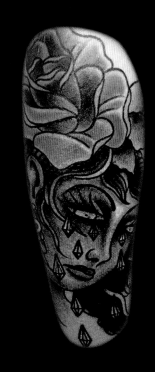
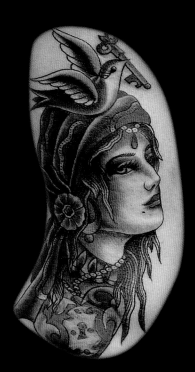
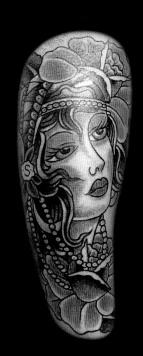
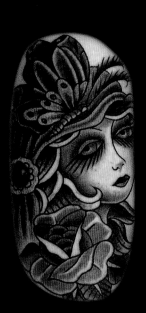

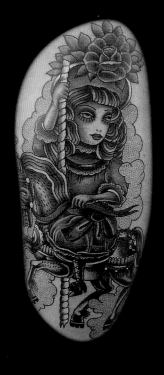
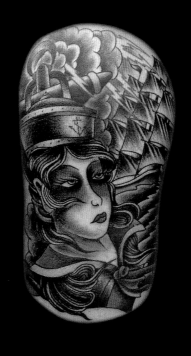
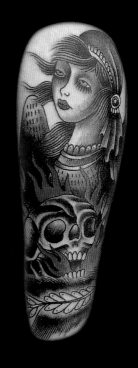
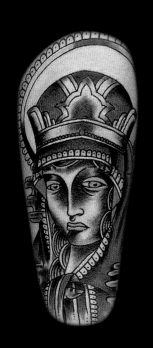
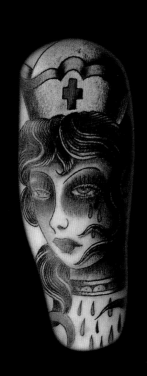
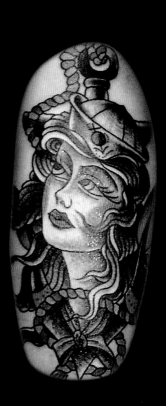

TATTOOS BY DIEGO BRANDI

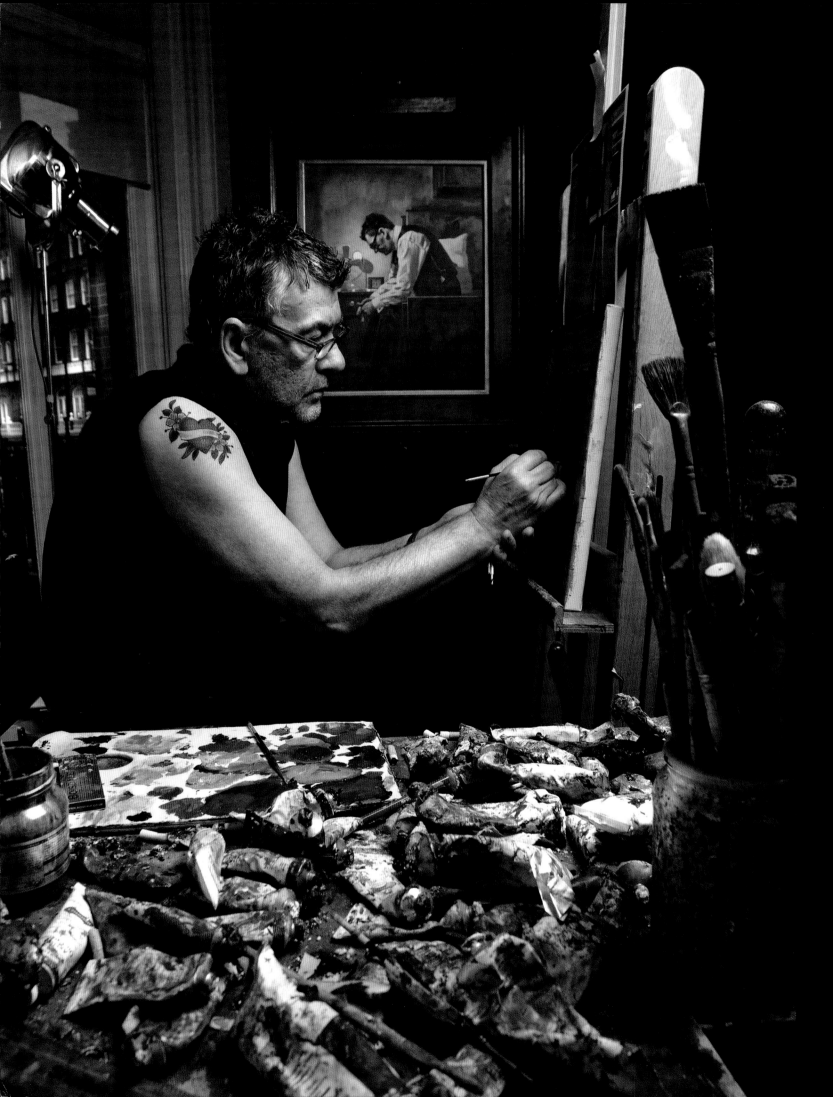

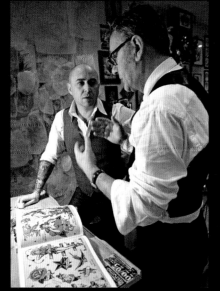
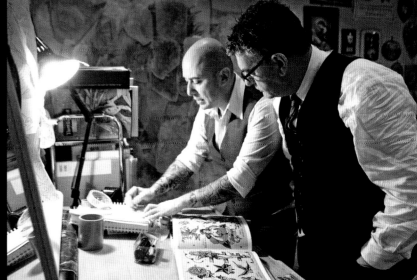
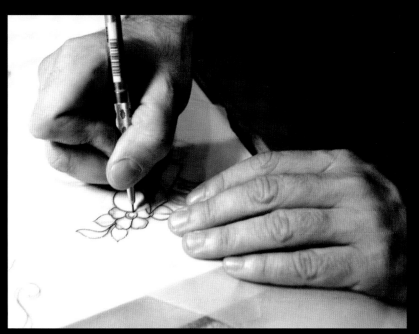
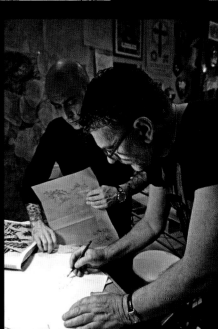

JACK VETTRIANO TATTOOED BY MO COPPOLETTA

Wander into The Family Business and you enter an artist's studio...
It's a melting pot of creativity; sights, sounds, and even smells, all around you,
stimulating your senses. But the moment you surrender to your artist, the experience
becomes oddly private, calm and intimate, between just the two of you.

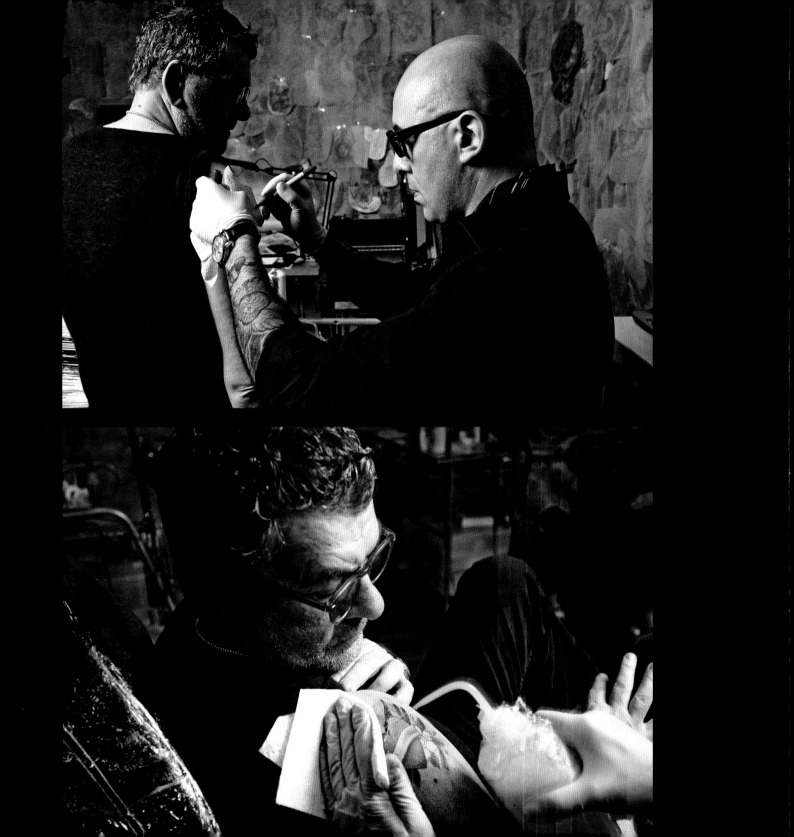

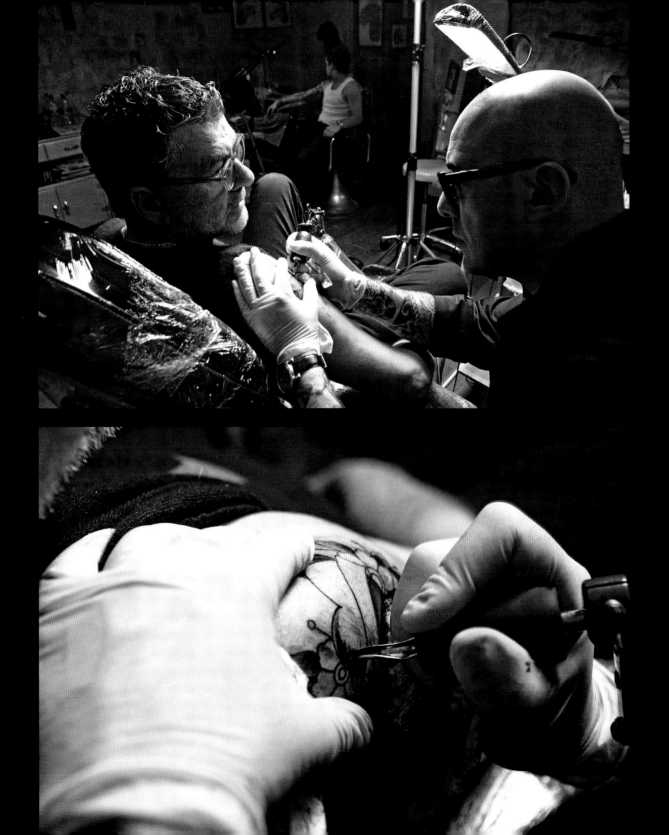

THE WORK

· FINIS CORONAT OPVS ·

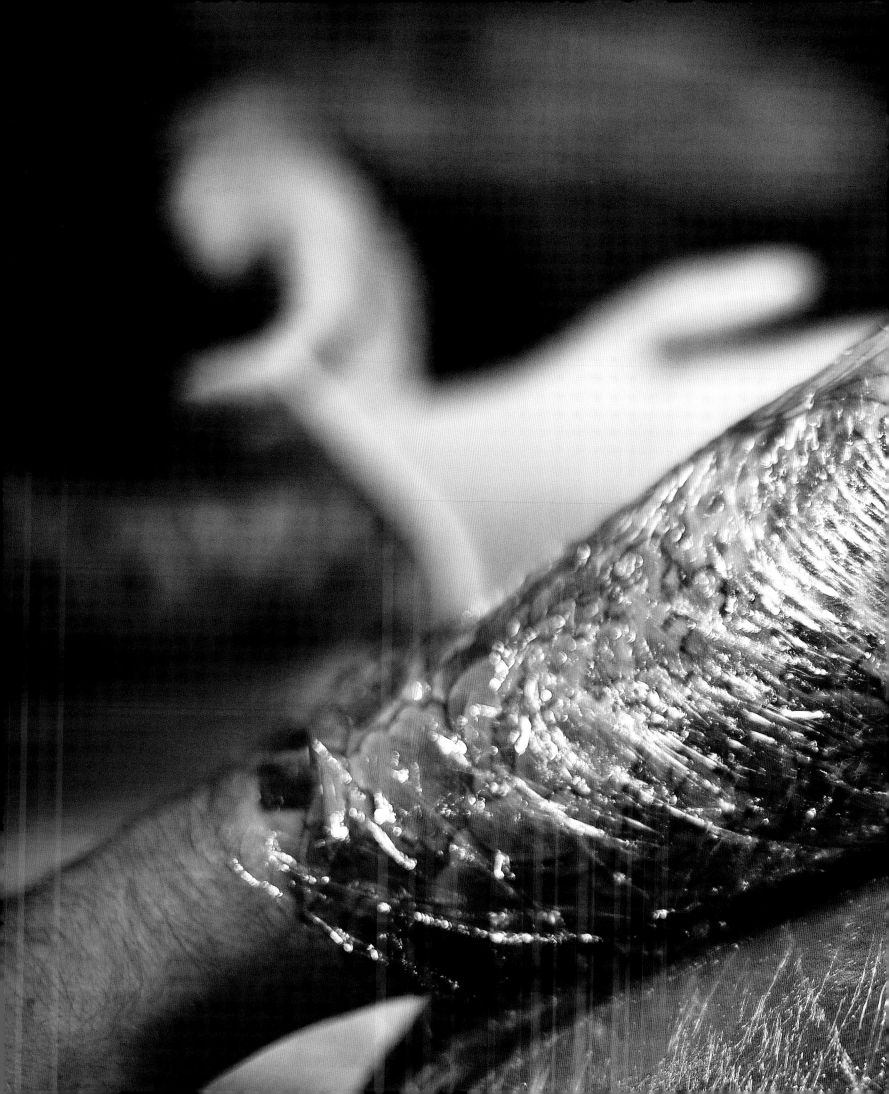

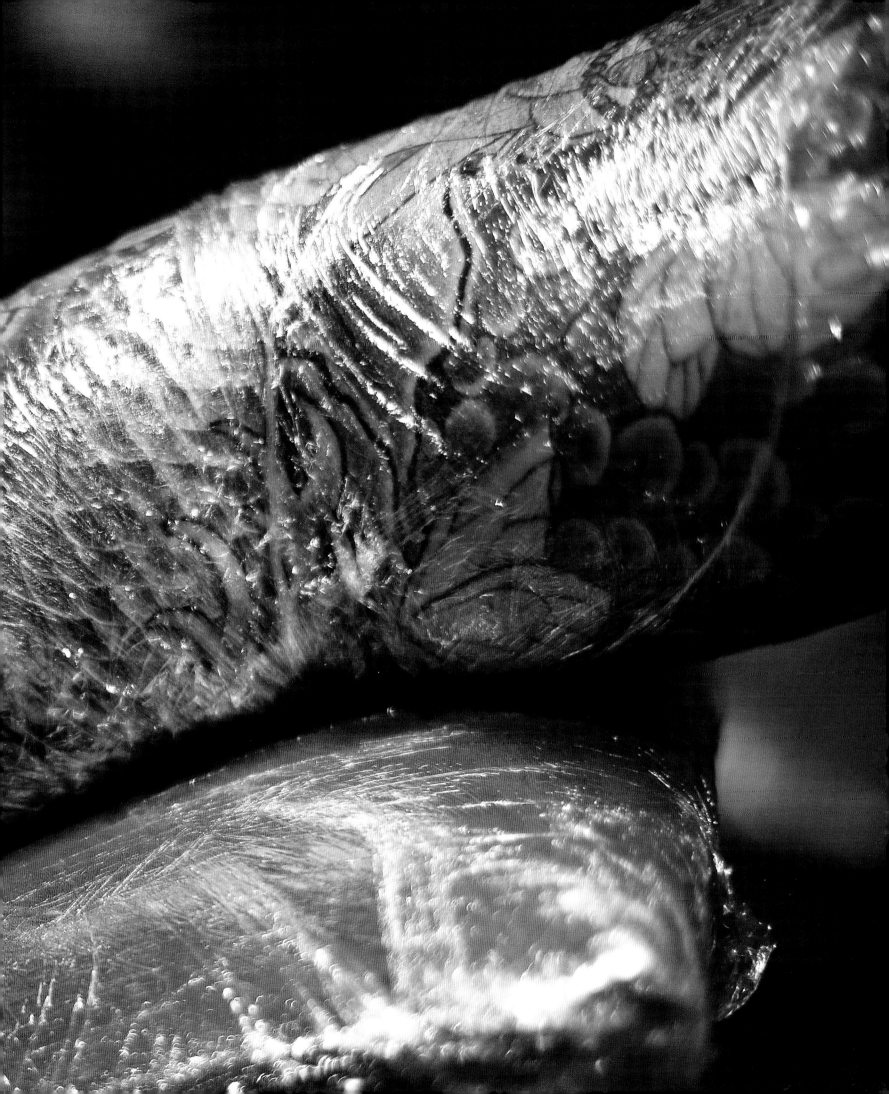

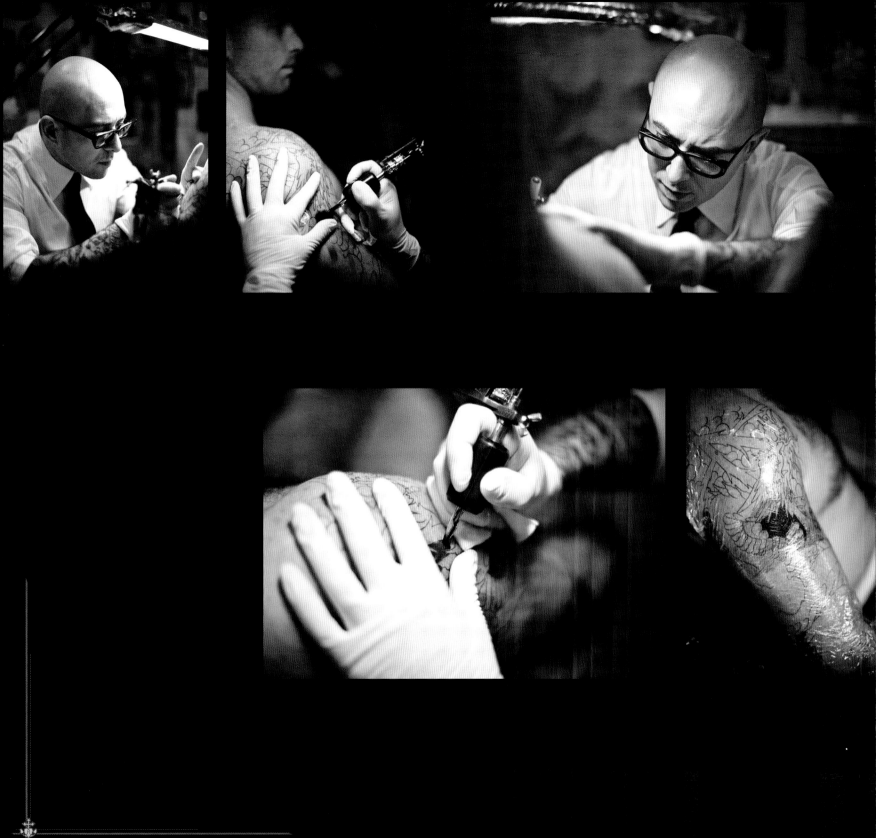

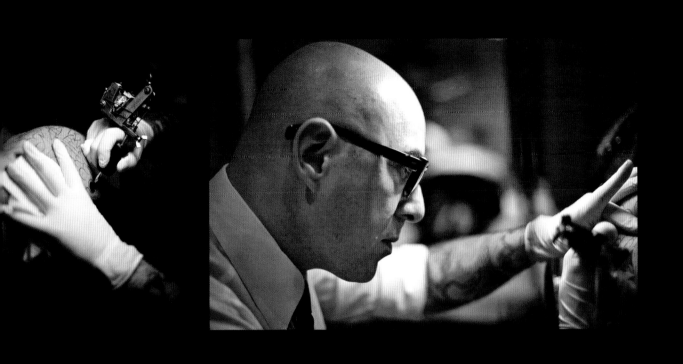
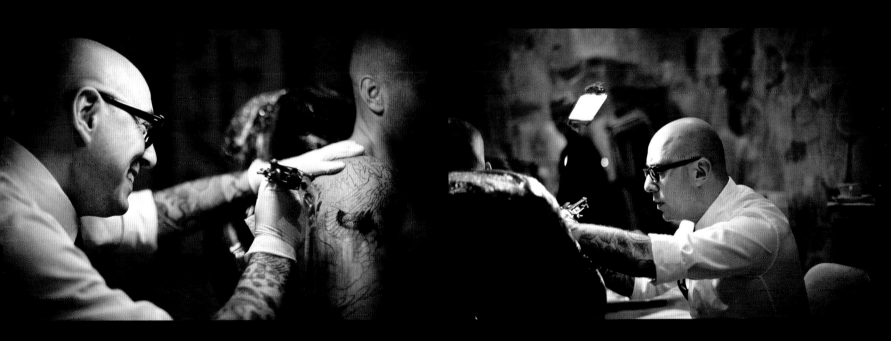

JAMES TATTOOED BY MO COPPOLETTA

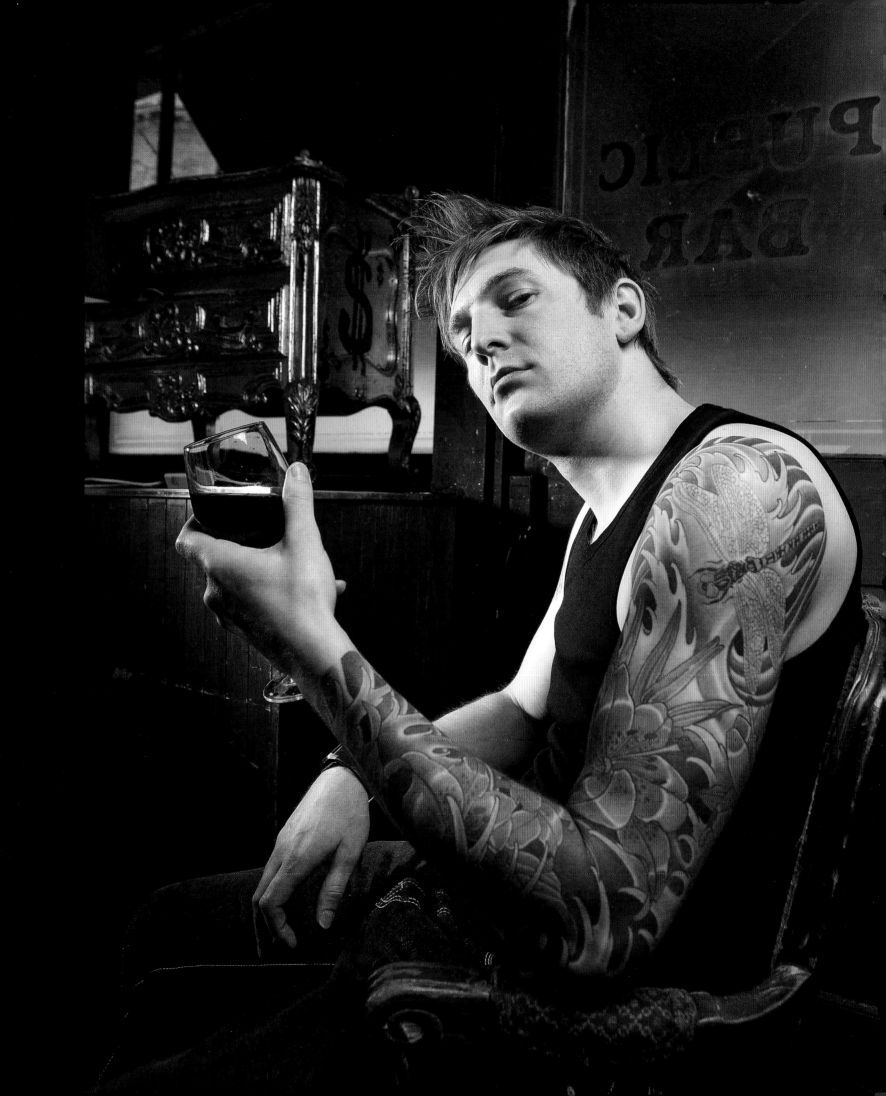

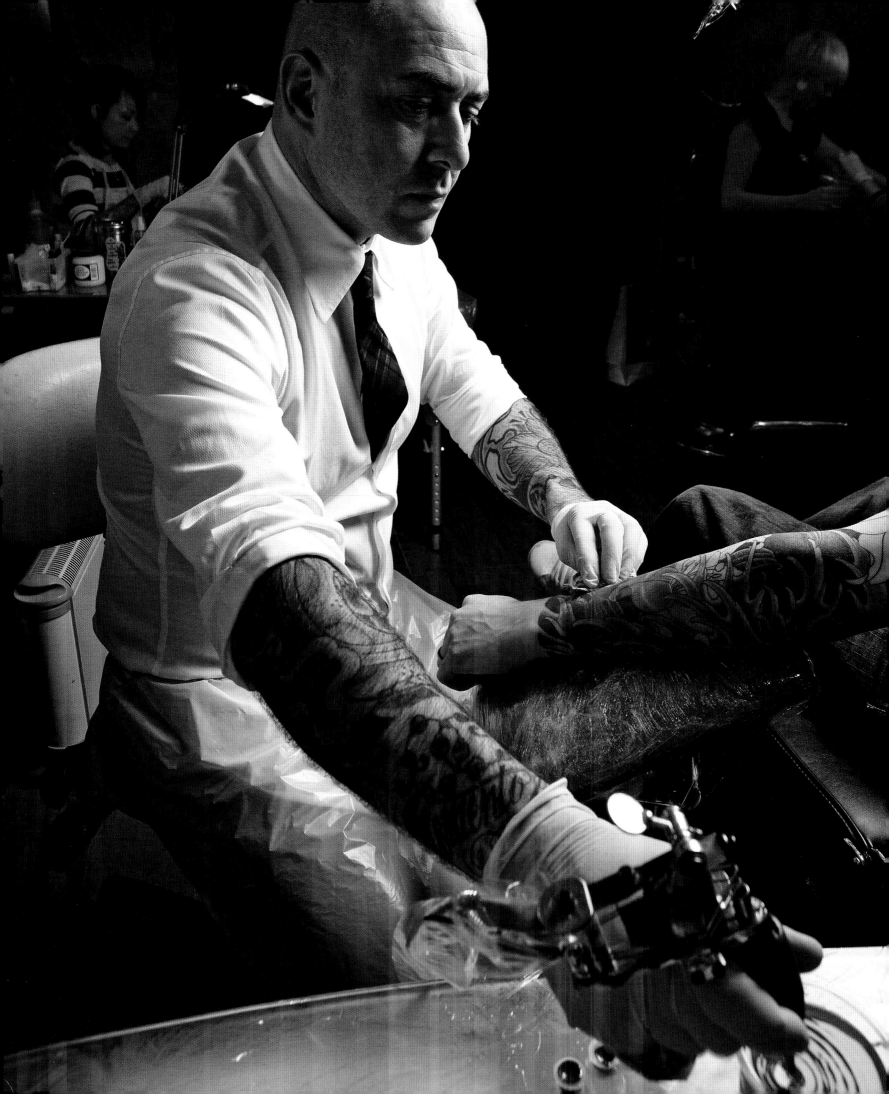

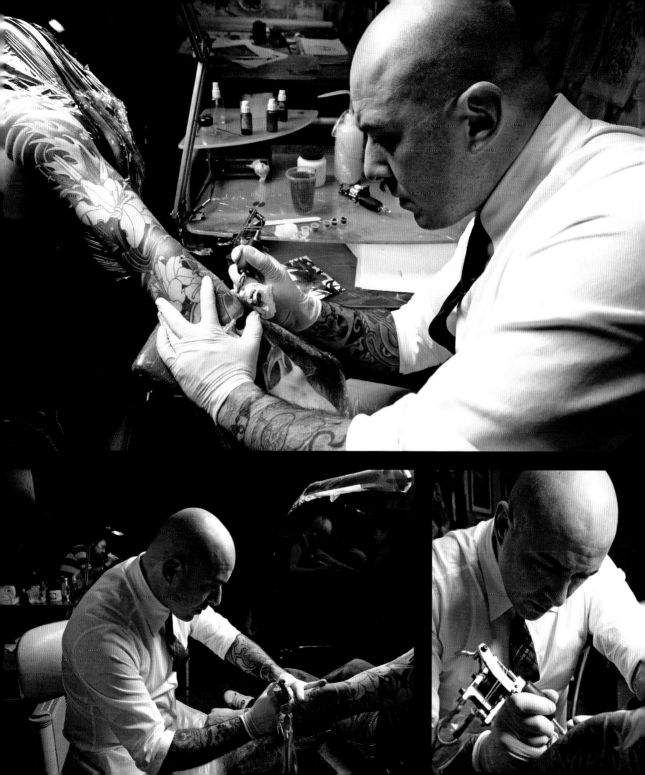

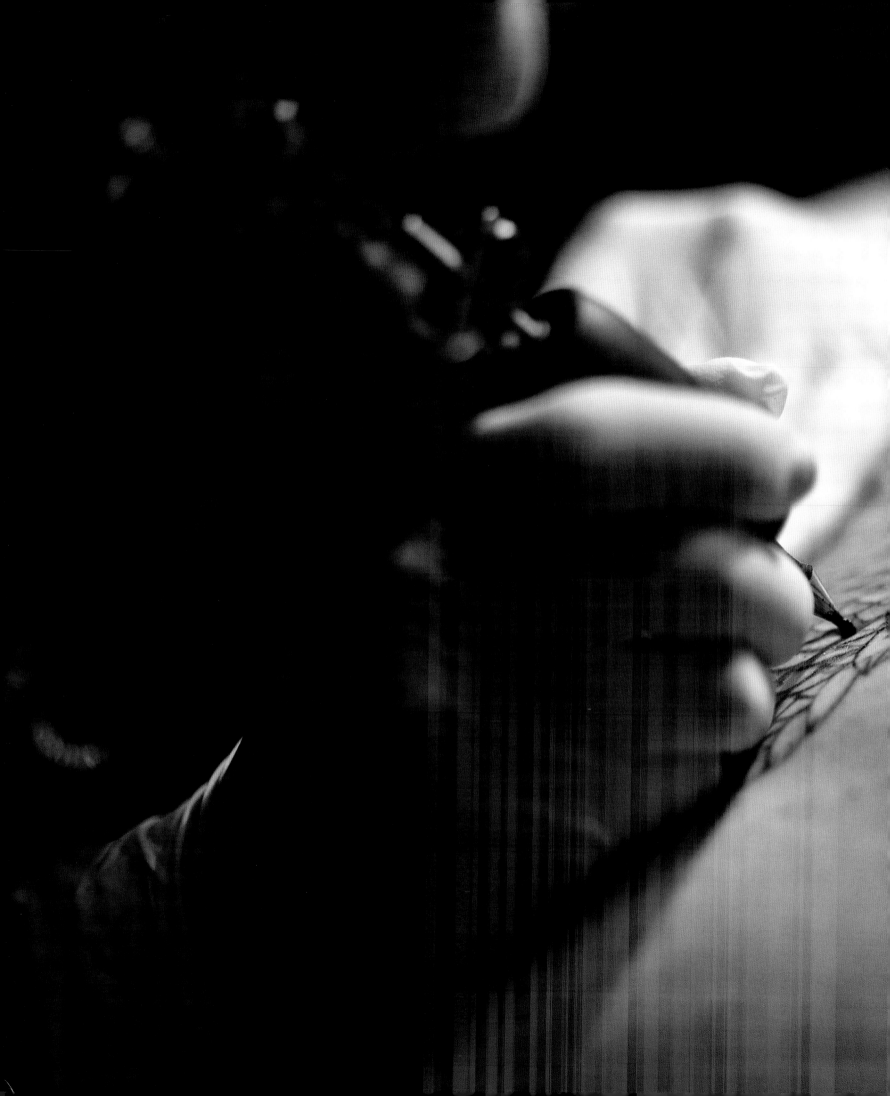

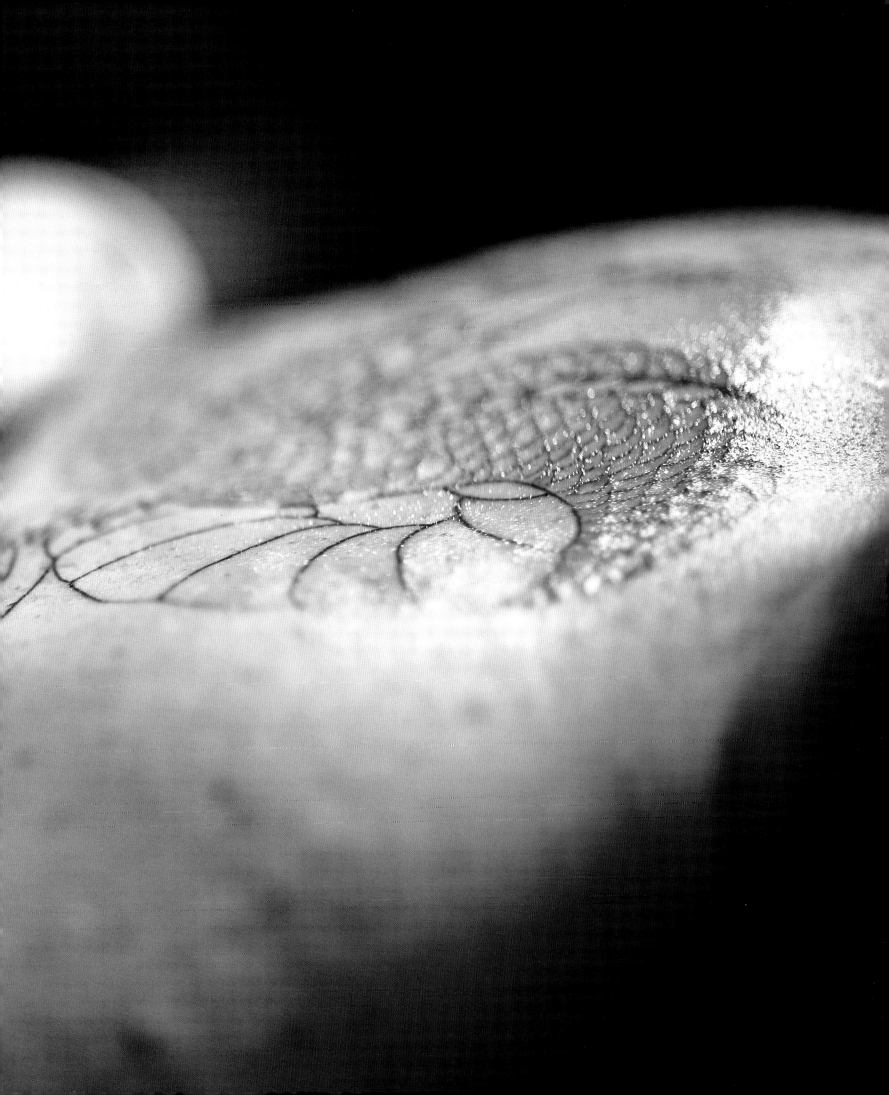

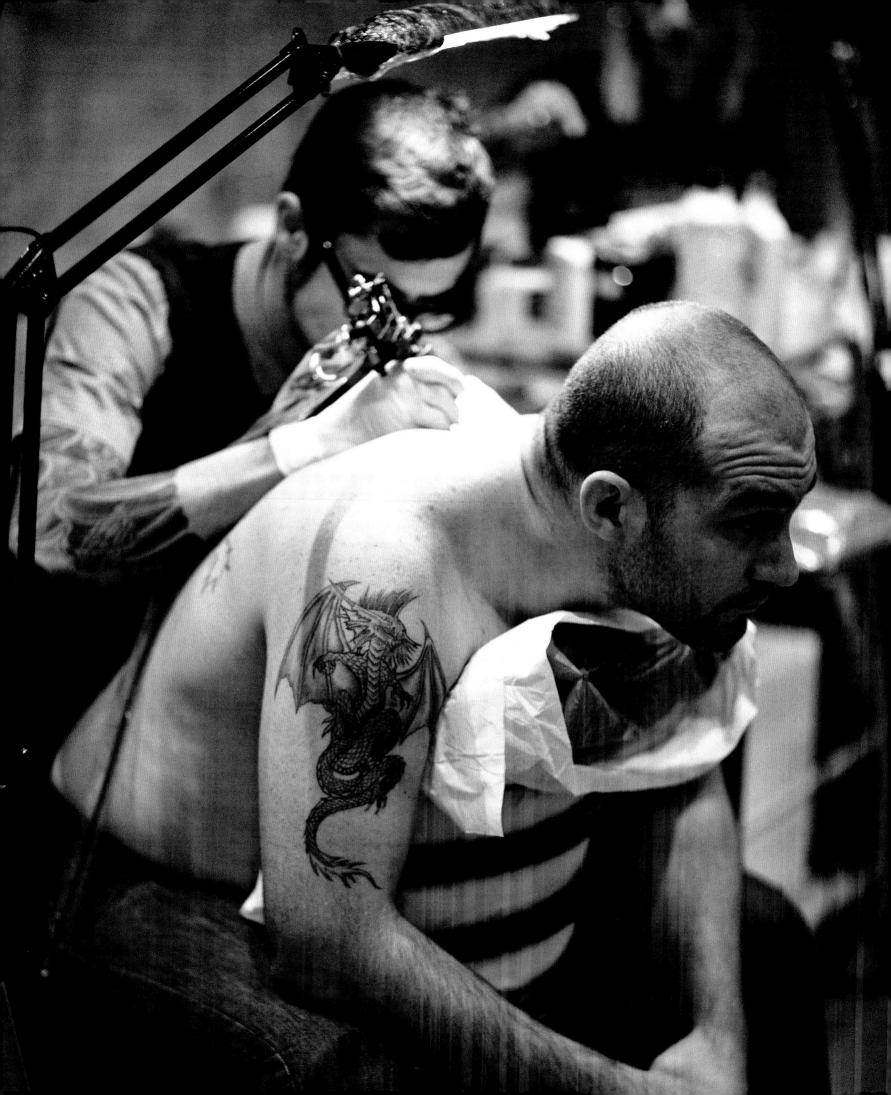

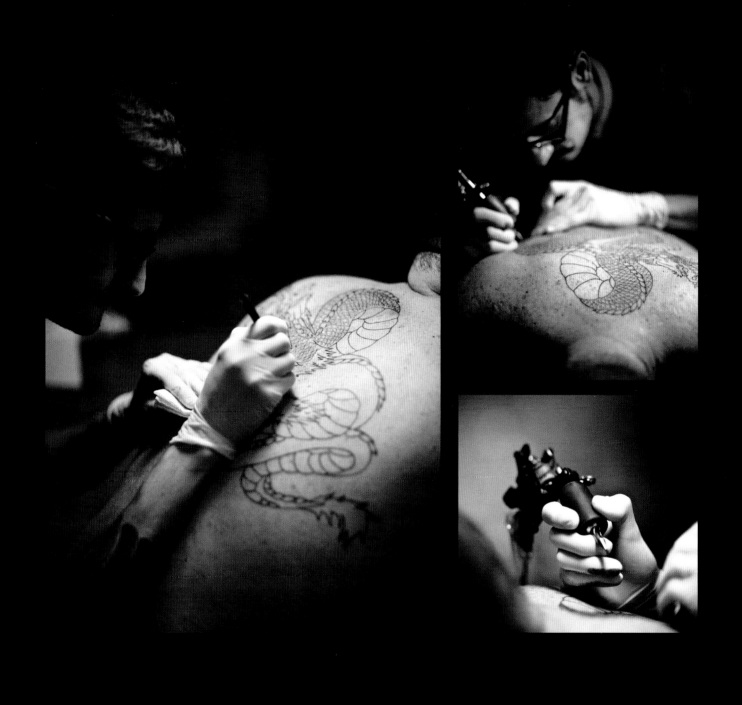

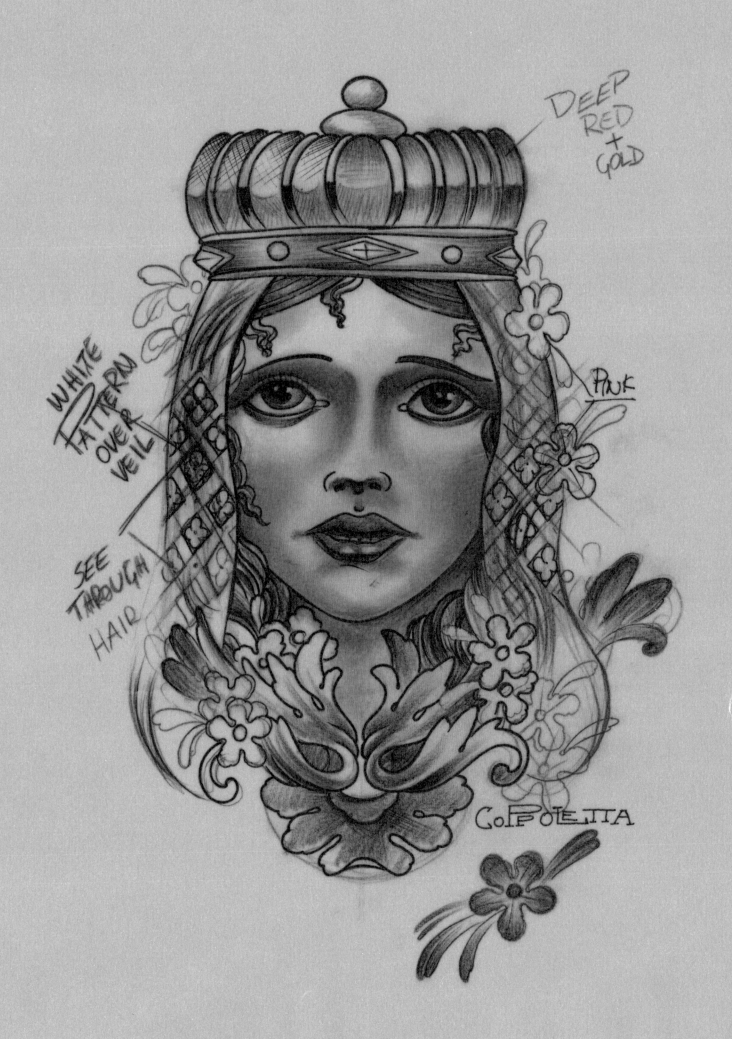

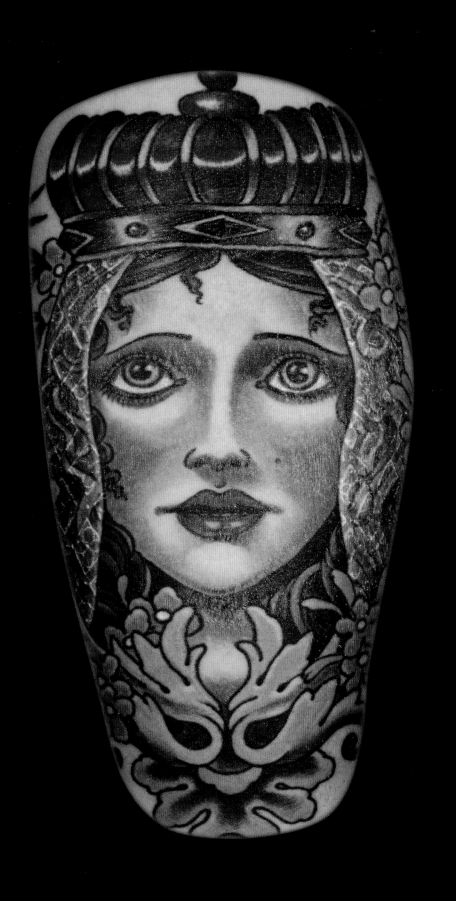

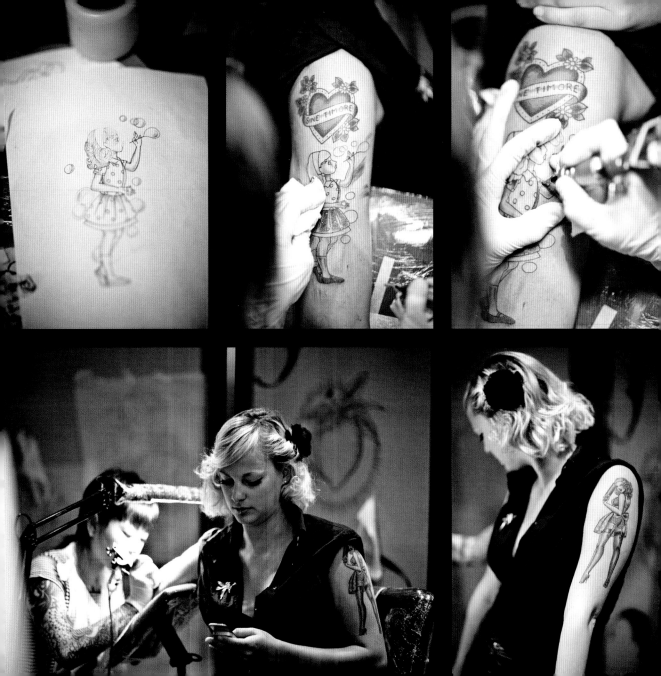

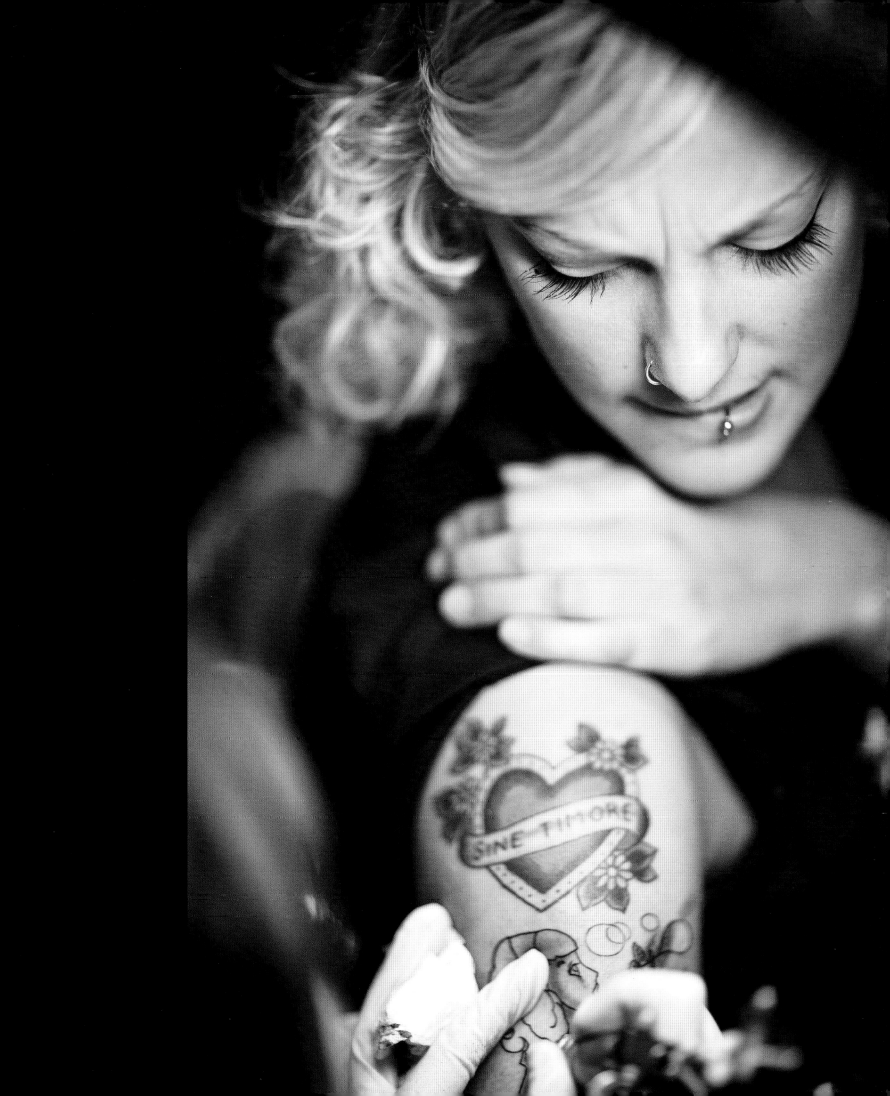

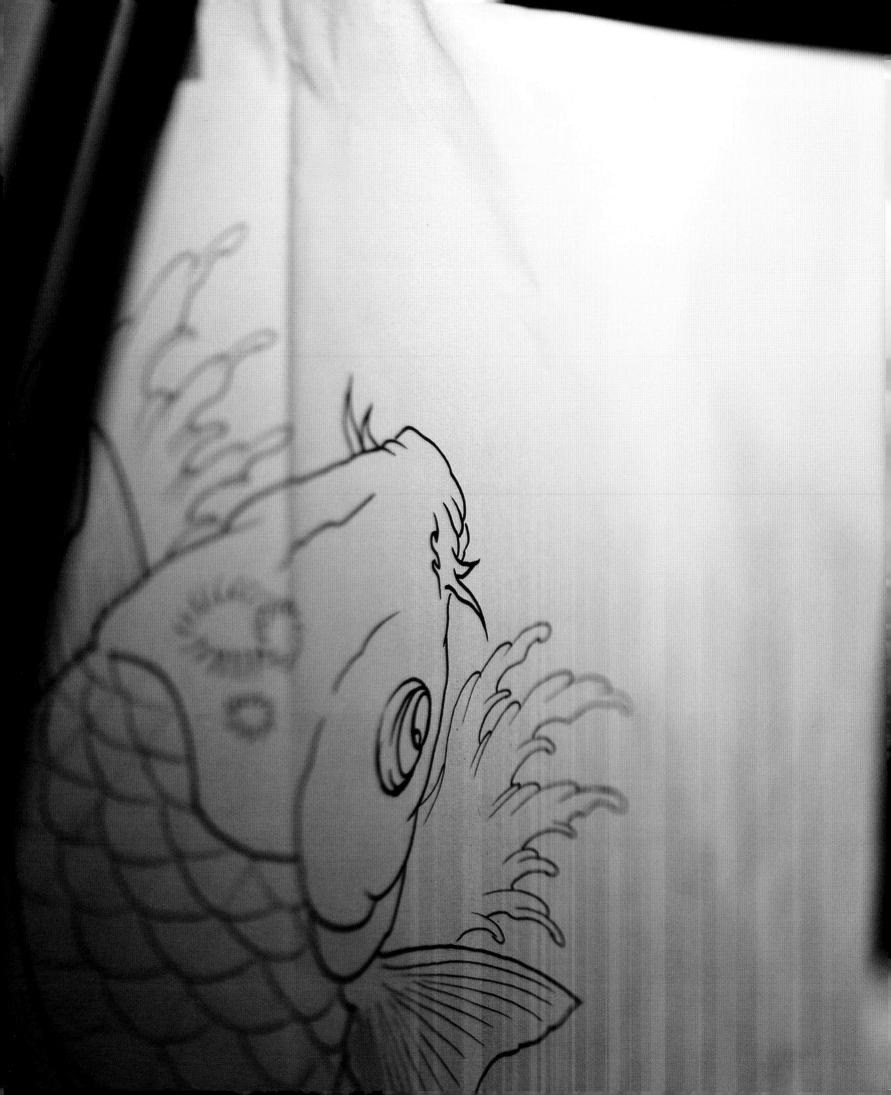

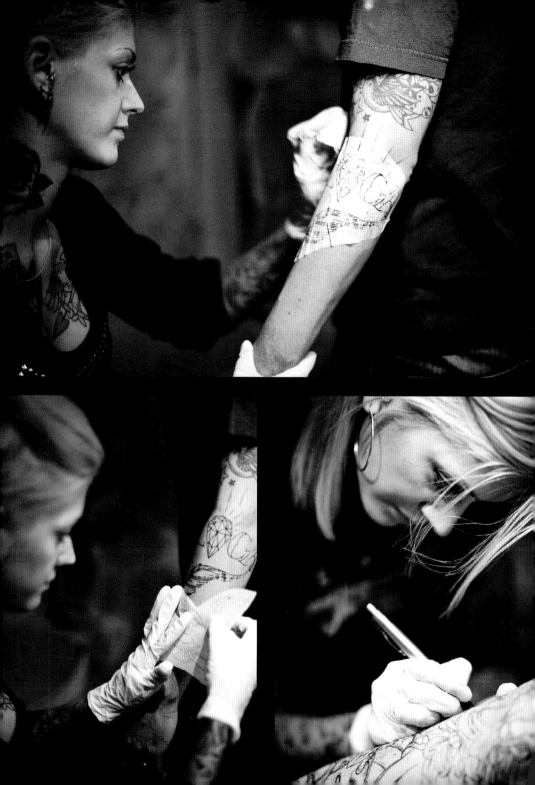

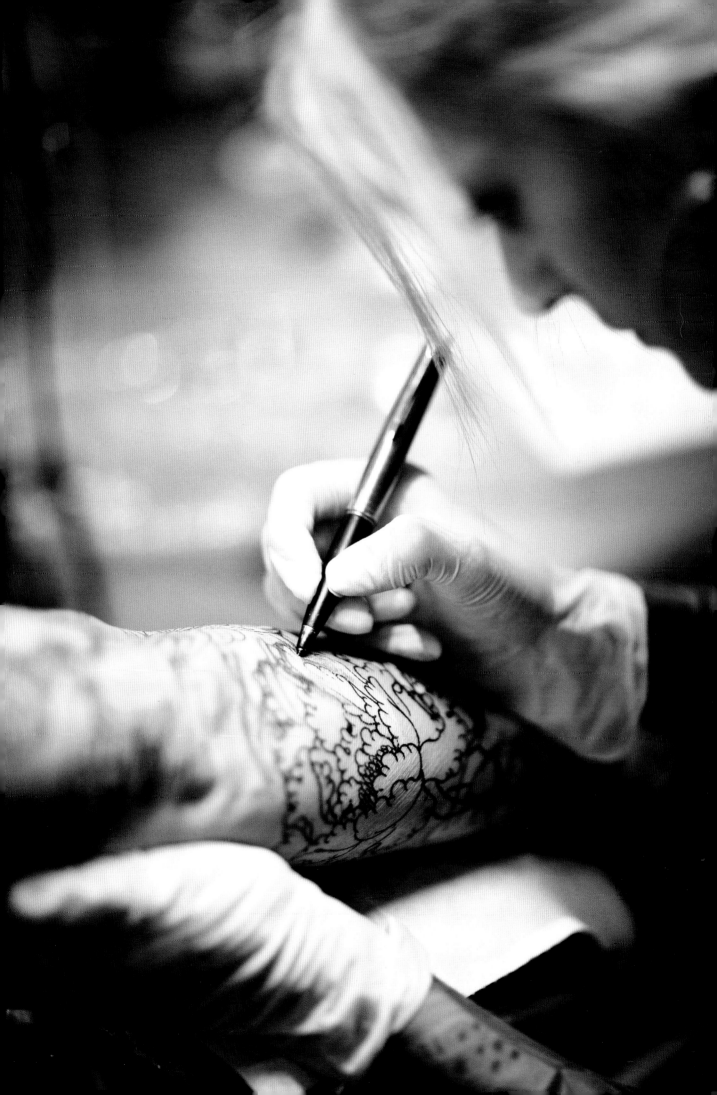

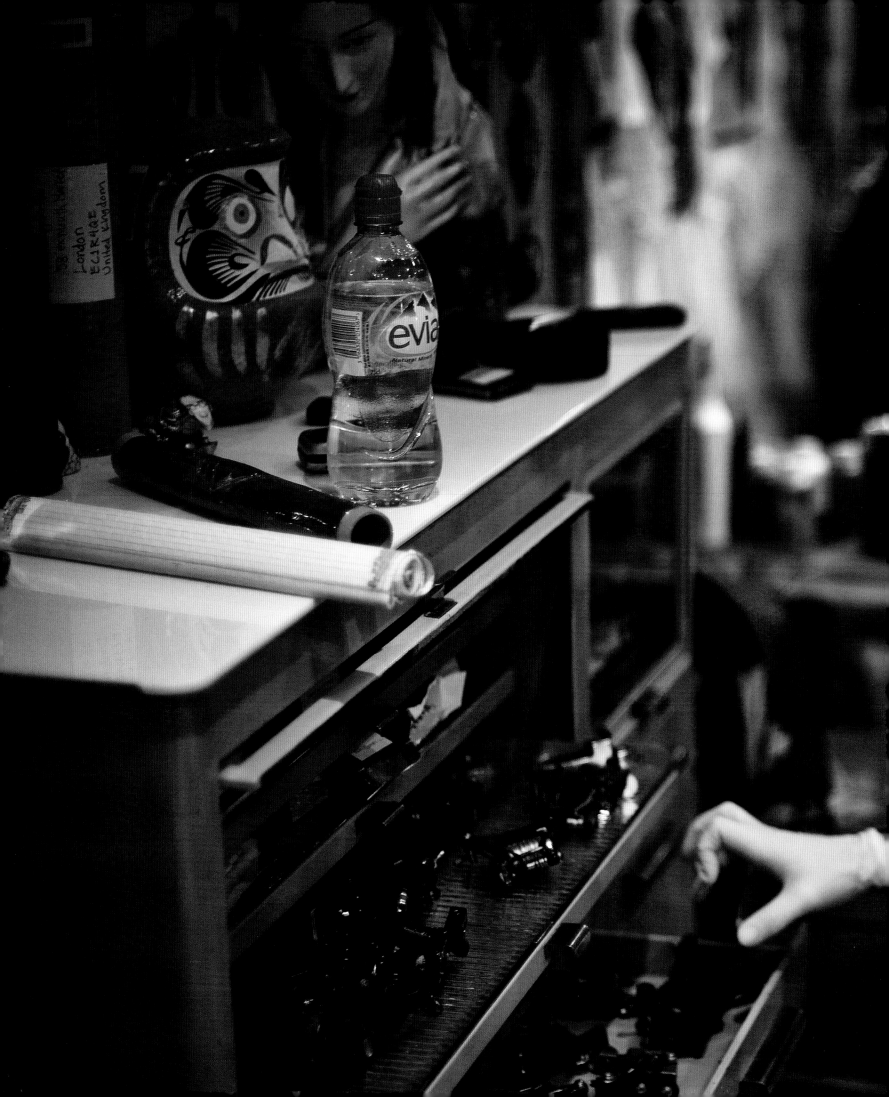

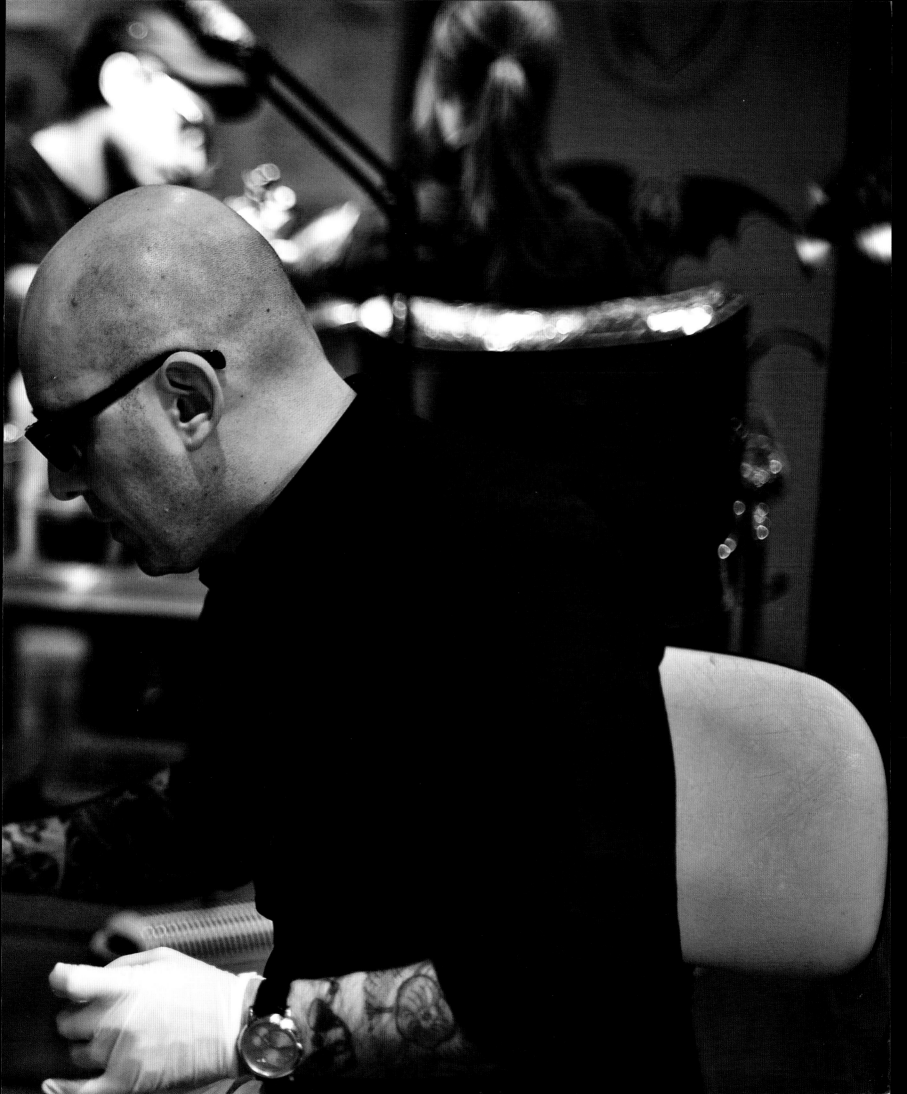

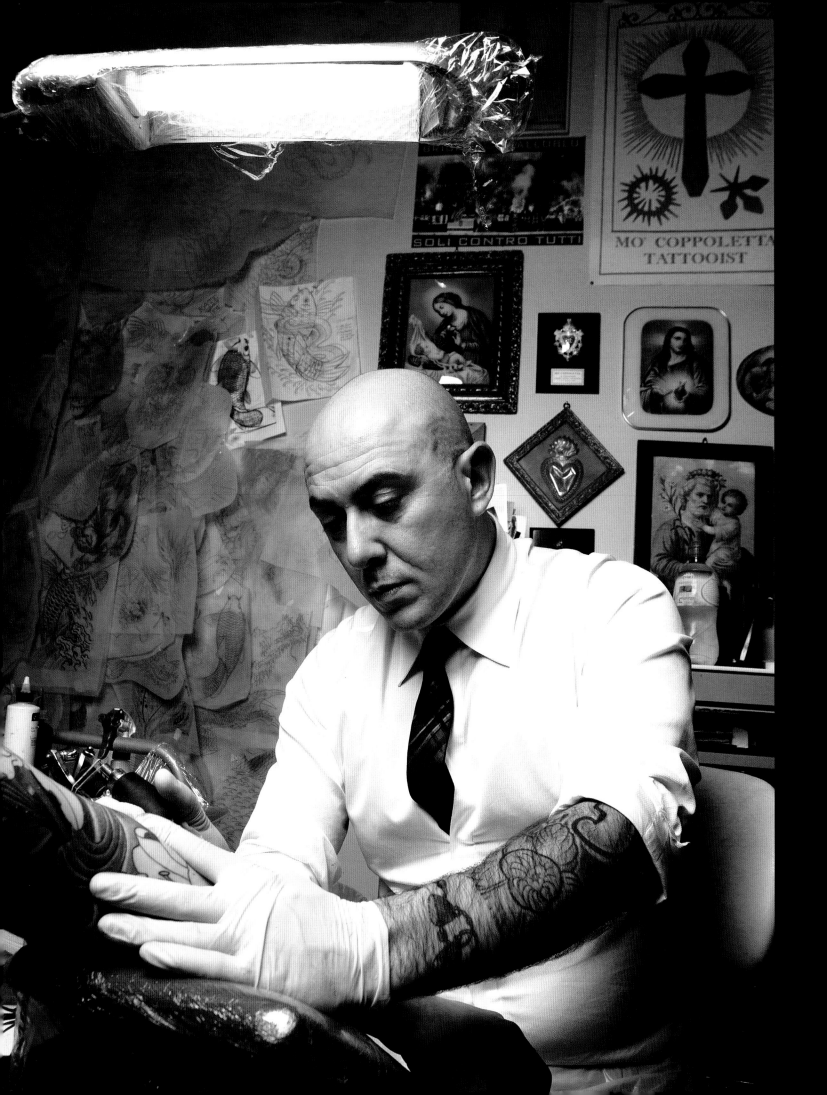

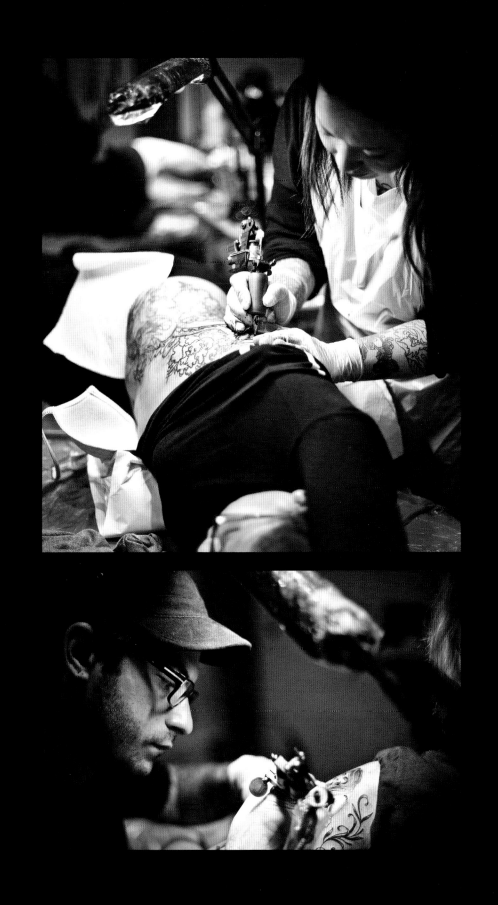

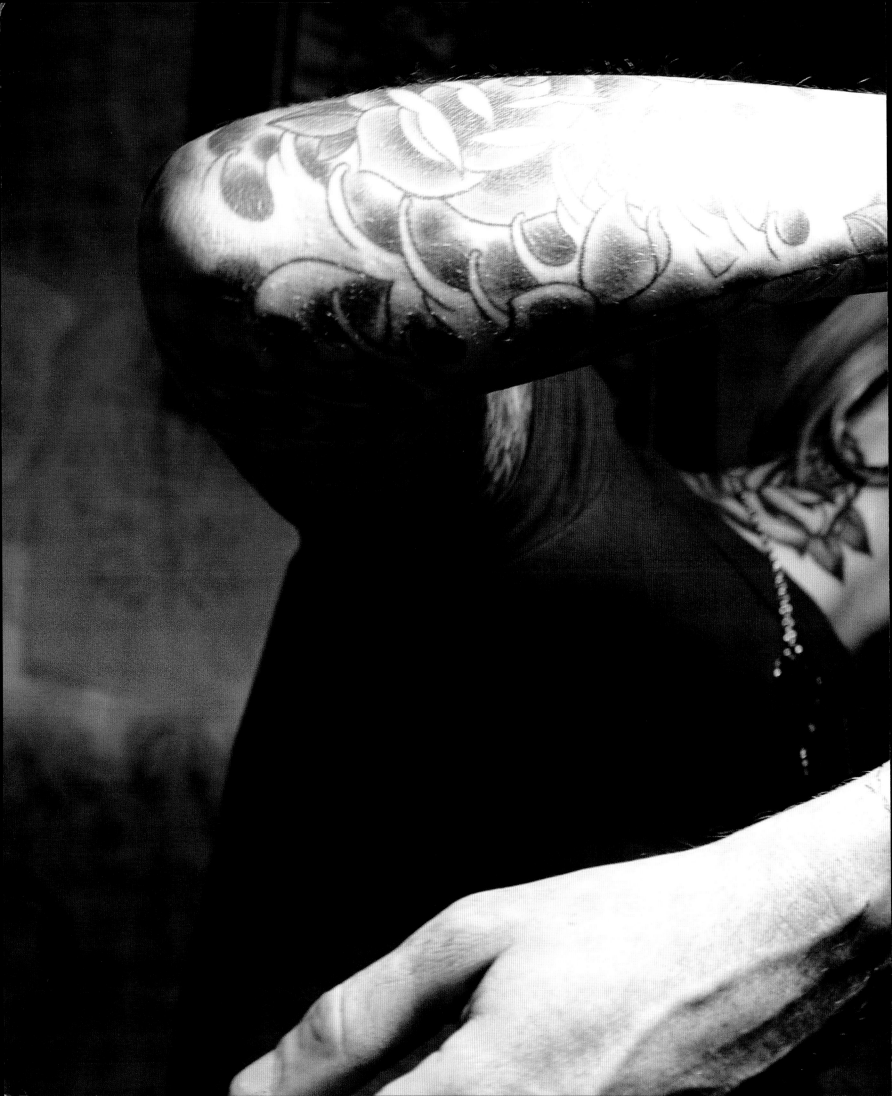

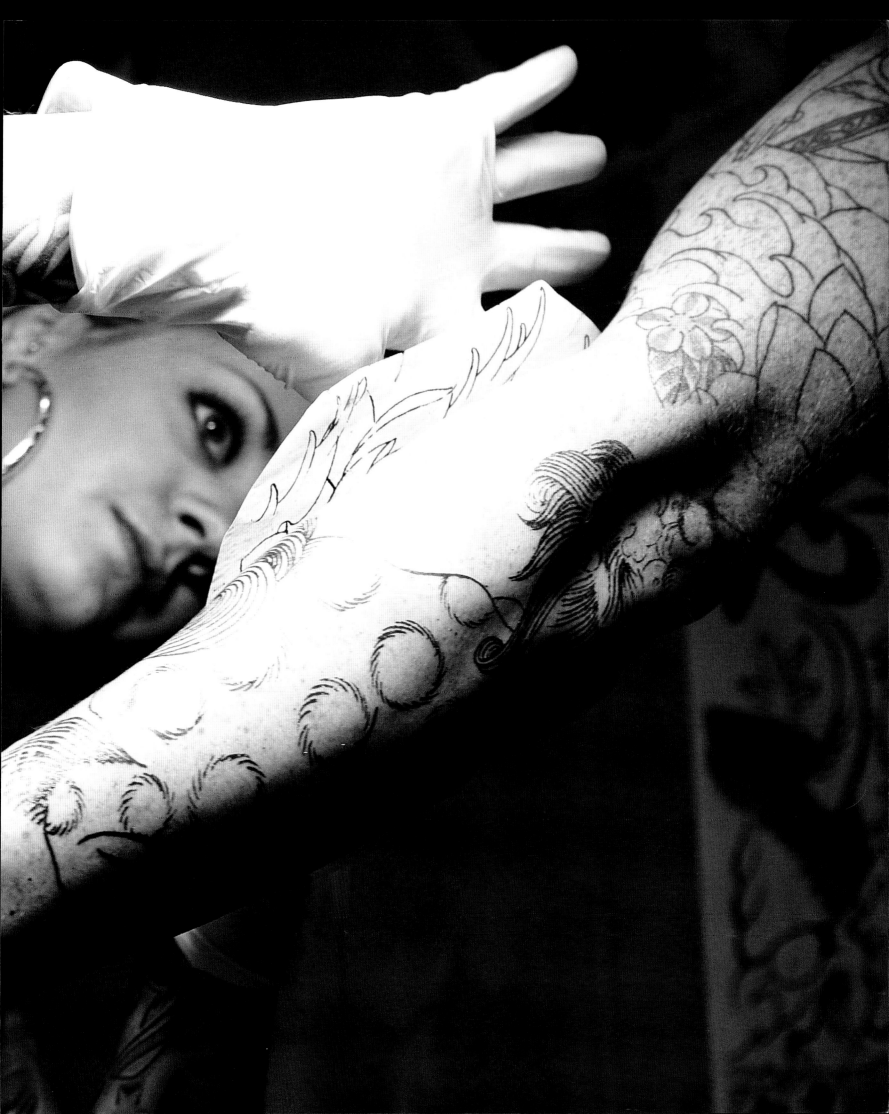

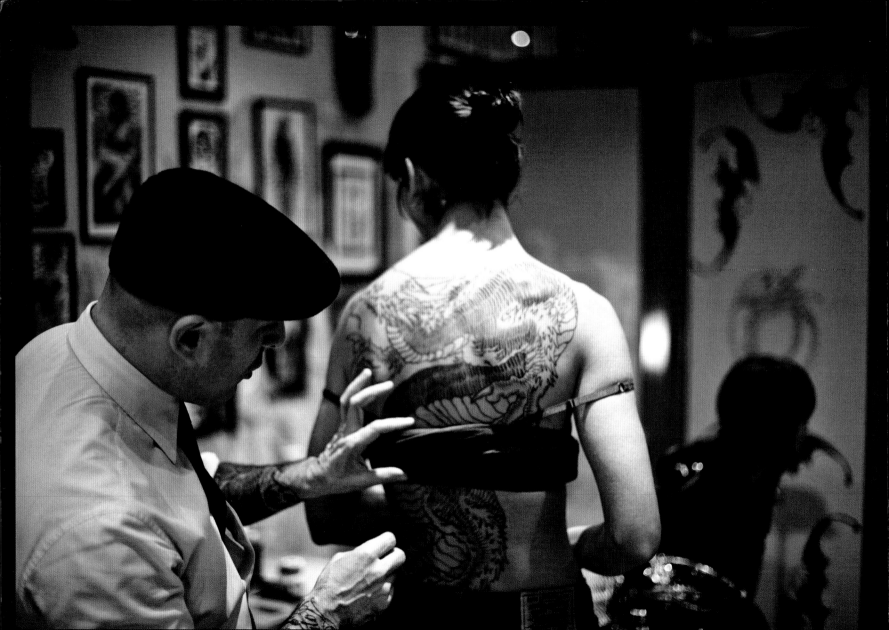

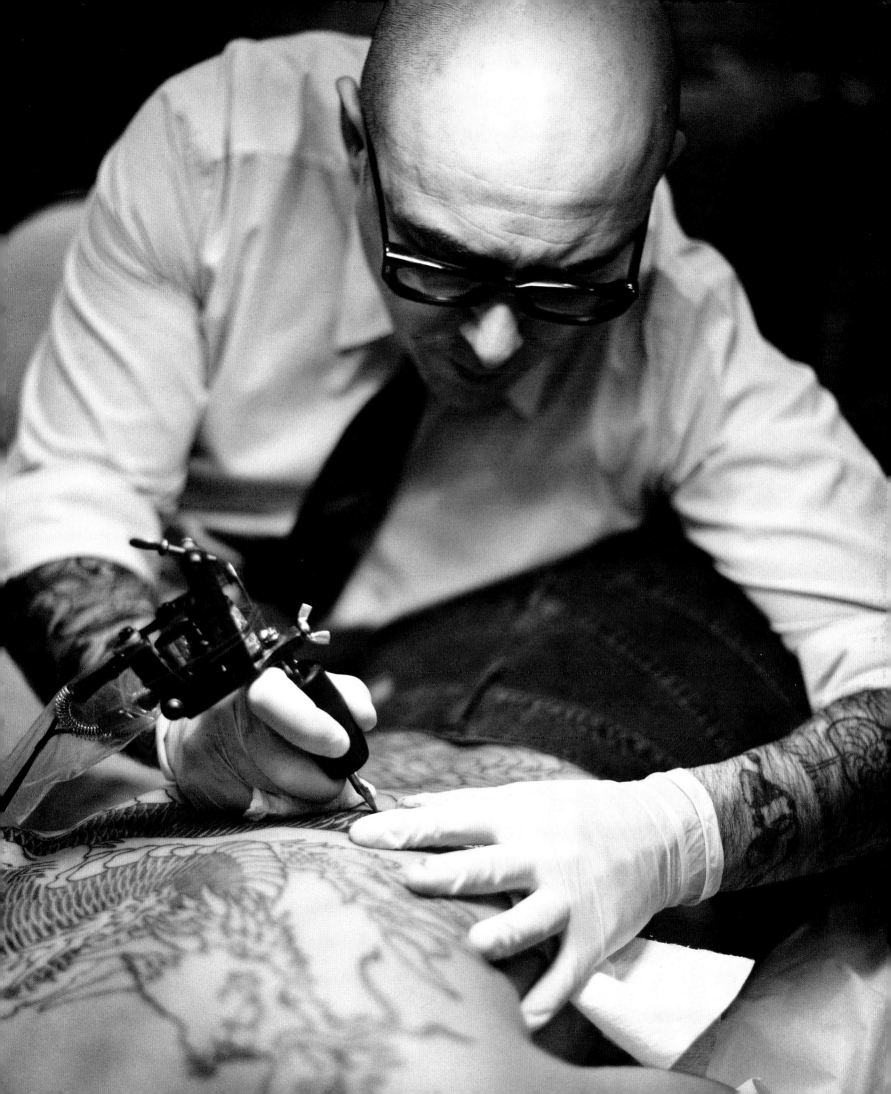

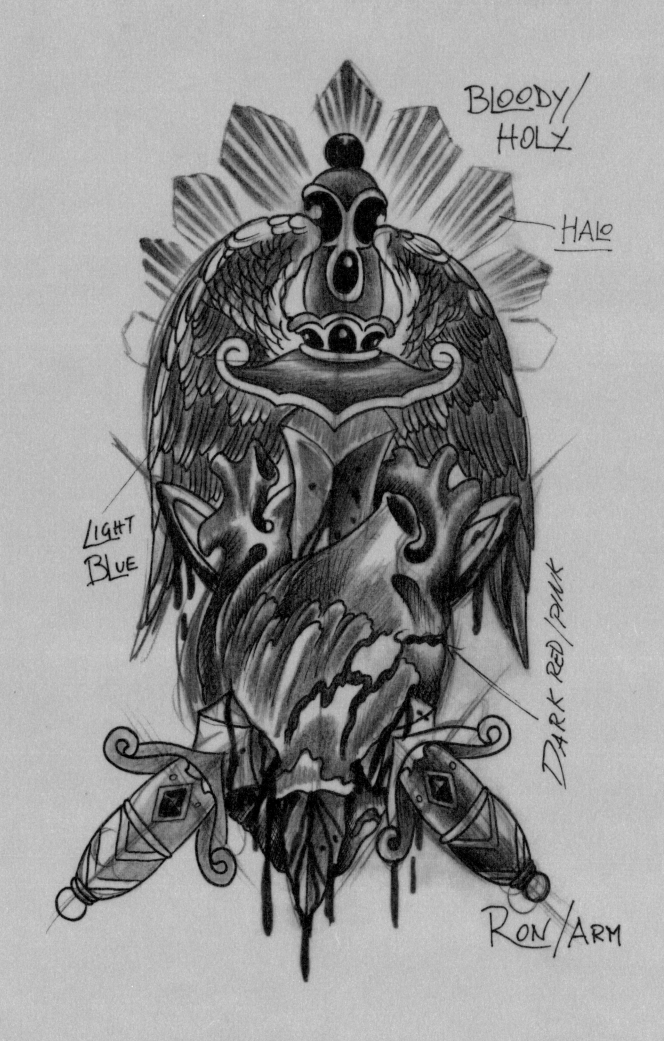

BLOODY/
HOLY

HALO

LIGHT
BLUE

DARK RED/PINK

RON/ARM

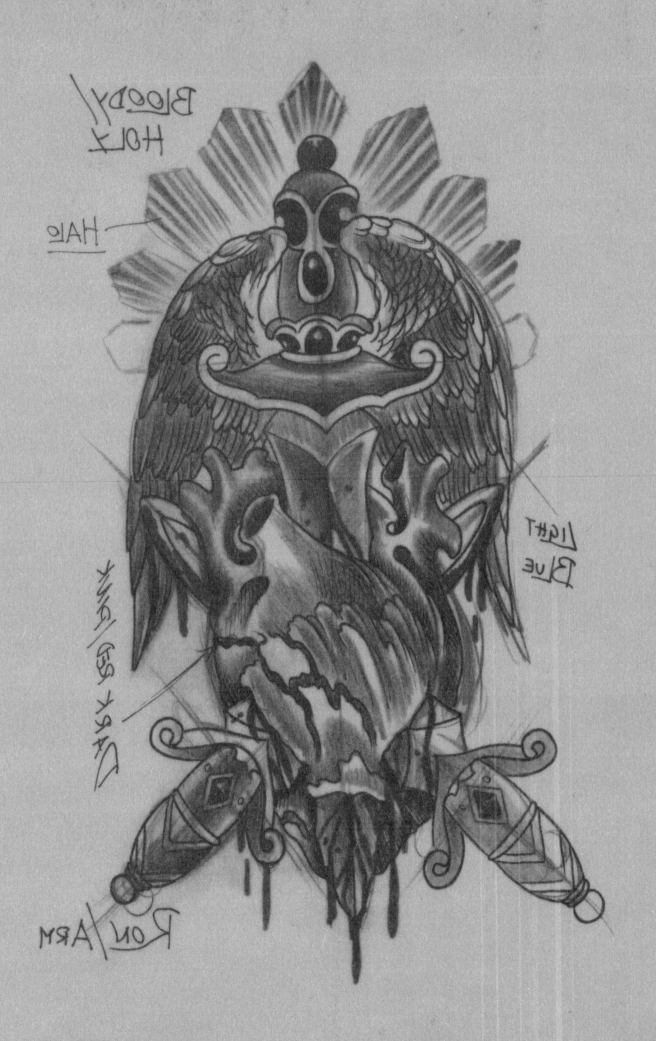

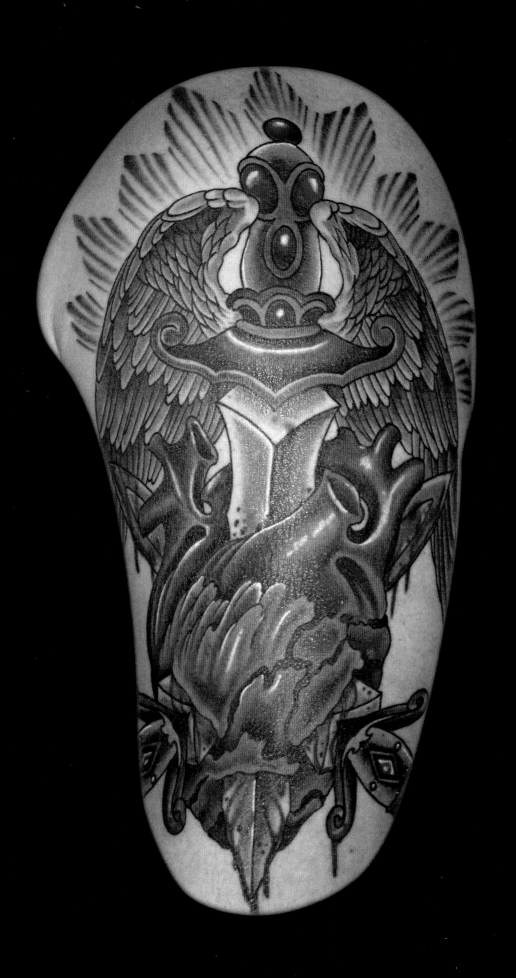

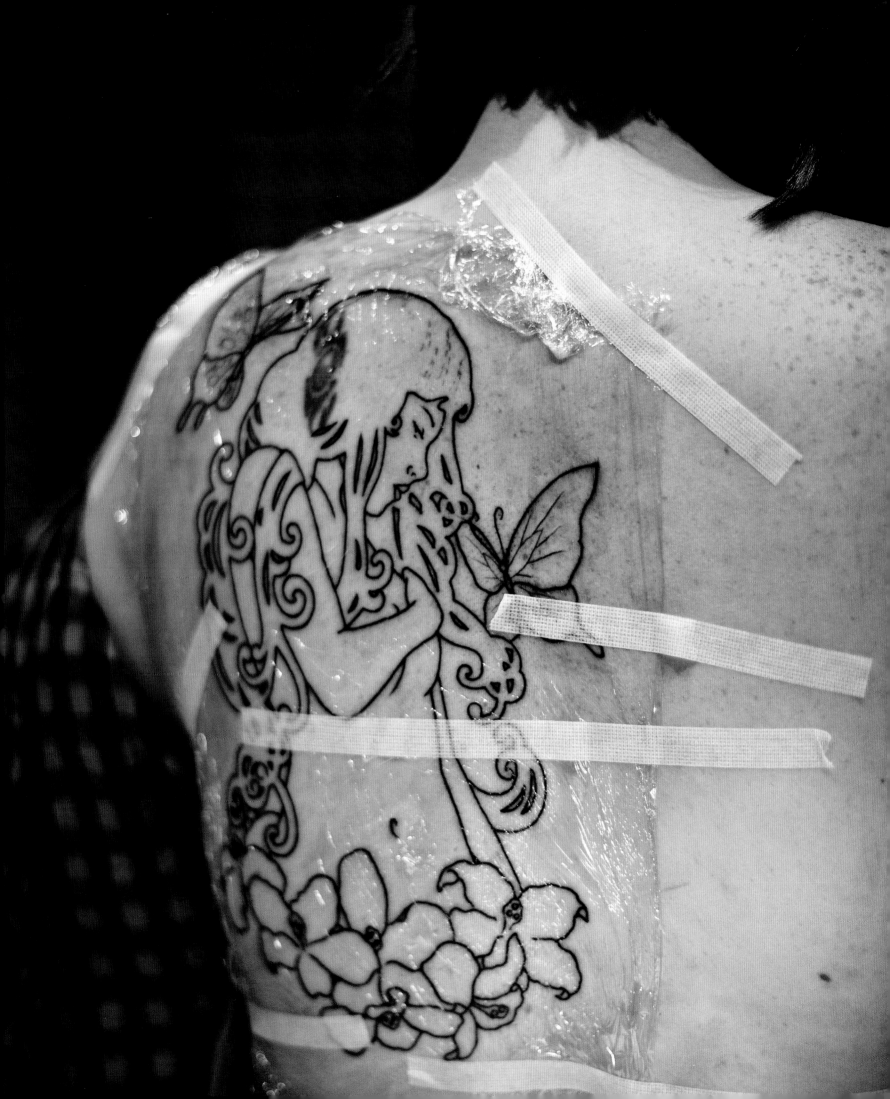

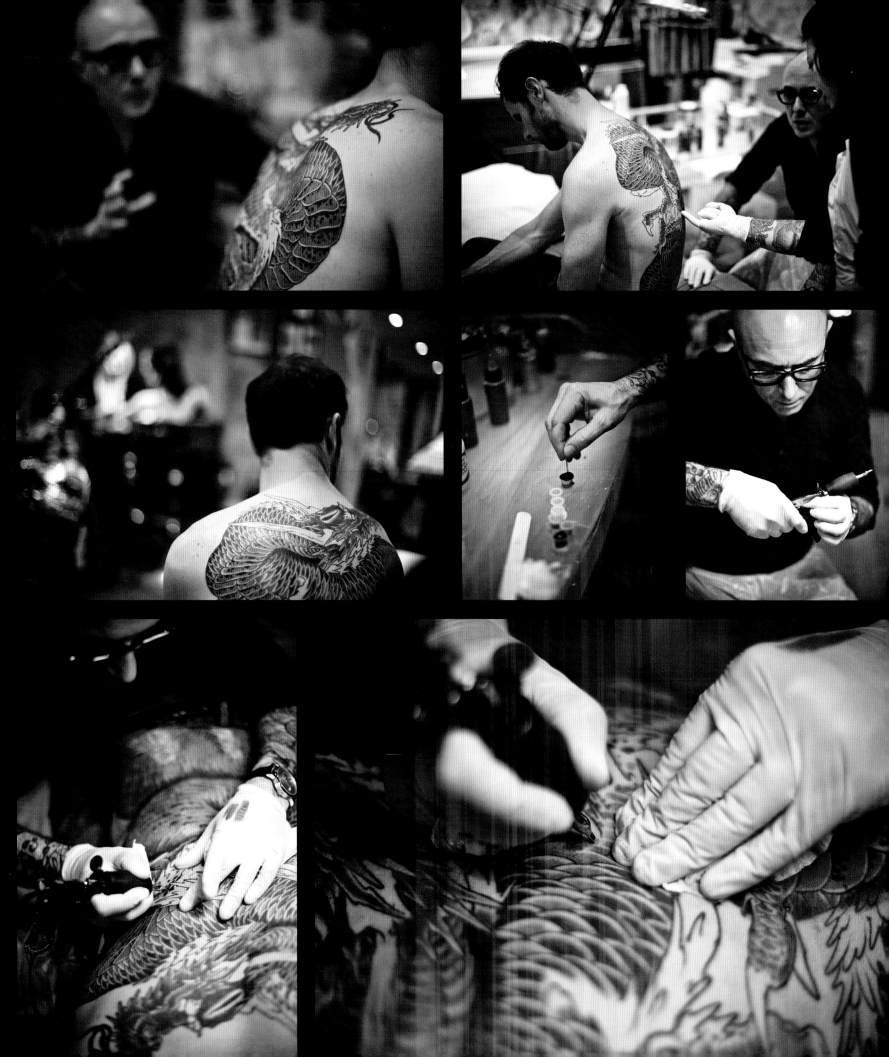

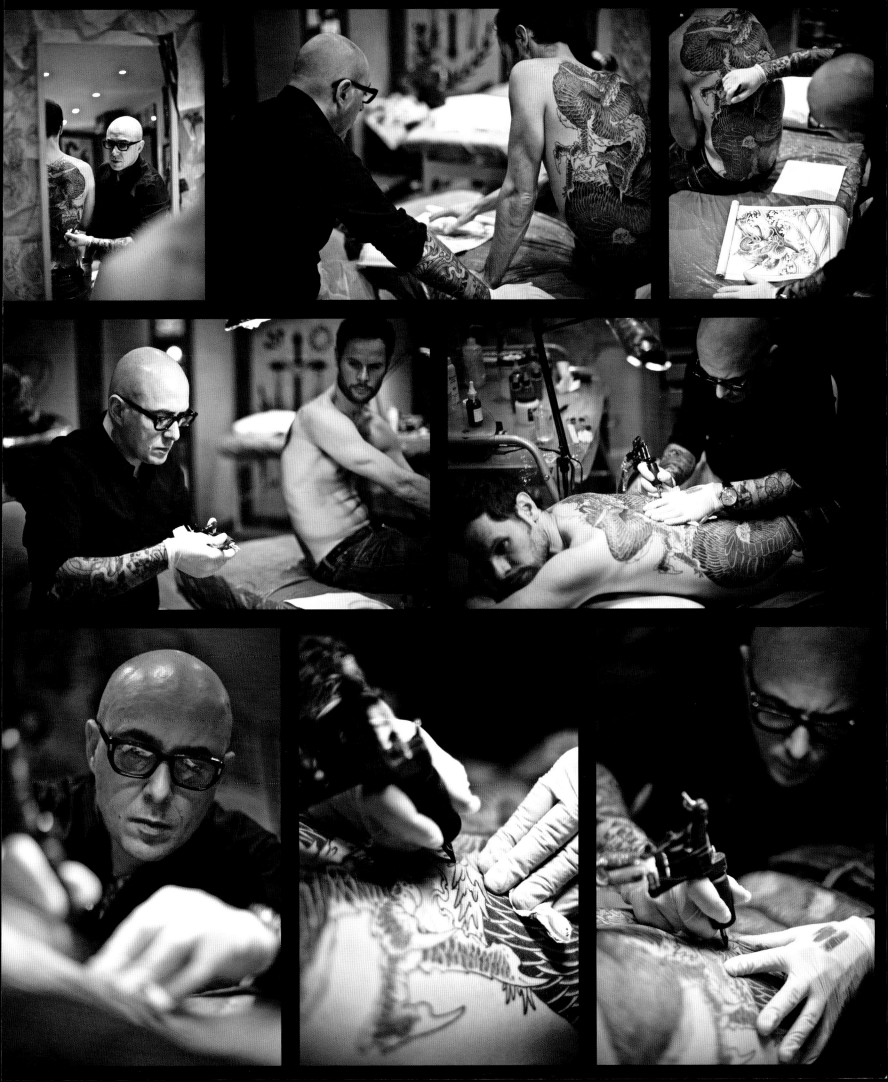

THE PATRONS

· VANITAS, VANITATUM ET OMNIA VANITAS ·

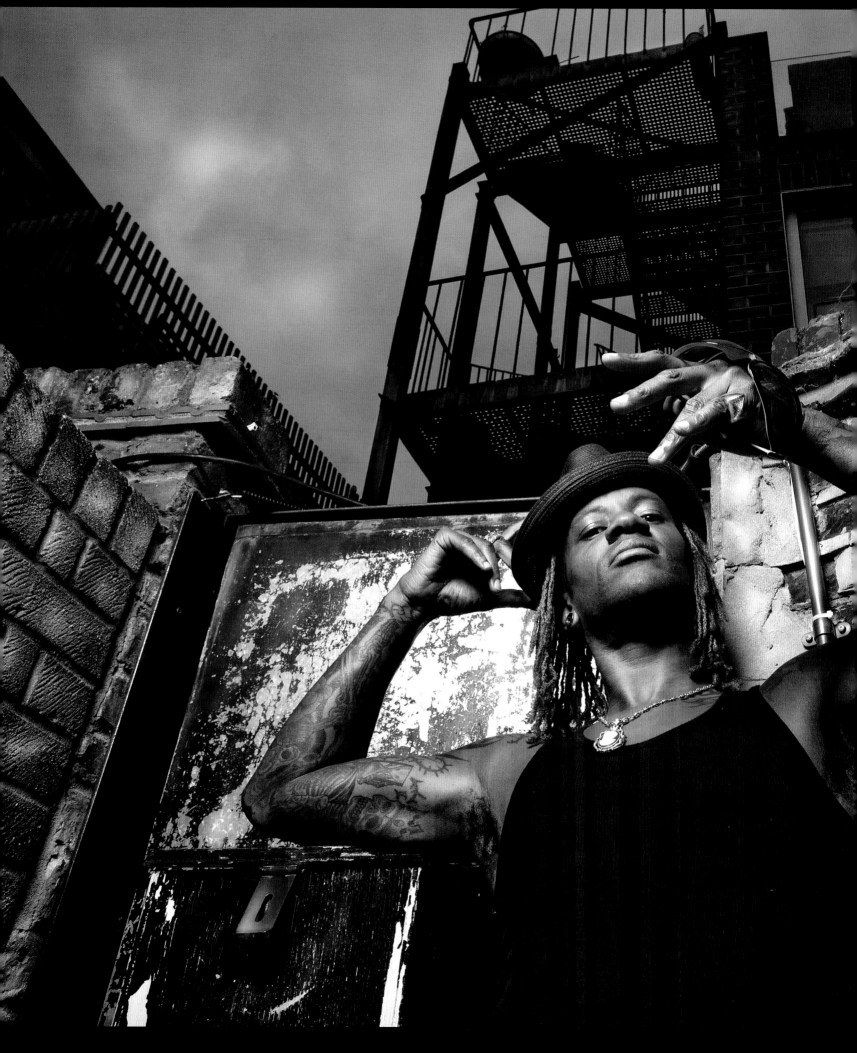

MAXIM TATTOOED BY MO COPPOLETTA

You get addicted, that's the only way I can describe it.
People sometimes say that you forget about the pain,
but you never really do. You remember, but for
some reason you always want more.

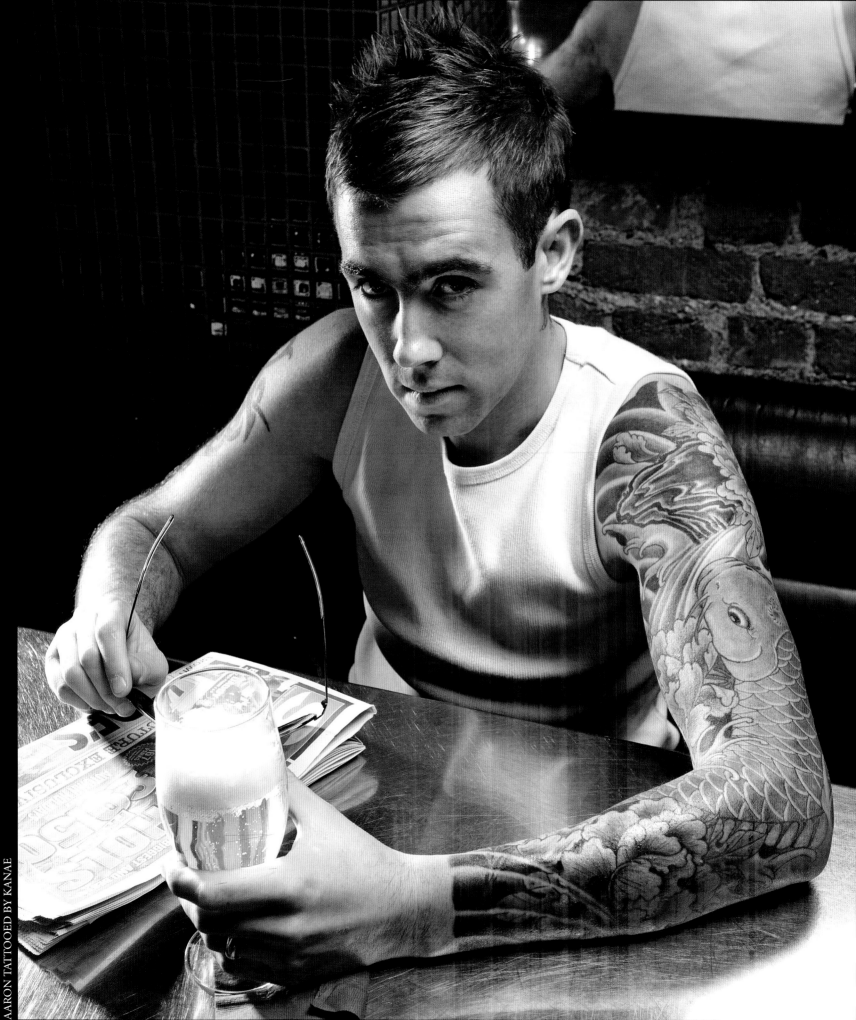

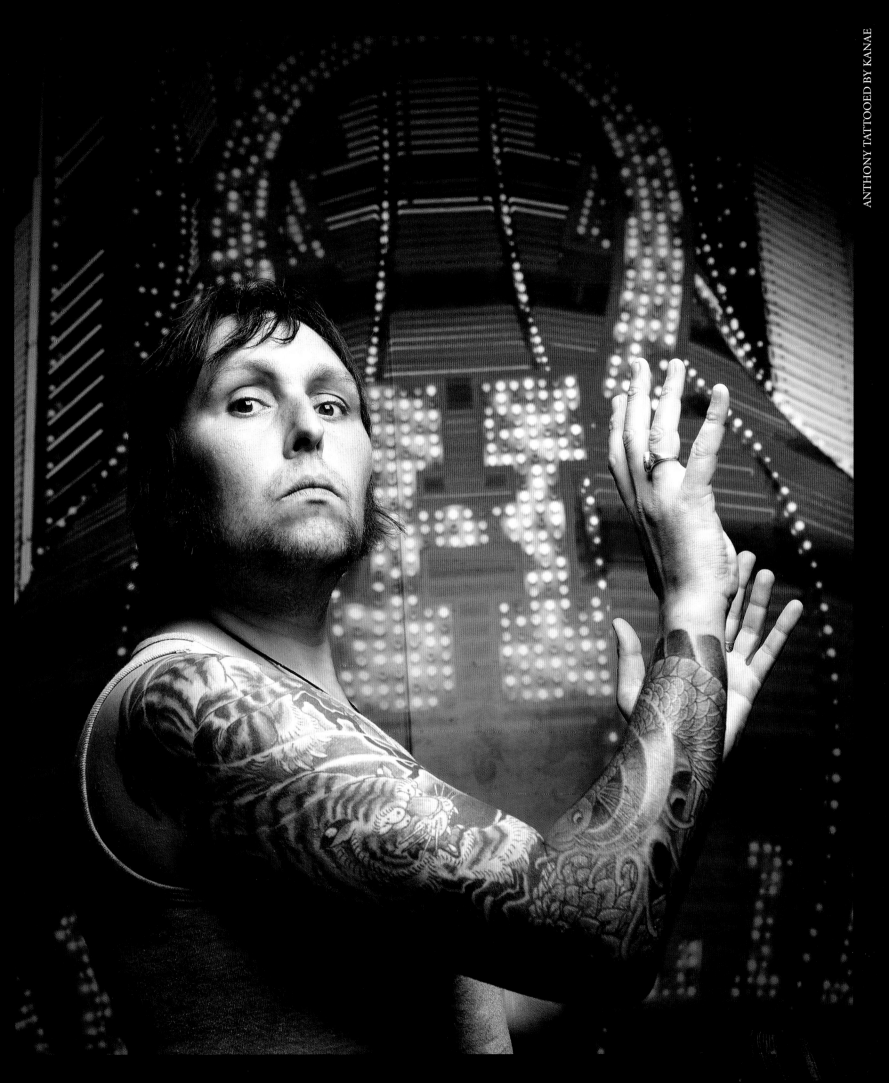

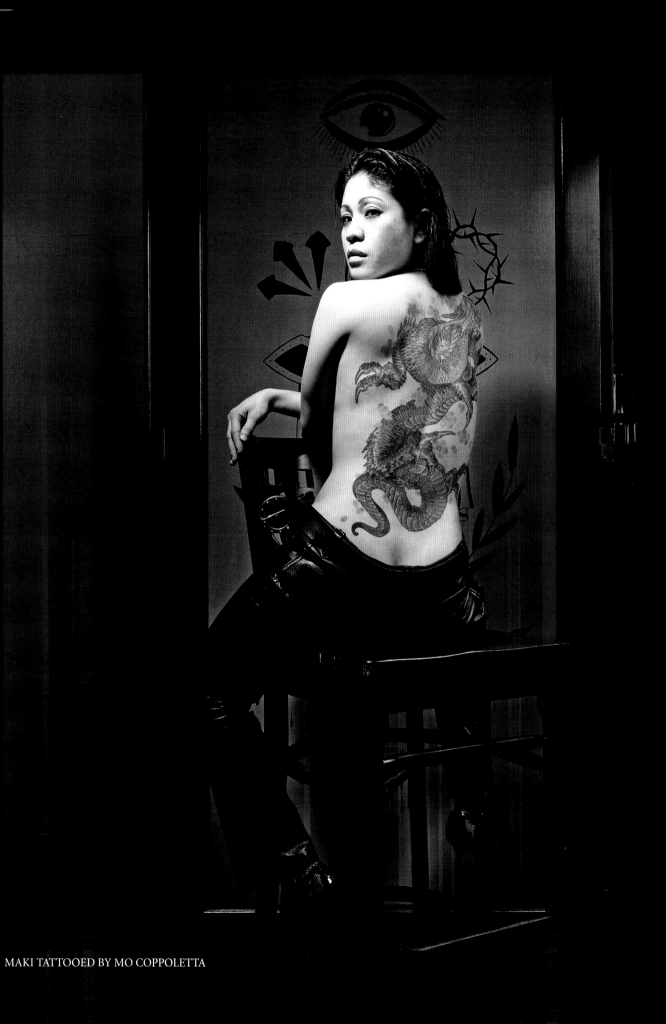

MAKI TATTOOED BY MO COPPOLETTA

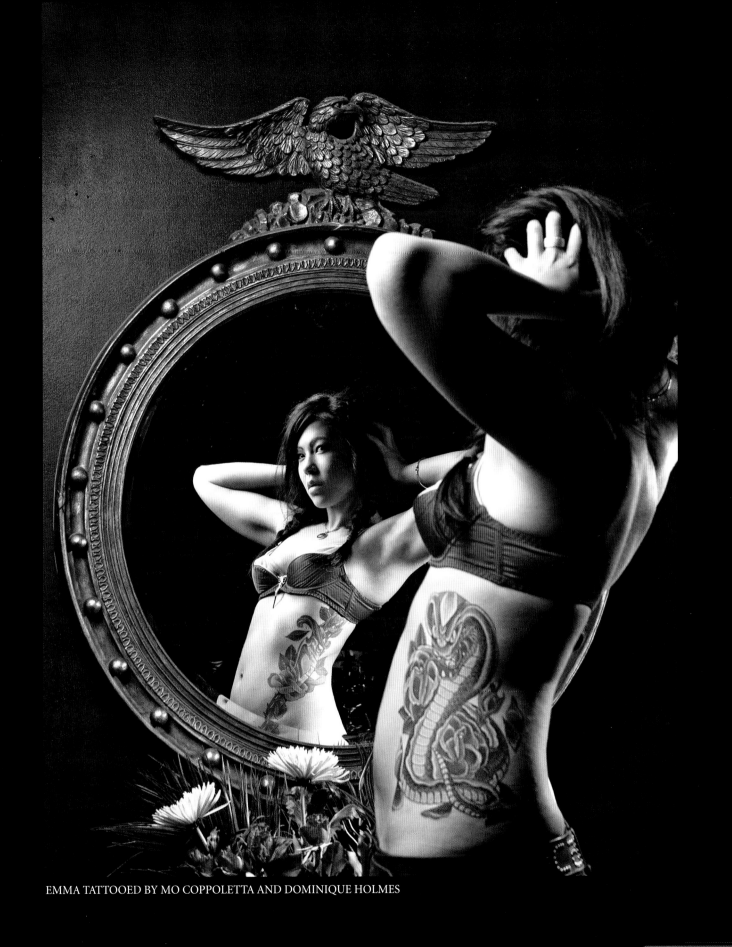
EMMA TATTOOED BY MO COPPOLETTA AND DOMINIQUE HOLMES

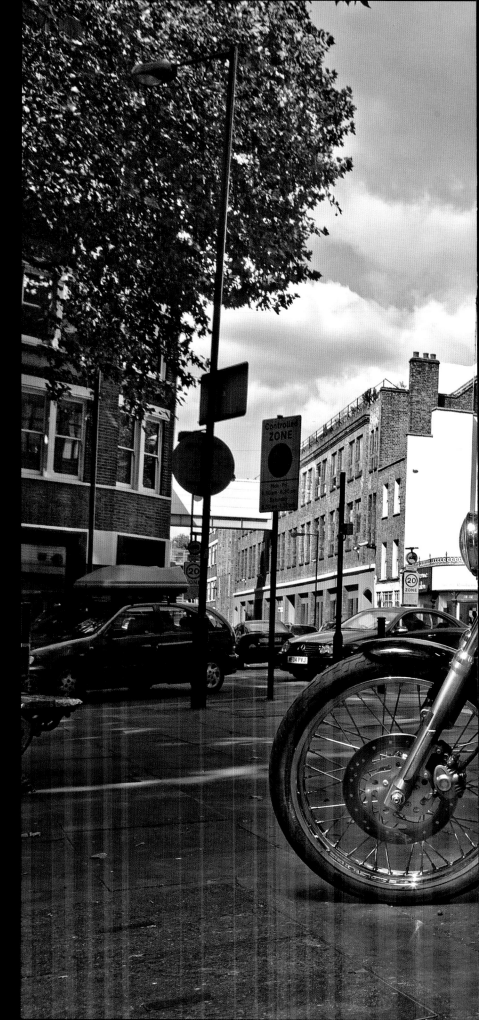

ANTHONY TATTOOED BY MO COPPOLETTA

I come up with an idea of what I want
and talk about it to Mo. He takes it away and
comes back with something completely different
and better. What you have to remember is that
it is not just about the design itself, but how it
fits on the body – that's what a good tattooist
thinks about.

I keep saying that I'll calm down.
But then I'll see someone else's tattoo on a part
of their body and I'll think, "Oh that's a good idea".
So I don't think I'll stop until I run out of space!

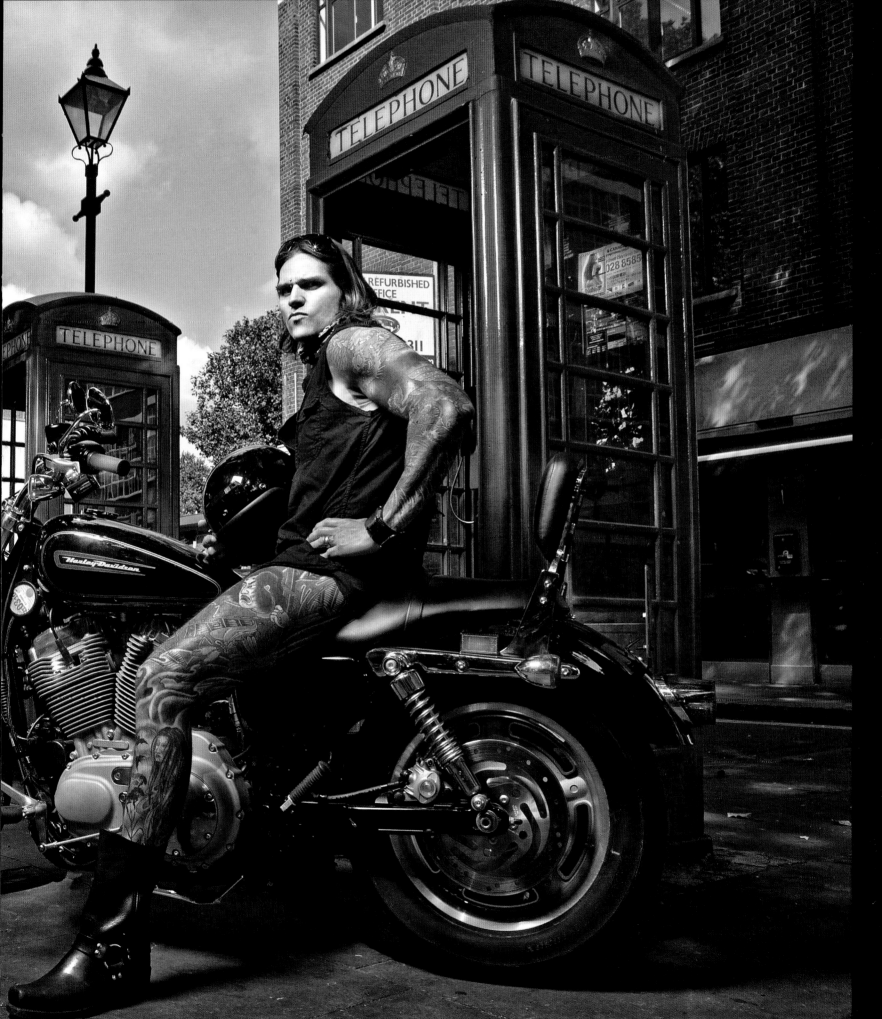

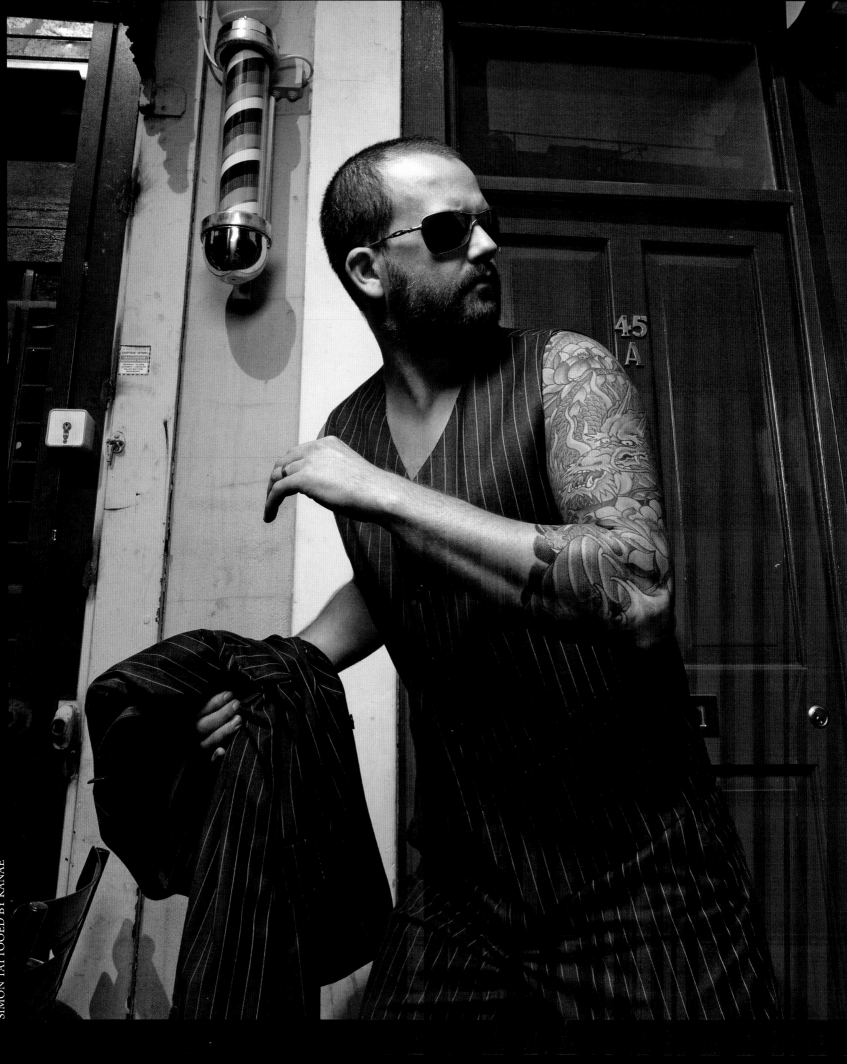

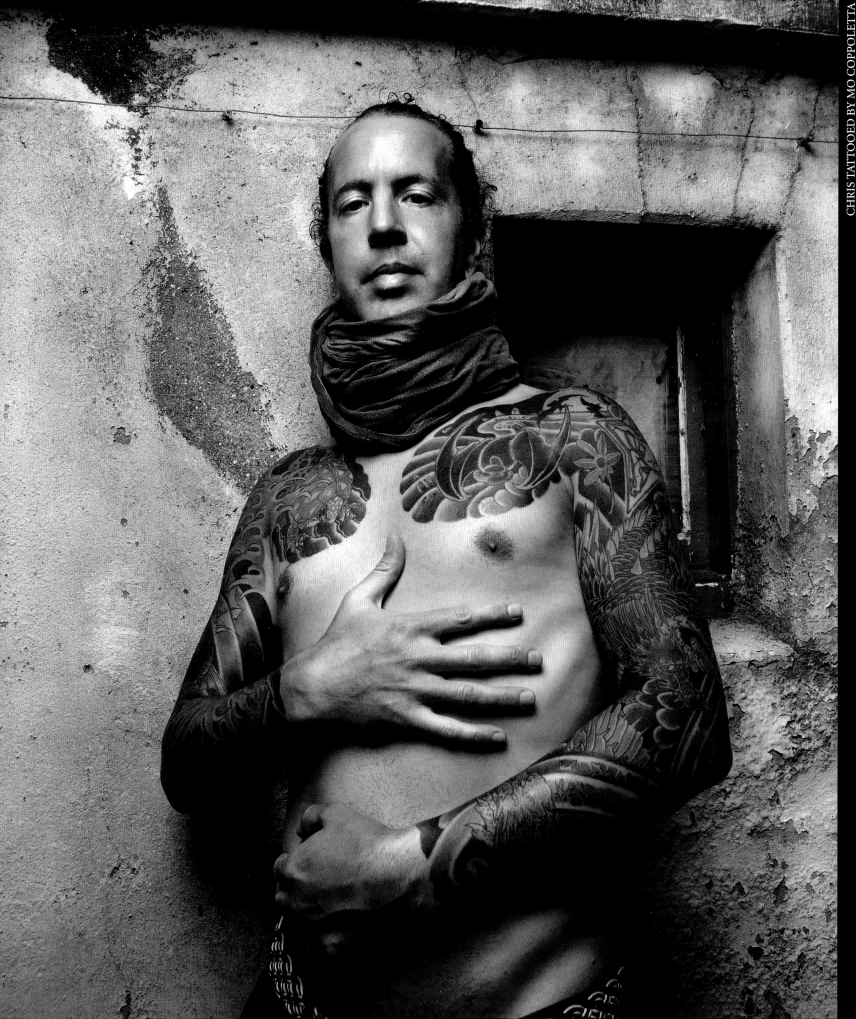

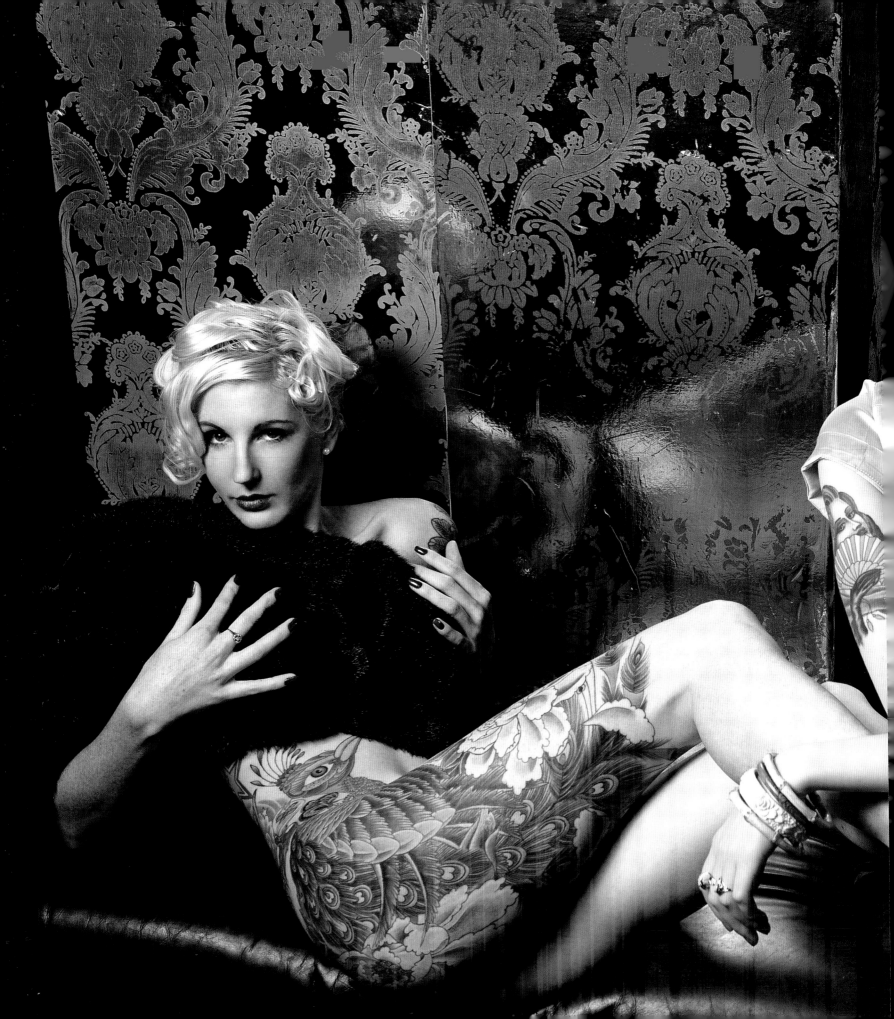

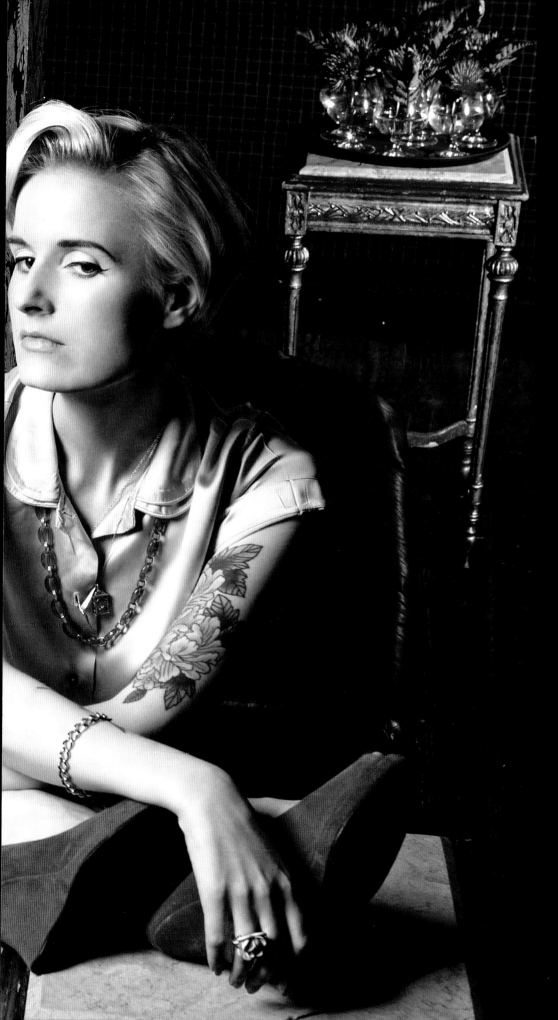

TRACY TATTOOED BY DOMINIQUE HOLMES

I was always very interested in tattoos and getting tattooed… I want to be a tattooist myself, so my interest has grown. I'm drawn to classic styles, but at the moment it's the old Japanese styles that are blowing me away.

FIONA TATTOOED BY MO COPPOLETTA

Someone once asked me if I designed my tattoos myself and I thought, "Why would I?" because what I think is essential about the process is when you come in with an idea in your head and talk it through with the artist, the person who is able to bring that image to life.

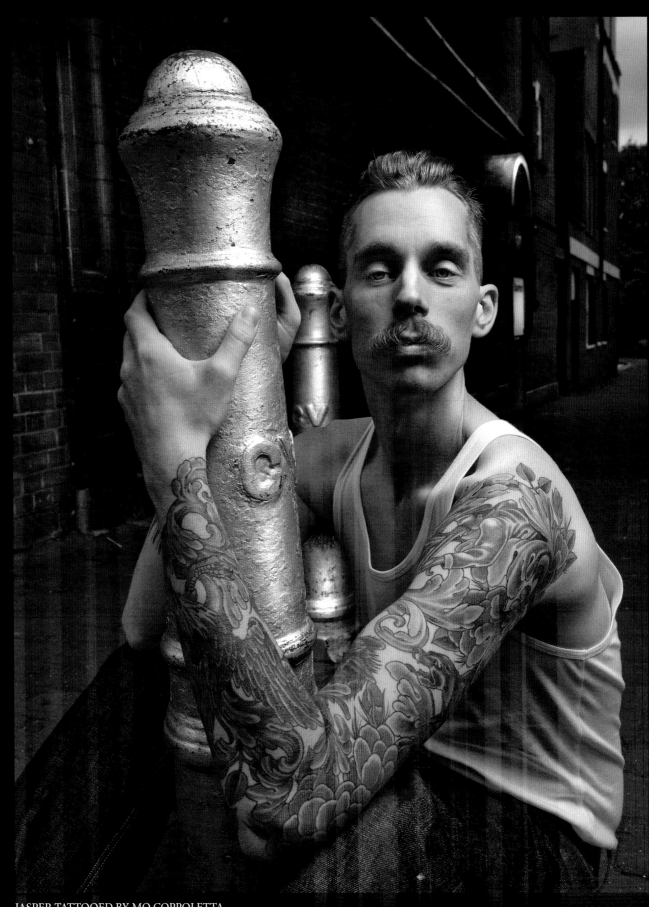

JASPER TATTOOED BY MO COPPOLETTA

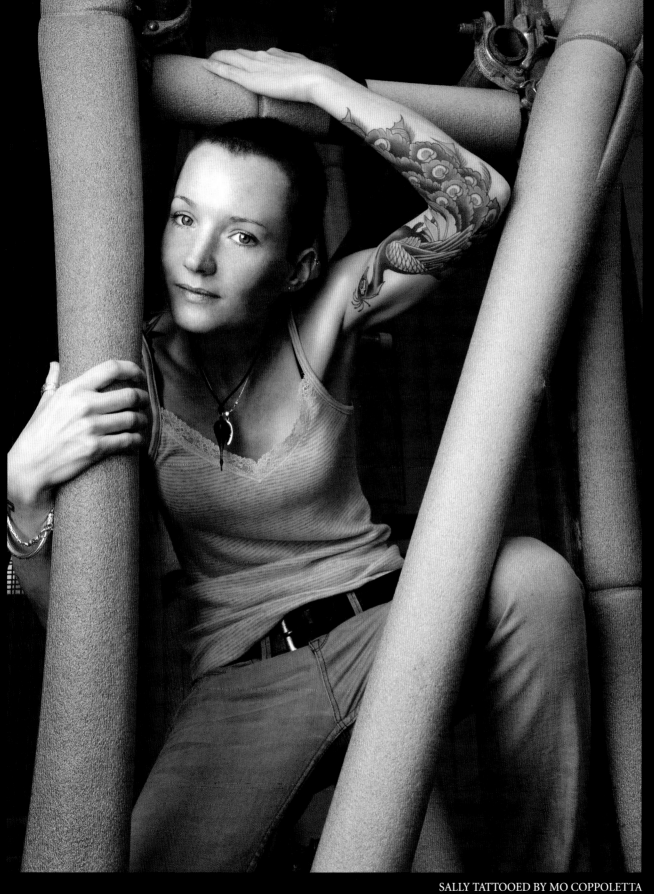

SALLY TATTOOED BY MO COPPOLETTA

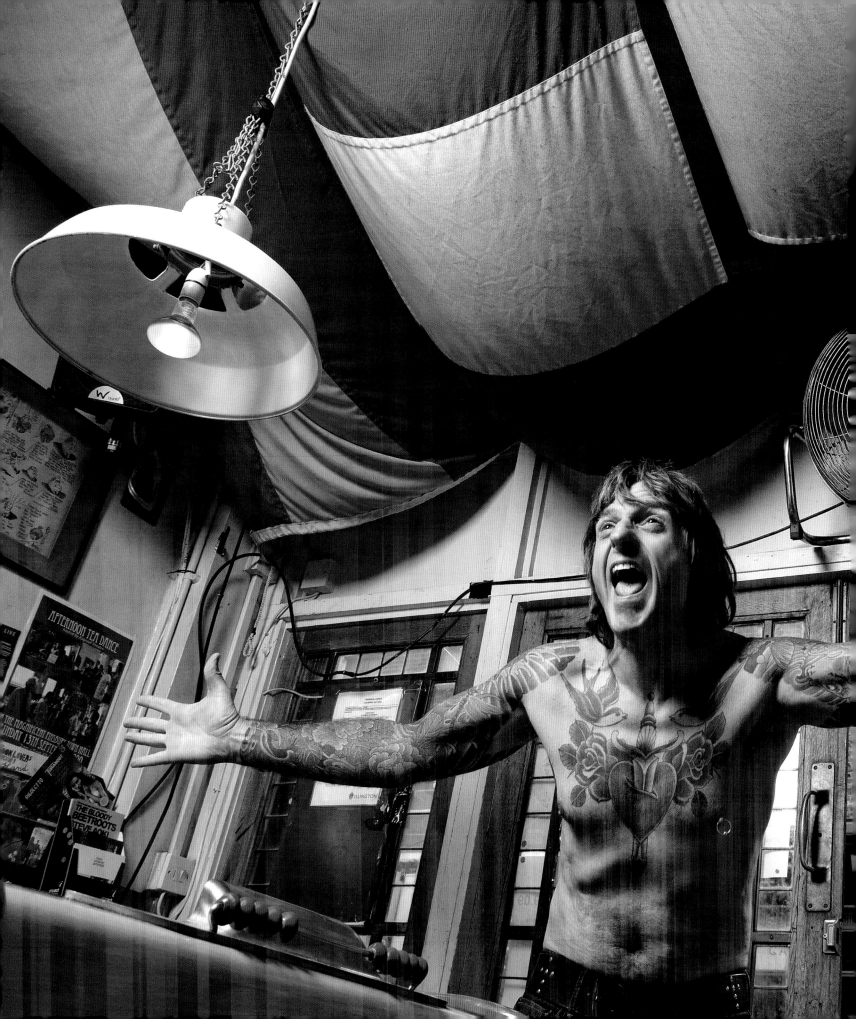

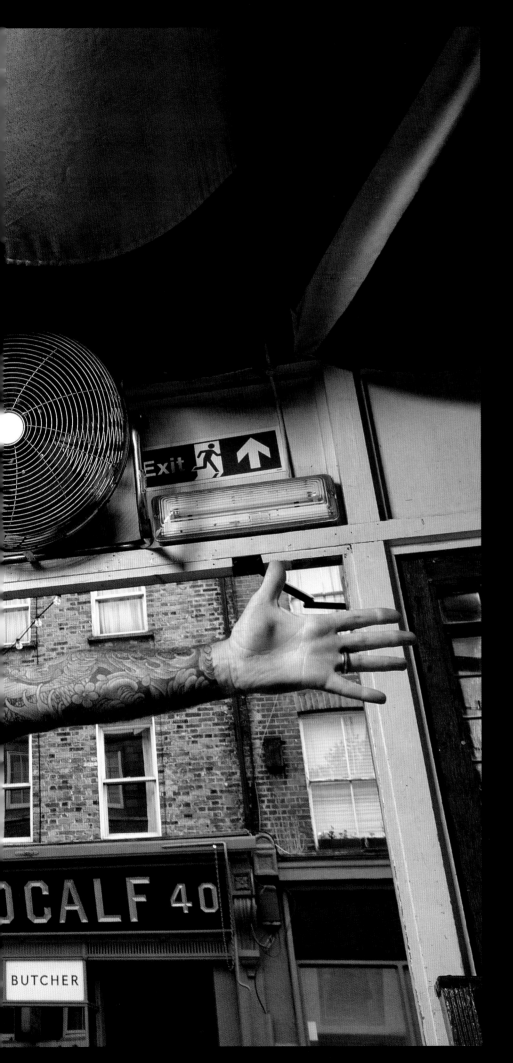

ANDY TATTOOED BY MO COPPOLETTA

There used to be taboos about tattoos,
I suppose, but now there's so little negativity
and I think that's great. Whenever I go out with
just a T-shirt on, people come up me to talk about
them. They are fascinated by them, by the
intricacy of the needlework.

I found Mo's work in tattoo magazines and
by going to conventions. I just love the shop,
so relaxed and chilled. But it's the work that's
brilliant. I won't let anyone but Mo and the Family
Business tattoo me. In fact, both my kids have now
been tattooed there. We're bringing a little family
business to the Family Business!

What I like about tattoos is that it is a unique
piece of art on your body – even if it is a common
symbol, it's different on everyone because
everyone's body is different. It is something
that lives with you and dies with you…
an installation piece.

I got my first couple of tattoos when I was about 16,
just smaller things, impulsive, as you do when you're that age.
Then it was a long time before I got another, not until my early 40s.
Some people asked, "Why are you getting these done now?" which I
found bizarre. Tattoos shouldn't only be something you get when you're
young. In fact, I'm really glad I waited, because they have deep meaning
for me. They signify certain points in my life and are not there
just because they look cool.

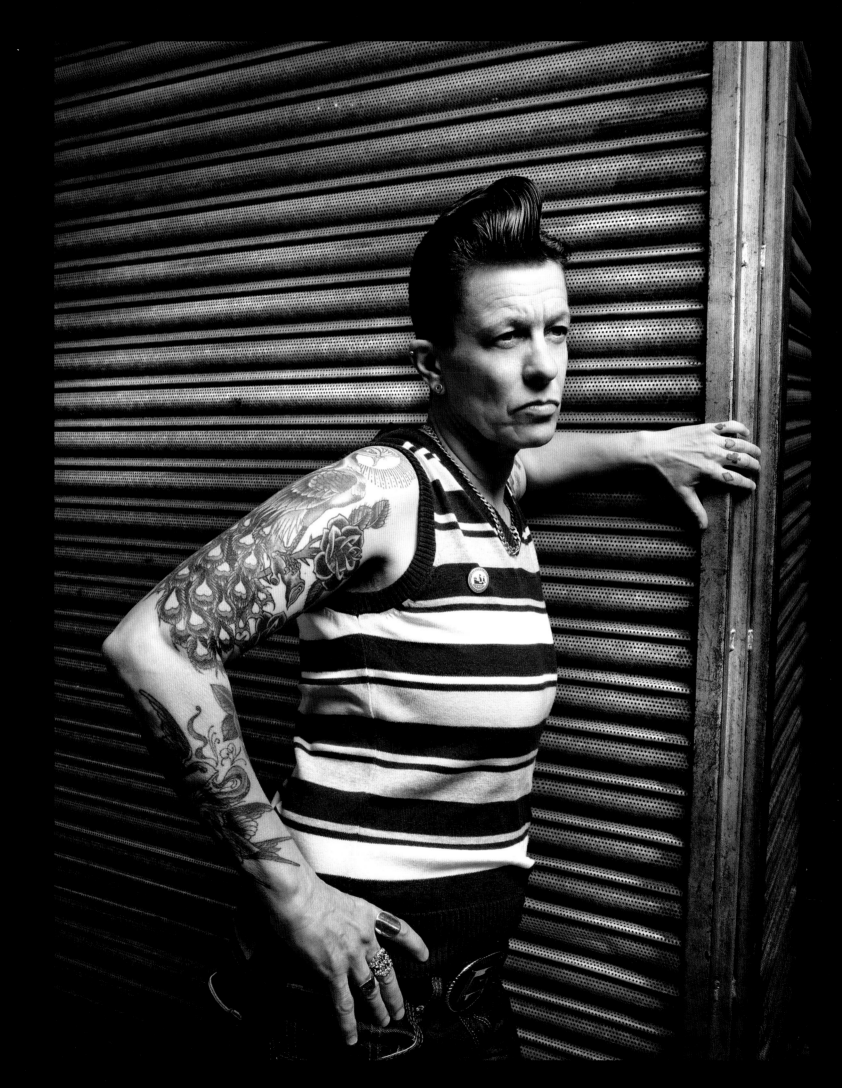

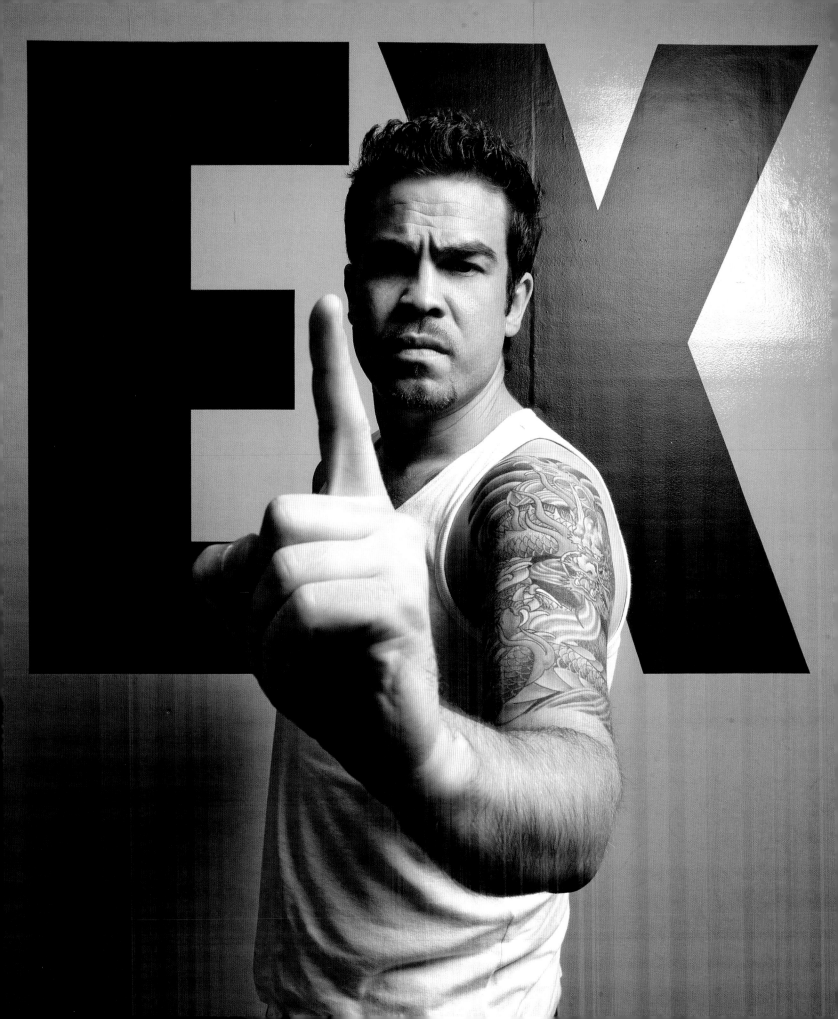

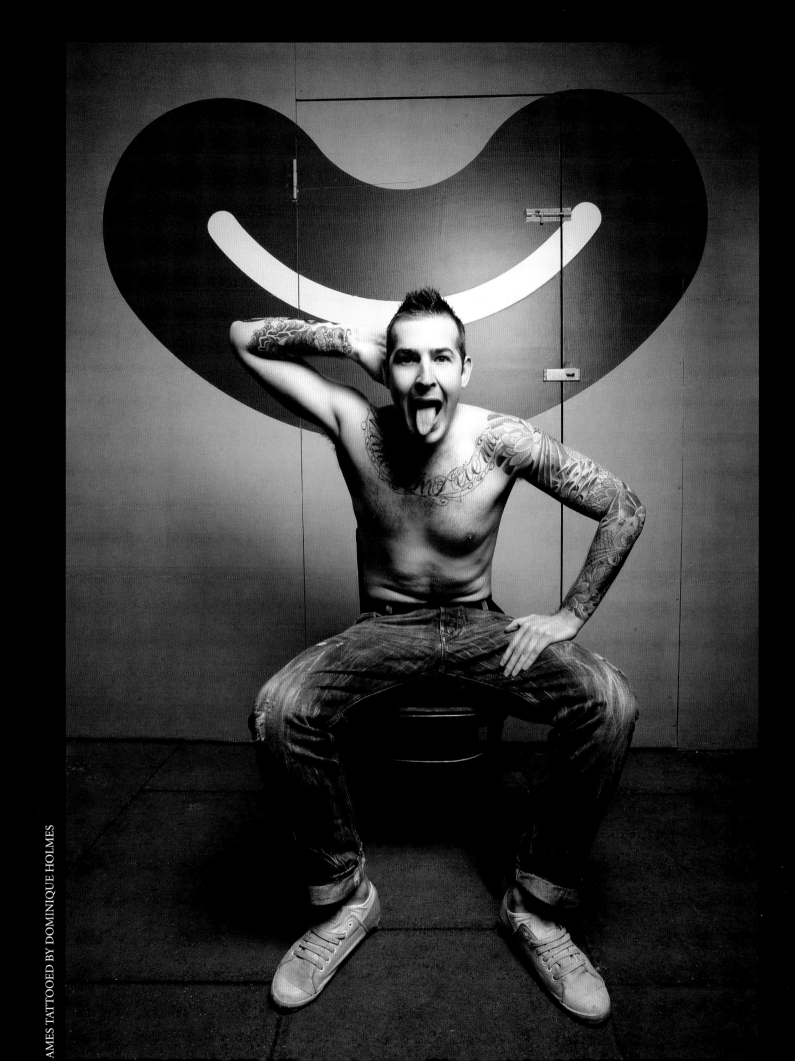

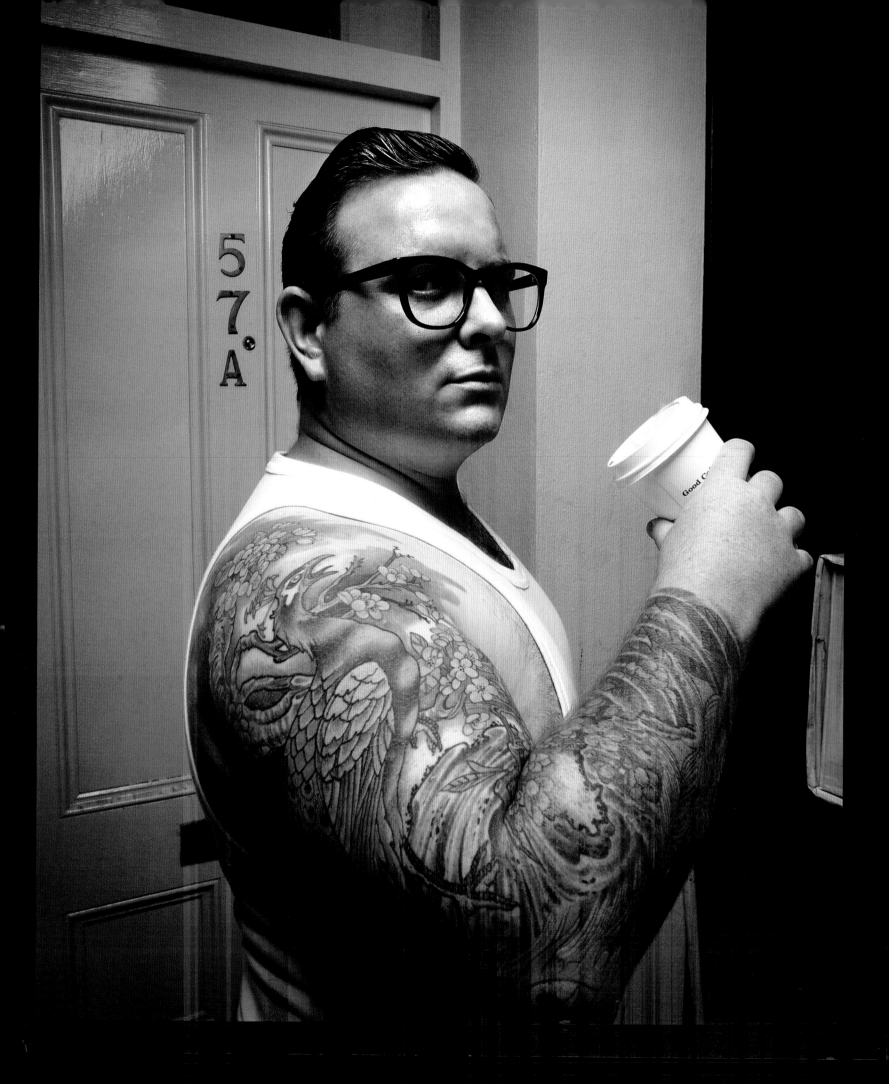

JOHN TATTOOED BY MO COPPOLETTA

This is actually my first tattoo, but it's a pretty big one:
an entire sleeve. I was always a fan of tattooing… but I thought
I never really had a good enough reason to get one.
I didn't want to say, "Well, I got this because it looks cool."
or "I got this when I was drunk."

I was going through a bad patch in my life when I came
upon a Hebrew inscription: "This too shall pass." It's an old
saying, it pops up in a lot of cultures, but it struck me. It means
that if you're going through a tough time it won't last.
On the other hand, if you're on top of the world,
you shouldn't get too cocky as you might
not be there forever.

My tattoo tells that story. At the bottom, near the wrist, is a
Koi carp trapped in a pond – Koi, like salmon, have to travel
upstream to spawn and feel free. In the middle there are
cherry blossoms, which come out for two weeks a year in Japan,
symbolising change. And at the top a peacock screaming
for joy at the sky – but his tail feathers also stretch back
to the pond at my wrist, to that low point.

I like the whole idea of getting a reference to a quote about
impermanence etched into my skin with permanent ink.
It is something I can talk about to people if they ask,
whether it is next week or when I'm in an old folks home.
I'm thinking of getting the other sleeve done;
but I have to come up with another story for it.

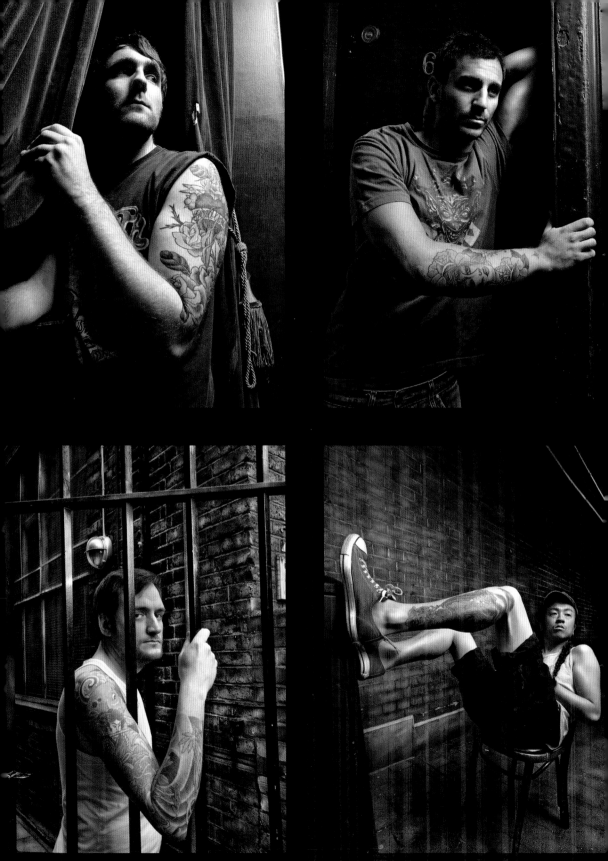

CLOCKWISE FROM TOP LEFT: BEN TATTOOED BY MIE SATOU, GIL TATTOOED BY DIEGO
BRANDI YOSHI TATTOOED BY MIE SATOU, JIM TATTOOED BY KANAE

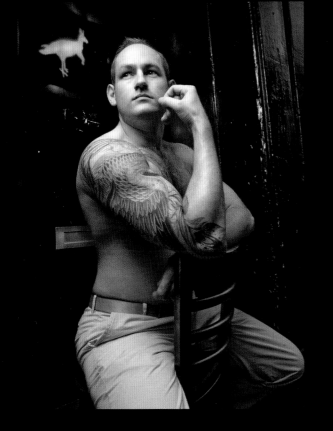
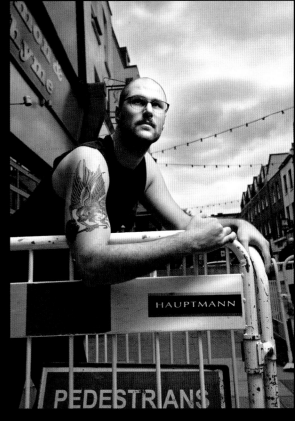
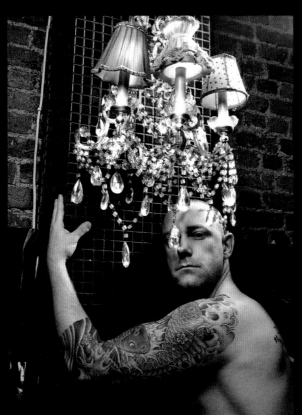
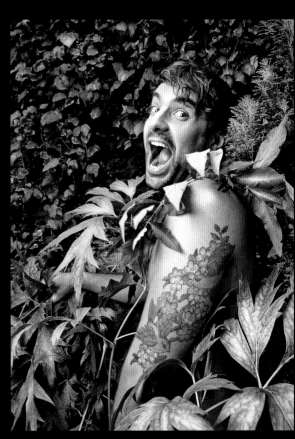

CLOCKWISE FROM TOP LEFT: BEN TATTOOED BY DIEGO AZALDEGUI, ALESSIO TATTOOED BY DIEGO BRANDI
TOM TATTOOED BY MIE SATOU, JULES TATTOOED BY KANAE

PALOMA FAITH TATTOOED BY MO COPPOLETTA

When I came in to get my first tattoo, I remember saying to Mo,
"This is going to be my only tattoo, so I want it to be the best tattoo
you've ever done." He just sort of smiled and said,
"Don't worry, you'll be back." He was right, of course.
My first tattoo started to look lonely and he's done several
tattoos on most of my back, and now there
is only a small patch left.

I don't care about how mainstream tattoos are getting.
I'm not interested if everyone has one, or if no one does.
I got my tattoos because they look beautiful, they mean
something to me, they are works of art. It's stupid to follow
fashion or get a "fashionable" tattoo; I'm glad I
never got a Celtic cross, that's for sure.

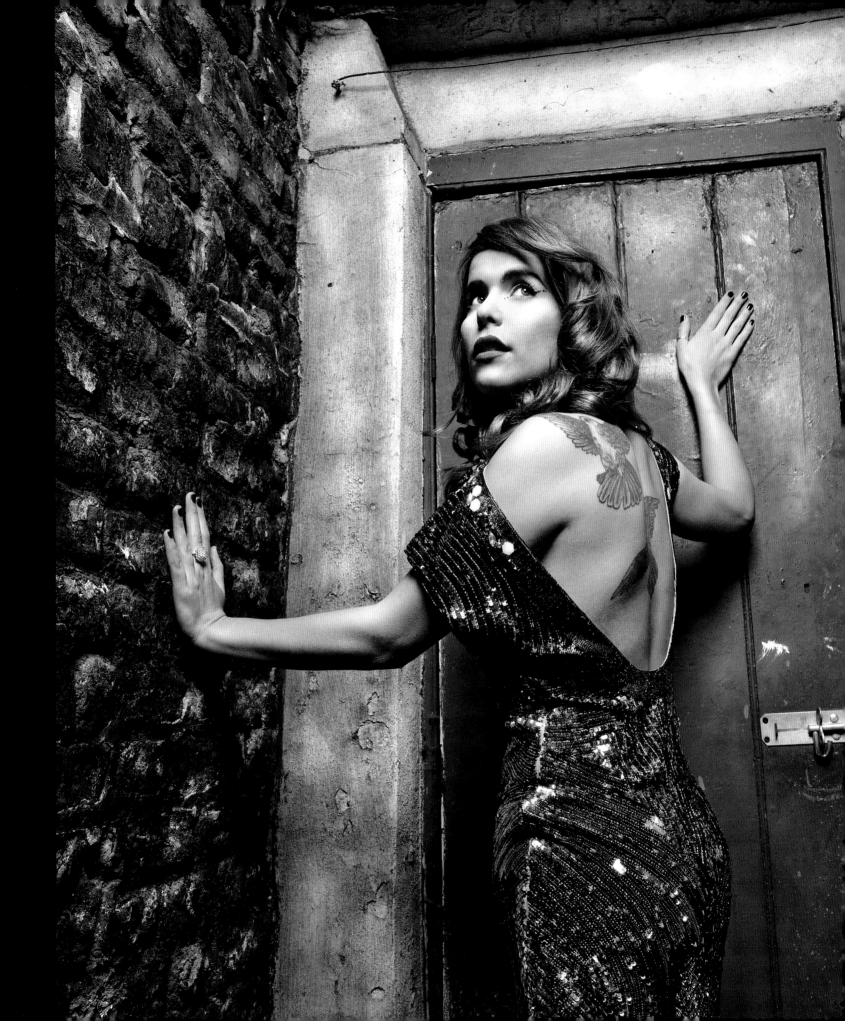

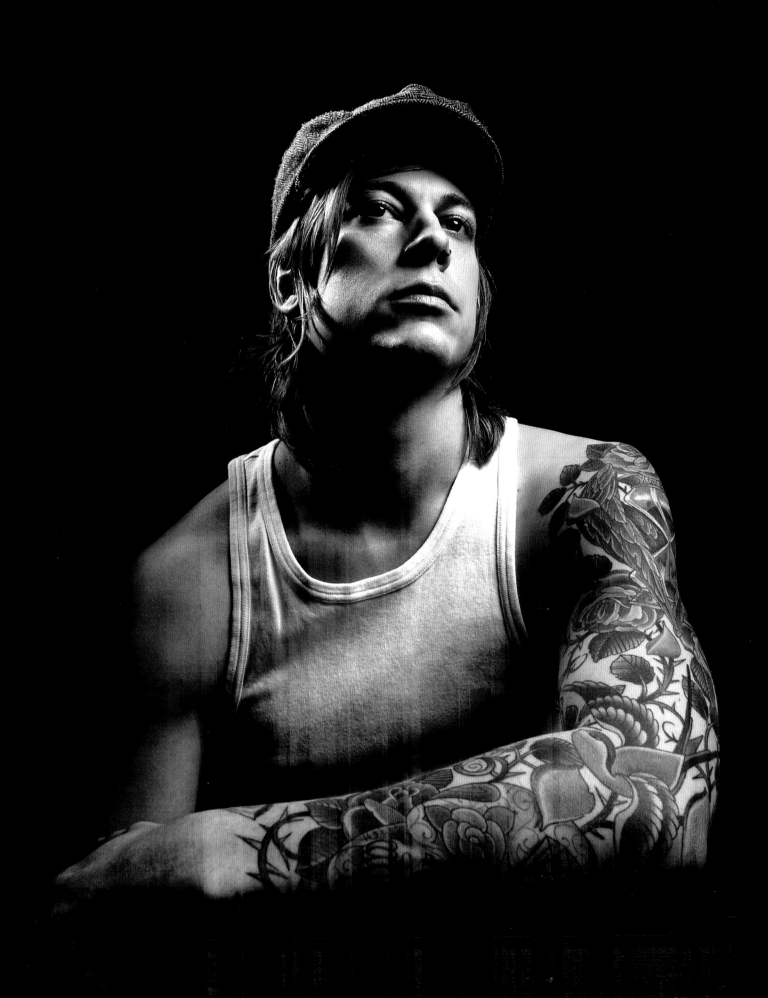

RHYS TATTOOED BY MO COPPOLETTA

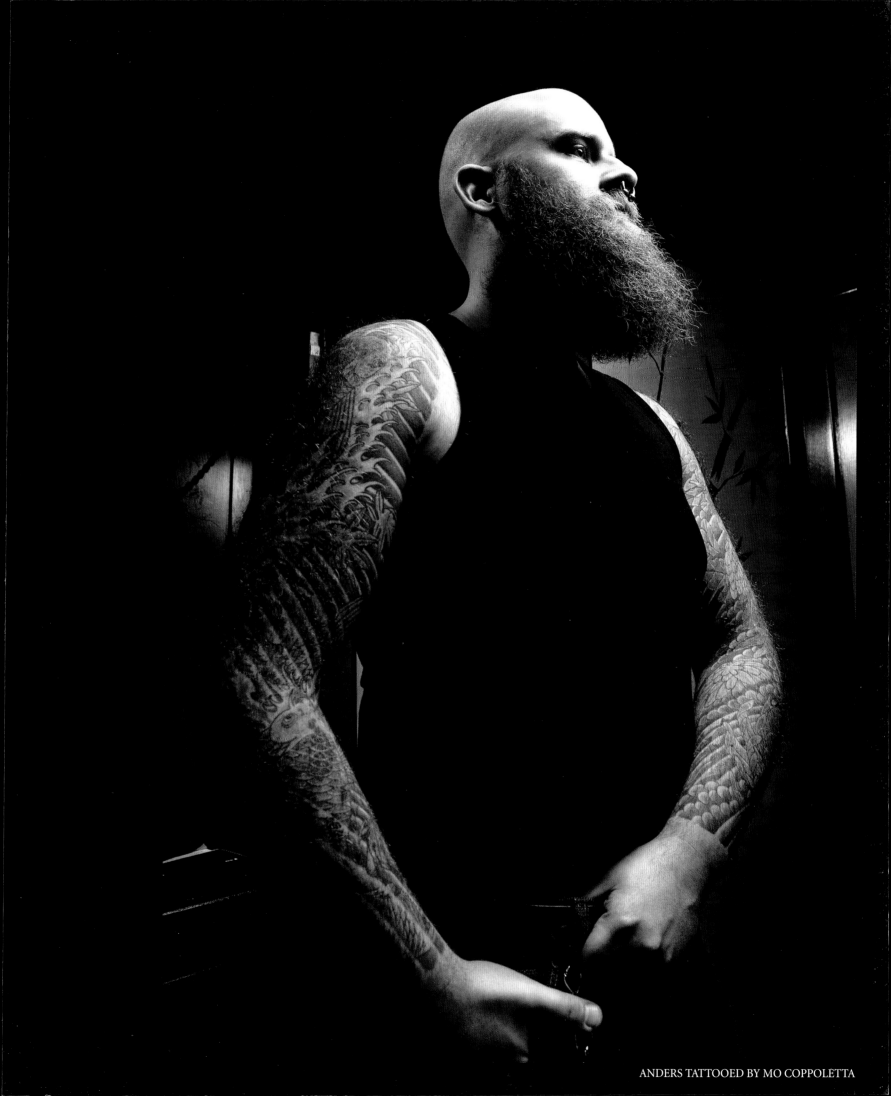

ANDERS TATTOOED BY MO COPPOLETTA

DUNCAN TATTOOED BY DOMINIQUE HOLMES

I've never really enjoyed getting tattooed!
It seems to hurt more and more every time.
Each time I ask myself why I do it, but then it heals
and you forget that you couldn't walk for
a week after it was done!

I always loved getting tattooed at The Family Business –
such a cool shop. The talent of not just the resident
artists but all the guest artists that pass through
keeps me coming back!

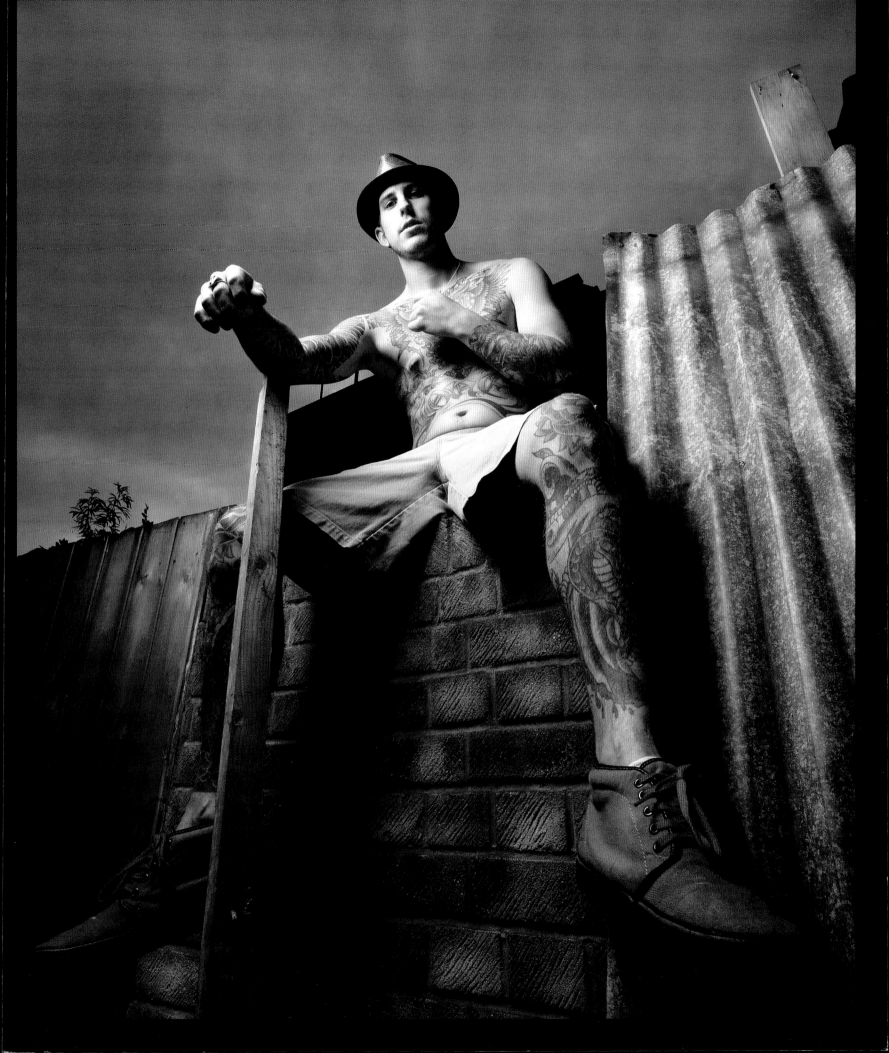

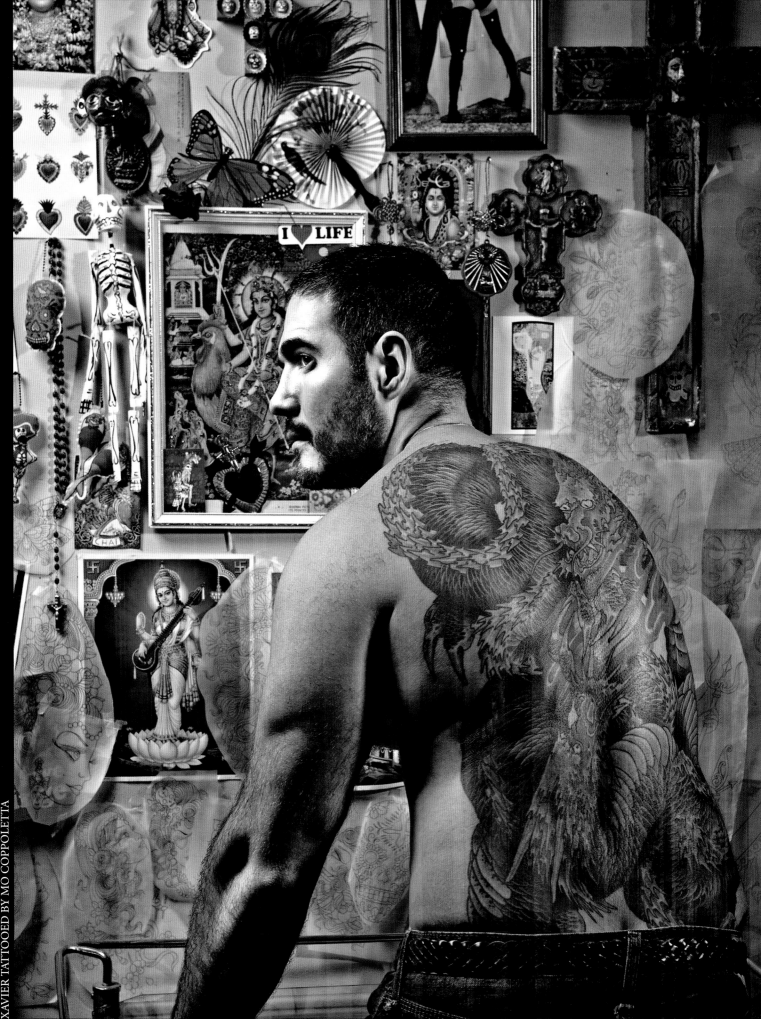

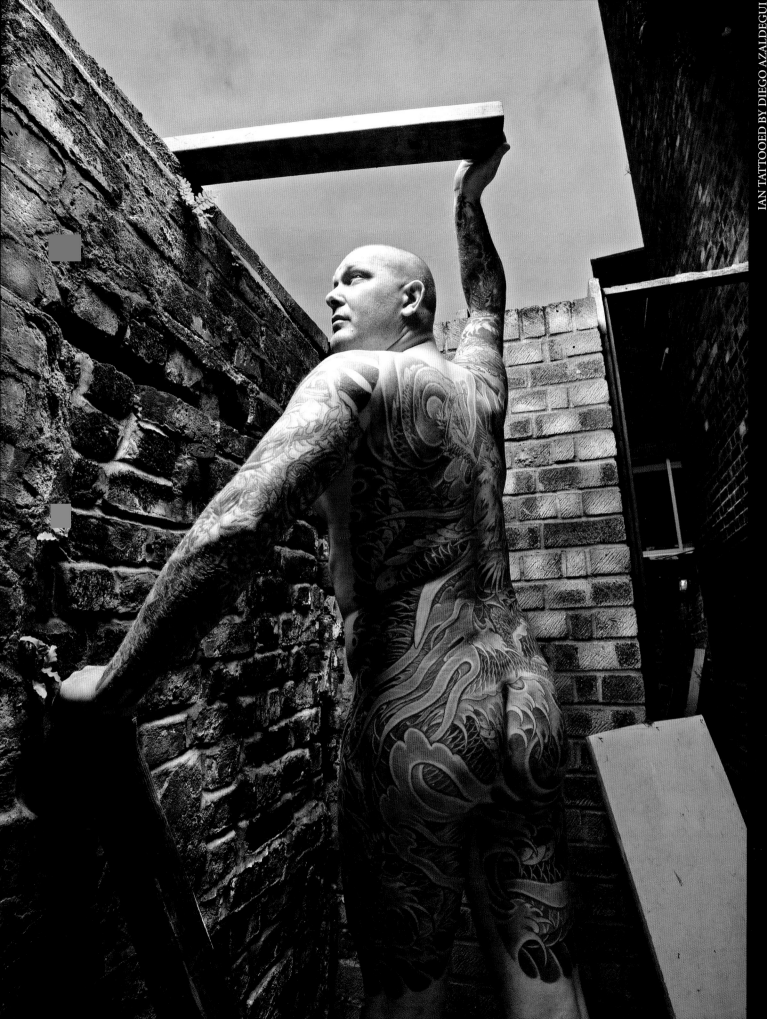

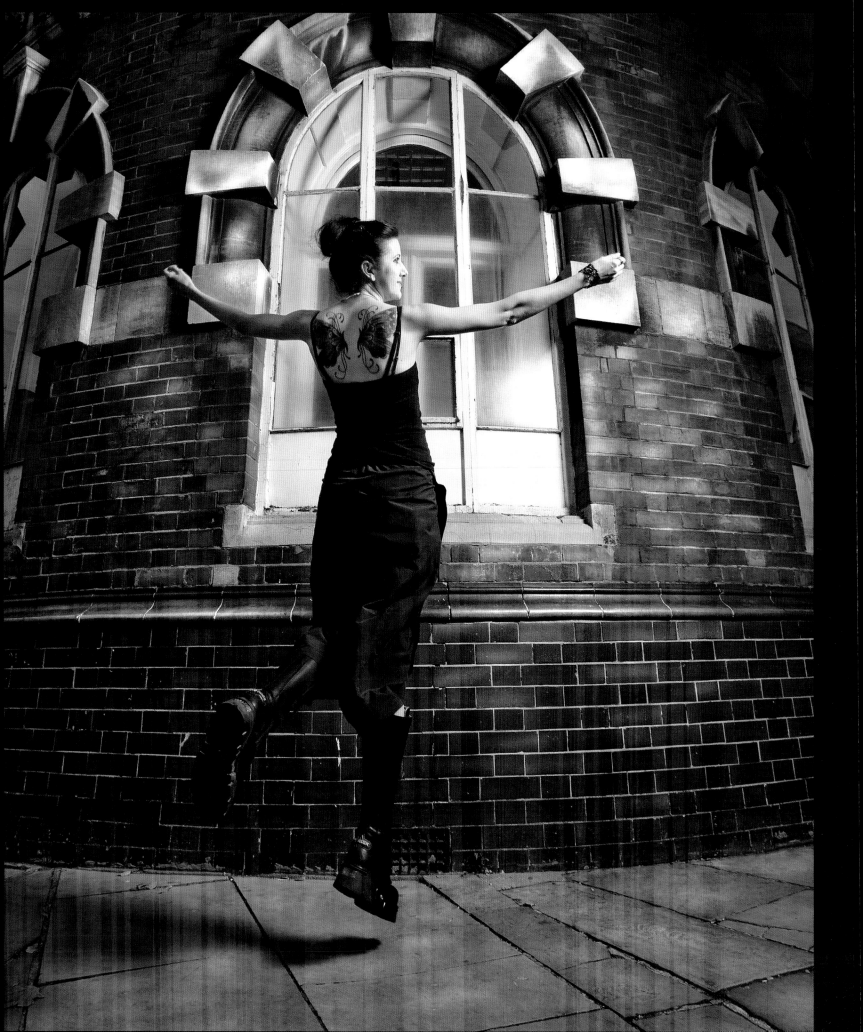

NICOLE TATTOOED BY DIEGO BRANDI

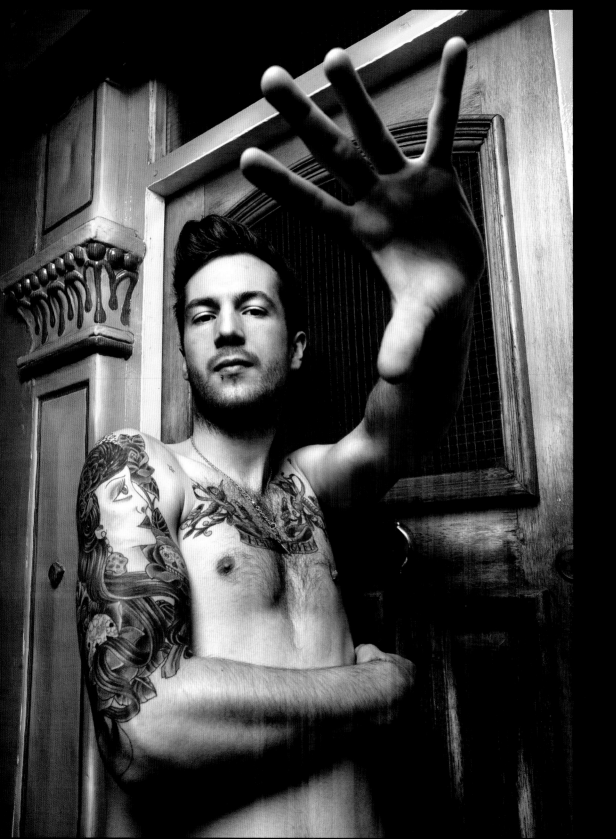

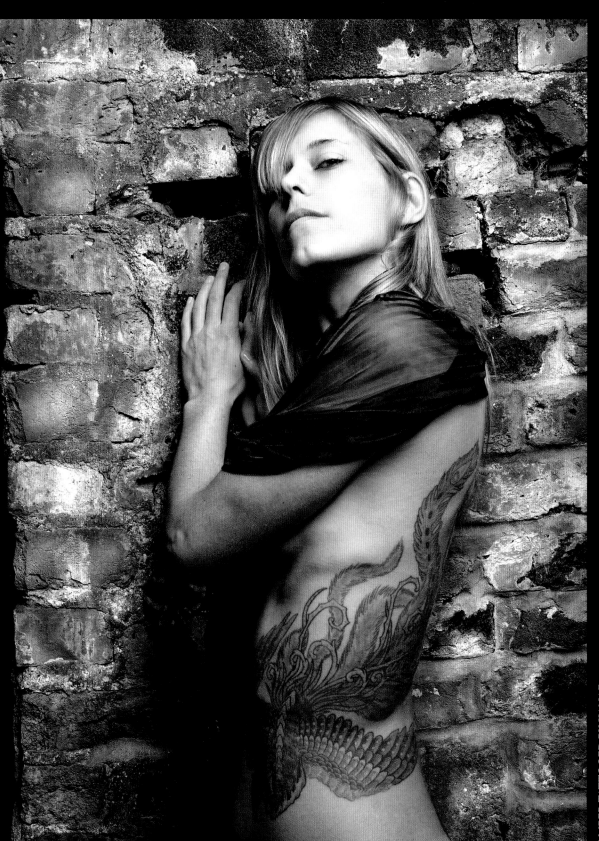

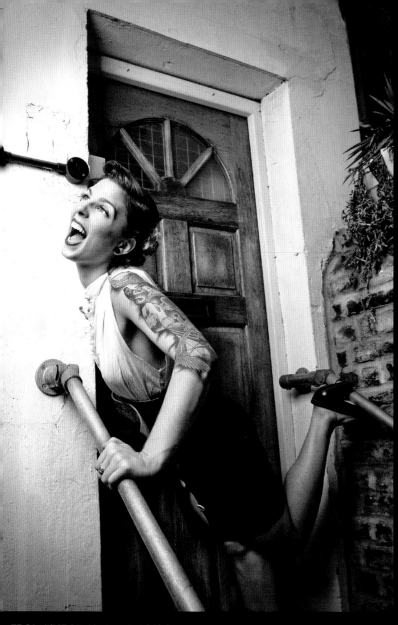
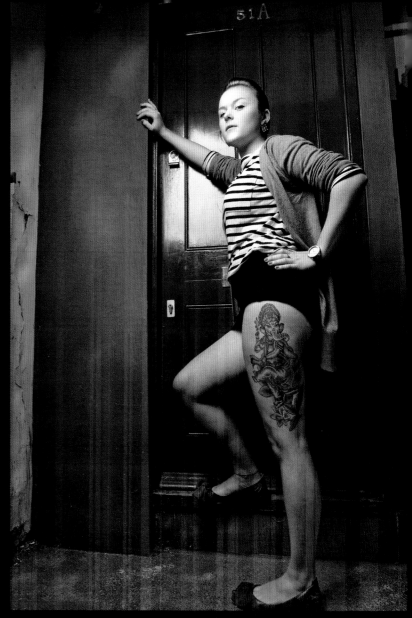

FROM THE LEFT: JADE TATTOOED BY MIE SATOU, NAOMI TATTOOED BY MIE SATOU, CLAIRE TATTOOED BY DOMINIQUE HOLMES, TESS TATTOOED BY KANAE

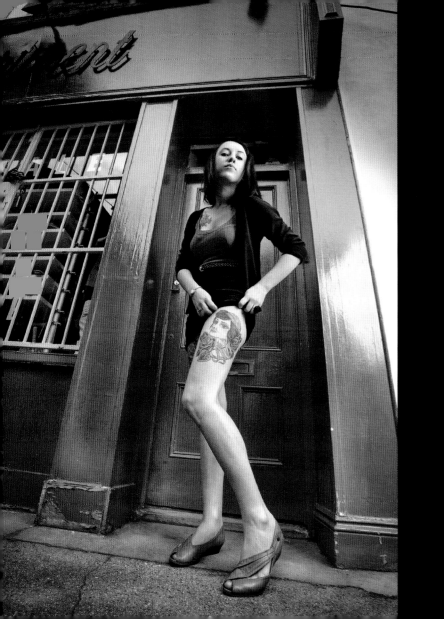
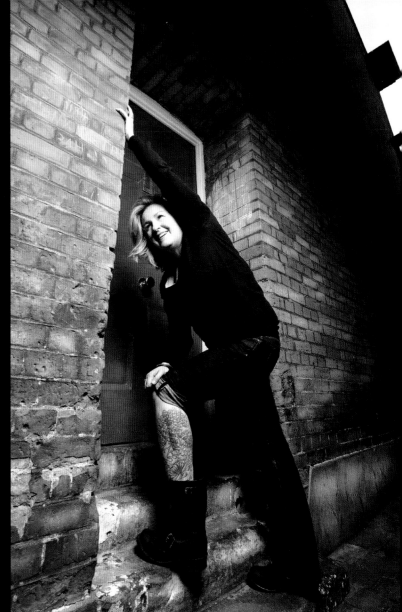

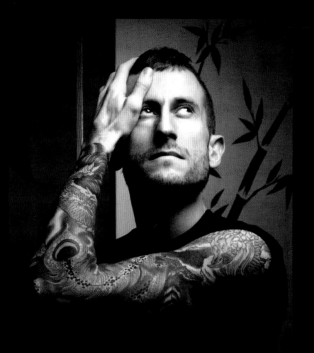

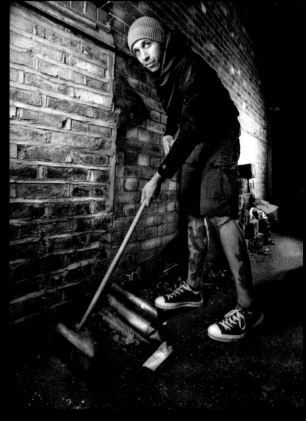

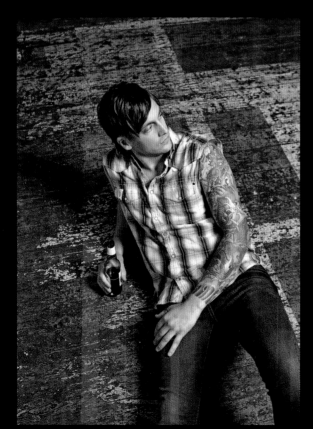

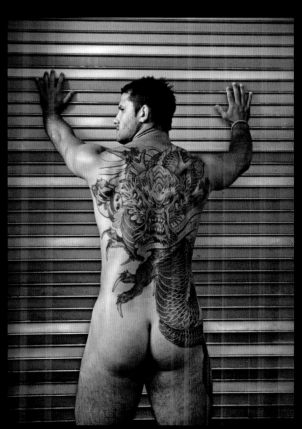

CLOCKWISE FROM TOP LEFT: BARRY TATTOOED BY MO COPPOLETTA, REG TATTOOED BY MIE SATOU
JOHN TATTOOED BY DIEGO AZALDEGUI, ANDREW TATTOOED BY KANAE

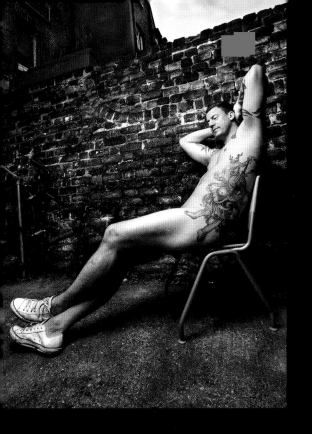
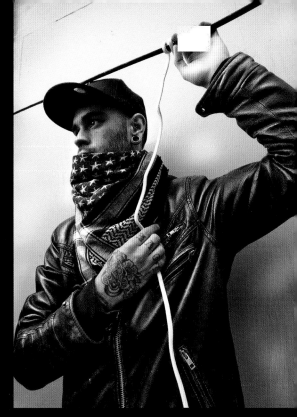
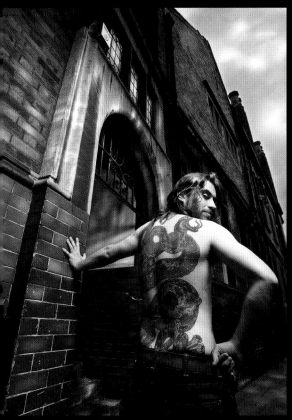
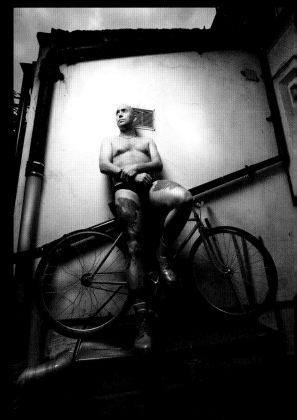

CLOCKWISE FROM TOP LEFT: SCOTT TATTOOED BY MO COPPOLETTA, TIAGO TATTOOED BY DIEGO BRANDI
MARK TATTOOED BY MO COPPOLETTA, ROBIN TATTOOED BY MO COPPOLETTA

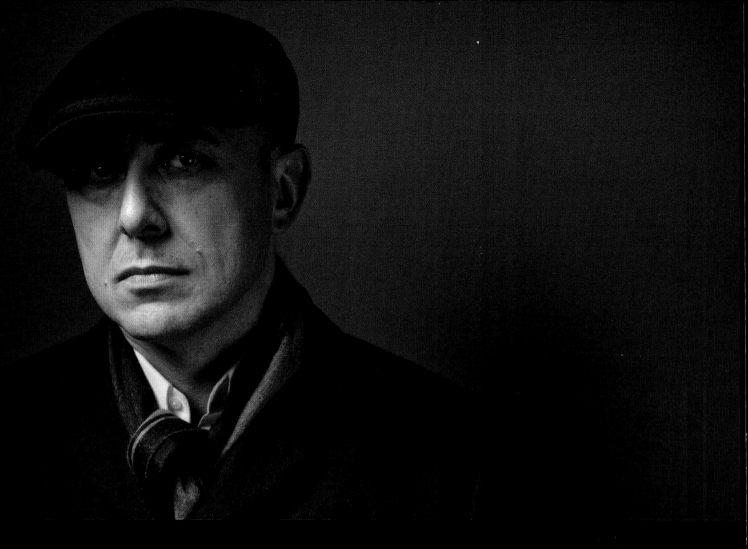

ACKNOWLEDGEMENTS

First of all, I would love to thank my family: my sister, my father, and especially my mother, for their love and support throughout the years, even though far away.

This book has only been possible with the help of a lot of people.

My team: Tracy and David for their organization and Dom, Mie, Kanae, Andrea, Diego Azaldegui and Diego Brandi for applying such a refined array of tattoos at TFB. A big thank you to Fredi Marcarini for his fiery passion about the project and to Chris Terry for such a fine job. Your shots really make the book. Thanks to Steve for spending endless hours on the design and putting up with my requests. Thanks to Nathalie and Laura at Heartbreak Publishing and Emily at Anova Books. Thanks to all our customers for choosing TFB for their projects, and especially to the ones in the book for their co-operation and kindness: you are our real resource! A special mention goes to Arianna whose help and support made TFB what it is today.

Thank you all, Mo Coppoletta.

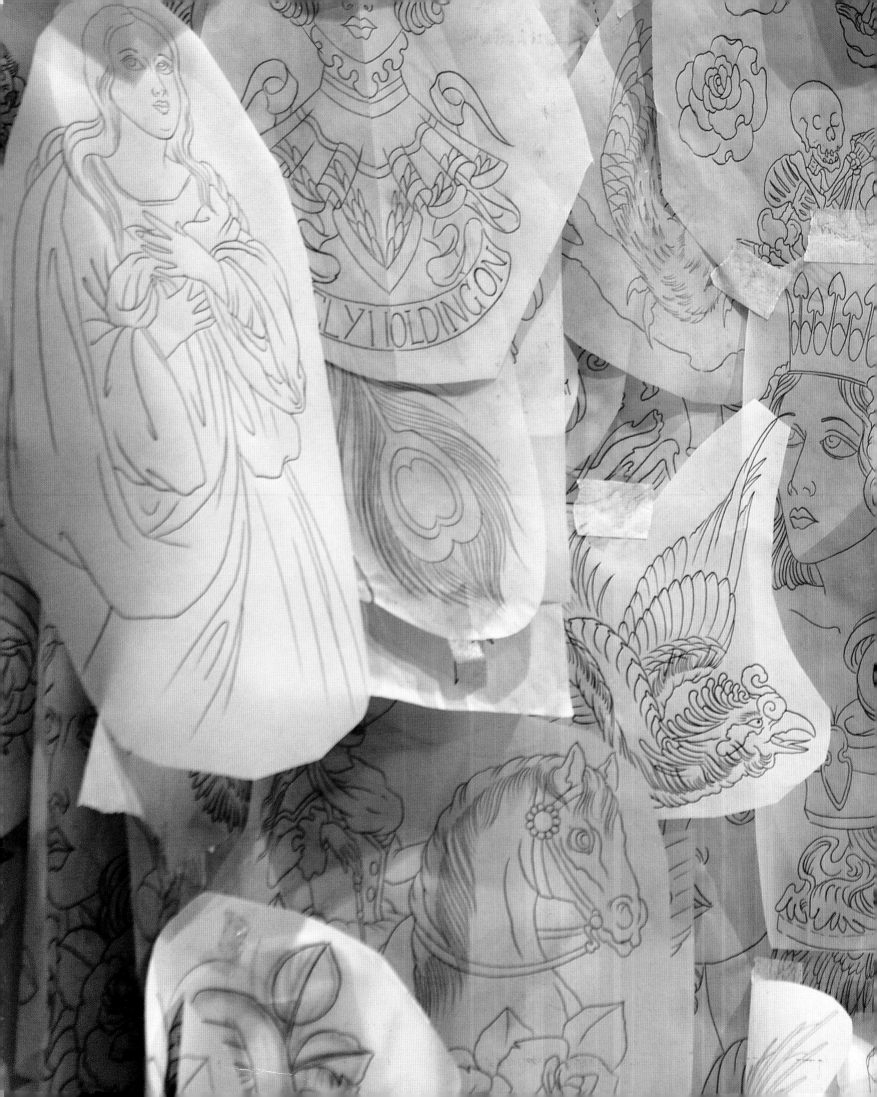